SEDUCED BY MRS. ROBINSON

Also by Beverly Gray

*Ron Howard: From Mayberry
to the Moon . . . and Beyond*

*Roger Corman: Blood-Sucking Vampires,
Flesh-Eating Cockroaches, and Driller Killers*

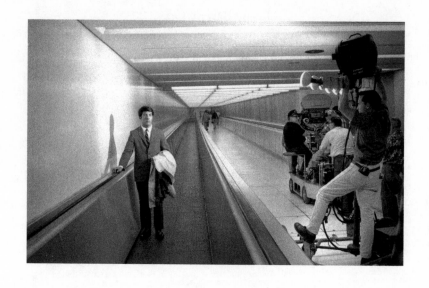

Benjamin Braddock, played by Dustin Hoffman, is filmed arriving at
Los Angeles International Airport. For decades the moving walkway and white
tile wall were familiar sights to travelers at LAX's United Airlines terminal.

SEDUCED by Mrs. ROBINSON

How *The Graduate* Became the Touchstone of a Generation

Beverly Gray

ALGONQUIN BOOKS OF CHAPEL HILL 2017

Published by
ALGONQUIN BOOKS OF CHAPEL HILL
Post Office Box 2225
Chapel Hill, North Carolina 27515-2225

a division of
WORKMAN PUBLISHING
225 Varick Street
New York, New York 10014

Library of Congress Cataloging-in-Publication Data
Names: Gray, Beverly, author.
Title: Seduced by Mrs. Robinson : how The Graduate became the touchstone
of a generation / Beverly Gray.
Description: First edition. | Chapel Hill, North Carolina : Algonquin Books
of Chapel Hill, 2017. | Includes bibliographical references and index.
Identifiers: LCCN 2017021025 (print) | LCCN 2017028467 (ebook) |
ISBN 9781616207663 (e-book) | ISBN 9781616206161 (hardcover : alk. paper)
Subjects: LCSH: Graduate (Motion picture)—Influence. | Graduate
(Motion picture)—History and criticism. | Motion pictures—Influence. |
Identity (Psychology) in motion pictures.
Classification: LCC PN1997.G665 (ebook) |
LCC PN1997.G665 G73 2017 (print) | DDC 791.43/72—dc23
LC record available at https://lccn.loc.gov/2017021025

10 9 8 7 6 5 4 3 2 1
First Edition

To the memory of
Estelle and David Gray
for shaping my past

To
Adrian and Mila Grayver
for enlivening my future

CONTENTS

AN INVITATION

There's this party. A young man, impeccably groomed, descends a staircase in a nouveau riche Beverly Hills home. He's instantly accosted by a bevy of squealing suburbanites—the female contingent of his parents' circle of friends—tricked out in sequins, feathers, and pearls. Liquor is flowing; tongues are wagging; everyone is keen to congratulate Benjamin Braddock on the honors he's racked up at an ivy-covered East Coast college. What's next for the prodigy? Out by the swimming pool, one no-bullshit businessman with a twinkle in his eye insists he's got the answer:

"Plastics."

But there's also a woman, with all-knowing dark eyes, who peels away from the others of her generation. She gives Ben the once-over, flicks her cigarette ash, and asks for a ride home. Though her intentions are not at first crystal clear, she's proposing a party of another sort. That's how this graduate comes to get a very different education, in a film that plays off adulthood against youth, pragmatism against idealism, lust against love, cocktails for two against a connubial champagne toast. The Braddock homecoming soiree is where it all begins. (Only to end, of course, when Benjamin

turns wedding crasher, disrupts a young woman's nuptials, and runs off with the bride. Which puts a real damper on the wedding reception.)

The whole world showed up at that party. *The Graduate* was intended as a small, sexy comedy based on an obscure novel by a first-time author. Neither its producer nor its director was a member of Hollywood's inner circle. Its cast was led by a short, big-nosed New York actor who, in the eyes of the era's pundits, looked nothing like a leading man. No major studio provided financing; it came instead from a low-rent entrepreneur best known for importing *Hercules* and other Italian-made schlock epics. But when *The Graduate* hit theaters in late December of 1967, moviegoers instantly took notice.

Once *The Graduate* burst onto America's movie screens, Hollywood insiders were thunderstruck by the audience reaction. Young people clapped and cheered; their elders flocked to see for themselves what their offspring found so provocative. Soon intellectuals, religious leaders, and even politicians were weighing in, trying to use *The Graduate* as a key to understanding those unruly post–World War II children who were now coming of age in large numbers.

I was one of them, a Baby Boomer with a lot on my mind. When *The Graduate* first touched down in Los Angeles, I was a college senior at UCLA. Longing to broaden my horizons, I had cajoled my family into letting me spend my junior year at a small university outside of Tokyo. It was a year of independence and adventure: I was speaking a foreign language and learning to adapt to very different cultural norms. But when I returned, in the early

fall of 1967, to the land of the smoggy palm, I reentered the realm of my parents. Proud of my academic achievements, they hovered over me, intent on helping to shape my future. Did I *really* want to earn a PhD in English? Had I thought about law school? And shouldn't I focus on the possibility of getting married?

No wonder *The Graduate* struck a chord. Though I had always loved movies, I had inherited my tastes (like so much else) from my father and mother. They favored lavish musicals, wacky comedies, and serious postwar dramas (like *The Best Years of Our Lives* and *Gentleman's Agreement*) that reflected their own social values. When I was small, those were the movies I got to stay up and watch on late-night television, and I took them to heart. In the fifties, both *The Wild One* and *Rebel Without a Cause* passed me by, partly because I was far too young to connect with them, but also because I was too secure to identify with angry social outcasts. Though in later years I would end up working on a slew of low-budget genre features for B-movie maven Roger Corman, I was never attracted to Corman's seminal sixties youth flicks, like *The Wild Angels* and *The Trip*. To be honest, I had no cause to be a rebel.

But once I'd moved back into my pink childhood bedroom, with its stuffed animals and a little sister too close for comfort, I paid rapt attention to the galvanizing movies coming to town. (Anything to get out of the house.) The turbulent year 1967 turned out to be a high-water mark for new American cinema, for films that took a hard look at the nation of my birth. Who could forget *Cool Hand Luke*? *In Cold Blood*? Arthur Penn's *Bonnie and Clyde*—with its exquisitely calibrated take on violence,

American-style—seemed particularly timely, and particularly dazzling. Nonetheless, I hardly saw myself as a natural heir to outlaws like Bonnie Parker and Clyde Barrow.

The Graduate, though, was another matter. That polite young high achiever, those loving but smothering parents, those comfortable but slightly bland surroundings: They combined to form an only slightly exaggerated version of my own cozy West L.A. world. (Yes, we even had a swimming pool.)

Hey, wasn't that me up there on the screen?

THE SIXTIES WERE romanticized by those who came later, but for me it was a time of struggling to cope with a social landscape over which I had no control. Television plopped the big news of the day right into my lap. At the start of the decade, my classmates and I had watched on TV a handsome new president urging us to consider what we could do for our country. Suddenly, on November 22, 1963, he was dead. In the halls of Alexander Hamilton High School, students and teachers cried together. As we obsessed over the reruns of Oswald's slaying, followed by Kennedy's funeral procession with its riderless black horse and its sad little boy, youthful idealists were rapidly turning into cynics.

We good-hearted Hamiltonians had been idealistic about the Civil Rights movement too. But the peaceful protests of the mid-1950s were now quickly evolving into violent clashes that left many of us feeling all too vulnerable. The TV sets in our rumpus rooms brought us the bad news in living color. Late in the long hot summer of 1965, just as my family was returning from a cross-country driving trip in a big-finned '59 Buick, parts of L.A. went up in

flames. (History calls it the Watts Riots.) By 1967, we saw inner-city Newark being torched, and then Detroit. No one could guess where public anger would explode next. Meanwhile, the Vietnam War had escalated to the point where almost all the young males I knew were looking over their shoulders and concocting desperate schemes to avoid the military draft. Walter Cronkite revealed, on a nightly basis, the bloodshed and the body count. Hell no, they didn't want to go.

THE GRADUATE APPEARED in movie houses just as we young Americans were discovering how badly we wanted to distance ourselves from the world of our parents. It was not that the film dealt directly with racial unrest, campus protests, or an overseas war. Benjamin Braddock's story was never intended as an accurate picture of the late sixties. Its makers had casually imagined their tale as set in 1962, the year in which Charles Webb wrote his original novel. (That's why Ben, lounging in his family backyard, has no fear of receiving that "Greetings" letter from his draft board.) Still, *The Graduate*'s prescience about matters of grave concern to the Baby Boom generation gave it a life of its own. If we young Americans were anxious about parental pressure, or about sex (and our lack thereof), or about marriage, or about the temptations posed by plastics, it was all visible for us on the movie screen. Today *The Graduate* continues to serve as a touchstone of that pivotal moment just before some of us began morphing into angry war protesters and spaced-out hippies.

Benjamin Braddock, barely twenty-one and fresh home from four years of high academic achievement, is no hippie. But he

upends social norms by hopping into the sack with a middle-aged woman not far removed from his mother. His summer is spent drifting aimlessly between a plastic pool raft and Mrs. Robinson's bed. This slinky dame may seem to put the "adult" in "adultery," but for Benjamin she is hardly the end of the road. In a dizzying about-face, he falls for her young daughter, with whom he climactically elopes from the church where she's just said "I do" to another man. By the end of *The Graduate*, Ben has made confetti of his parents' solemn hopes and dreams. We too—those of my generation—didn't much want to face a life built on the bedrock of our elders' choices. In Benjamin we found a hero willing to turn his back on the kind of bright, upper-middle-class future we weren't sure we wanted.

Yet if Benjamin turns a deaf ear to his mother and father, the film shows that he still craves intercourse that is more than merely sexual. A key turning point in *The Graduate* comes when Ben, between the sheets, tries to initiate a conversation with his bedmate. Another hit movie from 1967 got it right: What we had here was a failure to communicate. This phrase from *Cool Hand Luke*—one that has permanently entered the American lexicon—was useful, circa 1967, in suggesting the widening gap between the era's youth and their parents. In *The Graduate*, director Mike Nichols and his team express this gap visually, by tricking out the Braddocks' Southern California habitat with glass, water, mirrors, and reflective surfaces. The film becomes, then, a young man's *Through the Looking Glass* view of the haunting, daunting adult world. What Ben wants, when all is said and done, is a coequal with whom he can truly communicate the upside-down state of his emotions. When he finally locates his dream girl, nothing can stop him from

seizing the day, just as we young people were dreaming of doing for ourselves. In *The Graduate*, we found the power to make our own choices.

BUT ALL OF that happened some five decades ago, when the world (and our place in it) was very different. As *The Graduate* dances on, two questions emerge: How did this modest youth-movie turn Hollywood on its head? And what is the source of its staying power? The answer to both questions requires us to measure the distance between then and now.

Most of the original fans of *The Graduate* have slowly made their own uneasy truce with maturity. We've gone out into the world, held down jobs, gotten married and sometimes unmarried. We've also produced offspring and watched wrinkles and mortality take their toll. I've spoken over the years to scores of moviegoers whose response to the film has been transformed by their own aging process. Many who today carry AARP cards once saw *The Graduate* as a sexy romp or as a rallying cry for the concept of self-determination. Now, though, we're paying attention to the sadness beneath the comedic surface. Where we once accepted the film's final shots as romantically rosy, we are now ready to acknowledge the back-of-the-bus scene's disturbing ambiguity. In hindsight, it's easy to wonder: If Ben and Elaine have backed away from the future that's been preordained for them by a hypocritical older generation, where exactly are they headed? The fact that there's no good answer reminds us of what this film may actually portend. Perhaps that's what it's secretly about—the end of the happy ending.

We graying Baby Boomers, with our widening waists and our

narrowing outlooks, now watch *The Graduate* in duplicate, both through the eyes of our younger selves and with the more jaundiced perspective of today. But the film has resonance for others too, even our own children. *The Graduate* lasts partly because it offers something for everyone: the restless youth, the disappointed elder, the cinephile who values the artistic innovation that's the legacy of director Mike Nichols. And this film has also burrowed its way into Hollywood's dream factory. The American movie industry, which worships box-office success, has learned from *The Graduate* brave new ideas about casting, about cinematic style, about the benefits of a familiar pop music score.

A surprising number of the twenty-first century's aesthetic all-stars—those who write and direct and produce the pop culture hits of today—freely admit that *The Graduate* set them on their paths. I've talked to some of these tastemakers, as well as to insiders who were there when it all started. I've also read countless books and articles, checked out huge numbers of videotaped interviews, and spent weeks combing through producer Lawrence Turman's UCLA archives. My two in-depth interviews with Turman himself, one in 2007 and one eight years later, were invaluable in helping me grasp how an unlikely film came together. Equally important is the time I've spent with movie fans of all stripes, some of them famous and some decidedly not, probing how this small movie made a big impact on their lives.

One thing I've discovered is that Truth is a slippery fish. All of us unconsciously shape our memories to fit our circumstances. Moviegoers best remember those aspects of *The Graduate* that once touched on the private concerns of their own lives. And

in calling up participants' recollections of a filmmaking process that began over fifty years ago, I have stumbled against contradictions, myths, and embellishments. I've tried hard to separate fact from legend, but multiple versions of the same story persist. Paul Simon, whose songs add so much to the power of *The Graduate*, would understand: It's all part of the cacophony that contributes to the sound of silence. Still, we should be grateful for the sweet, though slightly melancholic, music that remains.

As for me, I've survived and even thrived. Which does not stop me from feeling a twinge of nostalgia when the films of 1967 are mentioned. In just saying "No" to plastics—and to the social and aesthetic conventions endorsed by Old Hollywood—*The Graduate* taught me to dance to the beat of my own drums. Long may it party on.

SEDUCED BY MRS. ROBINSON

PART I

Making the Movie

1

The Book

"I was always the kid who would sneak into a newsstand and swipe a dirty magazine."
—Charles Webb (1969), *Los Angeles* magazine

Dustin Hoffman, upon reading Charles Webb's first novel, came away convinced that its hero was a sun-kissed California preppy: tall, blond, and good-looking. He was certain that somewhere in the pages of *The Graduate* he had found precisely this description. That's why he told director Mike Nichols that the role of Benjamin Braddock was not one he felt equipped to play.

Hoffman, it turns out, was quite wrong, in more ways than one. Author Charles Webb never provides the slightest physical description of Benjamin Braddock. In Webb's spare, stripped-down novel, we come to know Ben—as he beds a middle-aged matron and then runs off with her beautiful daughter—solely through his

words and deeds. But the WASP traits that Hoffman, and so many others, have projected onto the character offer a near-portrait of the artist as a young man. Charles Webb was to prove, however, far more complicated than his bland surface might imply. I'd call him a rampant idealist, one who has resisted for more than fifty years the pragmatic demands of adult life.

Born in San Francisco in 1939, Webb was raised in Southern California's old-money Pasadena, where his father was a socially prominent heart specialist. Young Charles attended Midland School, a small Santa Barbara–area boarding school that taught self-reliance and independent thinking, then was accepted into the class of 1961 at venerable Williams College in Williamstown, Massachusetts. Dating back to 1793, Williams has been hailed as one of America's top liberal arts institutions. Though in Webb's day the student body was exclusively male (female students were admitted beginning in 1970), the young man didn't lack for female companionship. In his junior year he met Eve Rudd, a Bennington sophomore whose parents were on the faculty of a Connecticut prep school. The legend (one of many surrounding the pair) is that Charles and Eve's first date took place in a local graveyard. In any case, both were totally smitten, and before long Eve was pregnant. They decided to marry, but soon changed their minds. That's when Eve's parents whisked her off for an abortion, then enrolled their errant daughter in a Baptist college out West, the better to keep her from Webb's embrace.

After graduation, a restless Webb returned to his home state. He audited a chemistry course through the University of California, Berkeley, toying with the idea of becoming a doctor like

his father. In the Bay Area, he would eventually reunite with Eve, who'd come to San Francisco to study painting. But a postgraduate fellowship from Williams (akin to the Halpingham award won by Benjamin in his novel) allowed Webb to pursue his dream of a writing career. While pining for Eve, he'd been dabbling in short fiction. Then, newly home from college, he chanced upon a bridge game in his parents' living room. One player, the alluring wife of one of his father's medical colleagues, sparked his imagination. As Webb told an interviewer years later, "at the sight of her my fantasy life became super-charged." Few words passed between them, and certainly there was nothing resembling a liaison, but off he went to the Pasadena Public Library and "wrote a short plot outline to get that person out of my system. My purpose in writing has always been to work things out of me."

Webb's writing fellowship helped him return to the East Coast, where in 1962 he melded his Mrs. Robinson fantasies with his romantic attachment to Eve in a short novel he called *The Graduate*. As he explained soon after the film version was released, "Anything I write is autobiographical. I don't think it's anything to feel funny about." He consistently warned, however, that his supporting cast should not be confused with reality. (Such statements did not help improve the mood of Eve's mother, Jo Rudd, who resented until her death the widespread assumption that the predatory Mrs. Robinson was created in her image.) Webb may have put himself into his hero, but Webb's novel remains surprisingly vague about what's eating this very privileged young man. This vagueness has turned out to be an unlikely advantage: In both book and film, the root source of Benjamin Braddock's

discontent remains so elusive that whole generations swear *The Graduate* reflects their personal tale of woe.

The Graduate was bought by an upstart publishing house called New American Library. (Its editorial director, a former film executive named David Brown, would eventually return to Hollywood and produce *Jaws*, among other monster hits. In 1962 his wife, Helen Gurley Brown, enjoyed a monster hit of her own, thanks to the publication of her *Sex and the Single Girl*.) What sold Charles Webb's novel was doubtless the outrageous situations it portrayed, along with a distinctively austere prose style modeled after the work of Harold Pinter, whose plays Webb had discovered on a college-years trip to London. He was all of twenty-four when *The Graduate* appeared on bookstore shelves in October 1963. Though he insisted his work was a character study and not a generational attack, it angered his father, whose fury did not subside until the film version proved a major hit. This would not be the only time that father and son failed to see eye to eye. Webb would eventually turn down his inheritance, claiming to dislike the idea of family members at one another's throats.

To those of us who savor the wit of the film, the design of *The Graduate*'s original book jacket looks surprisingly somber. Noted graphic artist Milton Glaser produced an image of boldly silhouetted faces, one on the left and two on the right, looking toward one another across a void. I'm assuming this is meant to signify Benjamin pitted against his parents, because the accompanying flap copy strongly underscores the novel's generational tug-of-war: "The bewildering loss of communication between parents

and their grown children—the one experienced, wise, and deeply committed to the values that have shaped their lives, the other questioning, skeptical, and disruptively honest—forms the basis for Charles Webb's remarkably vivid and haunting book."

But hey, what about Mrs. Robinson? It's not until deep within a second paragraph that there's even a hint of the novel's famous romantic complications: "Ben's probing questions to another generation unable to understand them, his disillusionment with a society seemingly incapable of explaining its most honored values, his strangely urgent affair with an older woman and its unexpected outcome, will produce in some a response of anger, in others a smile of understanding and sympathy." Nowhere is there the slightest recognition that readers might find the story of *The Graduate* sexy and fun. Instead, the focus is entirely on Webb's probing of intergenerational tension. On its front cover, in bold typeface, *The Graduate* is solemnly praised as "a novel of today's youth, unlike any you have read." All this hype is aimed, I suspect, at parents trying to understand their rebellious next of kin. New American Library's marketing department seems not to have been looking for readership among the hordes of emerging adults trying to make sense of the world into which they were born.

Another feature of the book jacket is its prominent author photo, which takes up most of the back cover. Charles Webb, slim and blond, is depicted in conservative jacket and tie, with his hands in the pockets of a tweed topcoat. His hair is short and his expression soulful, as he modestly turns his head away from the camera's gaze. This photo is credited to Eve Webb, to whom the novel is dedicated. The two were married in 1962, apparently

with her parents' blessings. The Webbs gifted the young couple with a six-month trip to Europe: Charles lugged along a typewriter on which he wrote daily while his bride went sightseeing alone. Not exactly a storybook honeymoon, but they must have spent some romantic time together, because Eve was once again pregnant when they returned to American shores. Despite Eve's swelling belly, Charles convinced her to accept a housemistress position at a boarding school while he continued working on new novels and plays. He also persuaded Eve to sell their wedding gifts back to the givers, a move that must have baffled family friends who hardly wanted to purchase the same chafing dish twice. A few years later, Webb could not explain his motives, other than to say (to *Los Angeles* magazine's John Riley) that he didn't want the presents to own *him*. This eccentric rejection of material objects, even those given with a full heart, would point toward even more flamboyant gestures in the years ahead.

The Graduate, an experiment by New American Library in drumming up business for a fledgling hardcover line, got little attention from either the press or the reading public. But on October 30, 1963, the *New York Times* published a brief review by Orville Prescott. He praised the book's bravura dialogue but called the novel "a fictional failure" because of its "preposterous climax" and the sidestepping of its hero's psychological motivations. I'm convinced he hit the proverbial nail on the head when he asked, "Was Benjamin upset by sex? by the state of the world? by despair and the dark nights of the soul? by mental illness? Benjamin didn't know. Mr. Webb doesn't seem to know either." Still, Prescott lauds the young author for having "created a character whose blunders

and follies just might become as widely discussed as those of J. D. Salinger's Holden Caulfield."

In the long run, Prescott was quite right. His reference to the hero of Salinger's *The Catcher in the Rye* piqued the interest of an ambitious young producer named Lawrence Turman. Salinger's famous novel, a touchstone for restless adolescents of my generation, had been coveted by major filmmakers since it was published in 1951, but the reclusive novelist turned down even the most lucrative offers. If the movie rights to *The Catcher in the Rye* were unattainable by Hollywood's finest, perhaps *The Graduate* would be a good substitute. Turman quickly bought and read Webb's novel. His first thought was that Webb might make a good screenwriter. He soon changed his mind about that, telling me in the course of a frank 2015 interview that Webb "gave me in his book everything he had to give." Later suggestions by Webb (buried in Turman's archive at UCLA) as to how to adapt his novel for the screen convince me that the young novelist seems not to have understood his own literary strengths. For the Berkeley section of the script, Webb suggested that Ben's desperate quest to win Elaine's love be interrupted by cutaways to his anguished parents back home. At the same time he advised that Ben—posing as a jargon-spouting medical student in order to crash a party attended by his romantic rival—be embroiled in Marx Brothers–ish antics like hiding in closets to eavesdrop on a spat between Elaine and her college beau. Such an ungainly blending of melodrama and farce, violating the story's tone just at the time when the audience expects a ratcheting up of tension, shows the wisdom of Turman's hunch that Webb was not equipped to become a screenwriter anytime soon.

Though Turman had his doubts about Webb, he continued to be obsessed by the novel itself. As he wrote in his 2005 book, *So You Want to Be a Producer*, "The weird dialogue and situations were funny and nervous-making at the same time." What especially stuck in his mind were two evocative word pictures: a young man in full scuba gear peering up from the depths of his parents' swimming pool, and then the same young man, his clothing in disarray, seated in the back of a public bus next to a young woman in a formal wedding gown. Turman saw in these images his chance to move up to the Hollywood big-kids' table.

2

The Deal

"I'm a simple guy. I buy a movie for a million and sell it for fifteen million, and that's fourteen million in profit."
—Joseph E. Levine (1960), *Newsweek*

Early in the last century, Jack Turman left school in the eighth grade in order to help support his family. Through grit and hard work, he built a tiny but successful wholesale textile business in downtown Los Angeles. But, like most parents inching their way through the Depression, he wanted better for his son. That's why Larry Turman (born in 1926) was able to graduate from UCLA with a degree in English. The trouble was: Larry (not unlike the postgraduation Benjamin Braddock) was hardly inspired to pursue a specific career goal. So he wound up spending four years working for his father as a fabric salesman, struggling to persuade clothing manufacturers to buy what he had to offer. It was a dreary life. He would later

remark about those years: "Everyone always says how tough show biz is, and, of course, they're right, but it's kid stuff compared to the garment business, where someone will cut your heart out for a quarter-cent a yard. I'd carry bolts of cloth five blocks after making a sale, only to learn that the customer had bought it cheaper, and I had to schlep the bolts of cloth back to my dad's office."

At age twenty-seven, Larry Turman was fed up with flogging periwinkle-blue lining. Having learned persistence and how to bounce back from constant rejection, he set out to make his mark in the entertainment field. It wasn't quick or easy: Lacking money for rent, he was lucky to be living with his folks while he made the rounds. Finally he was hired by the Kurt Frings Agency, where he discovered he had a knack for representing showbiz clients. One of whom, Stuart Millar, invited him to become his producing partner on four films. The last of these was *The Best Man* (1964), a star-studded political drama adapted by Gore Vidal from his own Broadway hit. Still, Turman continued to feel that—for all this valuable moviemaking experience—he remained a perpetual newbie and a Hollywood outsider. Though he liked collaborating, he was determined to go his own way.

That's where *The Graduate* came in. Turman, wary of the daily grind that marked his parents' generation, deeply identified with Benjamin Braddock in his quest for acceptance, love, and purpose. So convinced was he that this film would be his ticket to bigger and better things that he was willing to take a risk on behalf of Charles Webb's novel. There were no other suitors, which is why the film rights came fairly cheap: $1,000 for an option, against a $20,000 purchase price. (The $20,000 total price would today

be more like $120,000.) But that first $1,000 had to come out of Turman's own pocket. It was a sum he could barely afford to spend.

With few top Hollywood contacts at his disposal, Turman got lucky. On October 23, 1963, just before he read Orville Prescott's review of *The Graduate* in the *New York Times*, a romantic comedy called *Barefoot in the Park* had opened on Broadway. This amusing Neil Simon trifle, about two newlyweds surviving life in the big city, was destined to be the longest-running hit of Simon's career. Elizabeth Ashley and Robert Redford played the young duo, and the neophyte director was Mike Nichols, just two years removed from the disbanding of his comedy act with Elaine May.

Nichols and May had met while dabbling in theater at the University of Chicago. They bonded when they discovered that each had a talent for improvisational comedy, as well as family members who inspired loads of fresh material. Together May and Nichols were a sensation, performing their acerbic skits (as girlfriend and boyfriend, as nurse and doctor, as mother and son) on radio, television, and the Broadway stage. Their first recording, *An Evening with Mike Nichols and Elaine May*, collected a Grammy award for best comedy performance. But when May abruptly broke up the act in 1961, Nichols found himself at loose ends. Fortunately the life of a stage director proved to be a perfect fit. Hollywood had yet to call.

When Turman sent him a copy of Charles Webb's novel, Nichols was hooked. Though he'd had stage success, he adored movies. He saw flaws in *The Graduate*, especially in its second half, but its J. D. Salinger quality moved him as it had moved Turman. Later Nichols was to tell film editor Sam O'Steen, speaking of

Benjamin Braddock: "I identify with that boy a lot. This is as close to *The Catcher in the Rye* as anything I've found." Always honest, Turman was up front with Nichols about his financial situation, confessing, "I have the book, but I don't have any money. I don't have any studio. I have nothing." He promised that whatever money came in would be split between the two of them, fifty-fifty. And so it came to pass. Part of the agreement was that the film be billed as a Lawrence Turman/Mike Nichols production, with Turman listed first. Three years later, Turman was glad to reverse the order of the two names, in recognition of the fact that Nichols' Hollywood star was by then very much on the rise.

In late 1964, with *The Graduate* as his calling card, Turman began scouring Hollywood for possible studio interest. This was the era when studios, still trying to compete with the allure of television, were placing their bets on lavish epics and musicals. Big hits of 1964 included a costume drama, *Becket*, as well as the hugely successful *My Fair Lady* and *Mary Poppins*, with *The Sound of Music* just around the corner. True, this was also the year of *Dr. Strangelove*, but squeaky-clean Doris Day romantic comedies (like 1964's *Send Me No Flowers*) were far more the norm. So no one was keen on *The Graduate*. Hollywood honchos seemed not to find it the least bit funny, and some of the turndowns were harsh. One Paramount executive who'd read a draft of the script in December 1964 griped that Mrs. Robinson was a monster, Ben a jerk, and all the others in the screenplay gross caricatures. The involvement of Nichols meant little to the West Coast moguls, who knew his reputation but did not yet consider him one of their own. Things looked bleak, which is why Turman was forced to approach Joseph E.

Levine of Embassy Pictures, seeking $1 million—it would ulti-
mately balloon to just over $3 million—with which to make his
film. (In that period, a budget of $1.25 million was considered
average; Fox's ambitious 1967 family musical, *Doctor Dolittle*, cost
a whopping $15 million.)

Joseph E. Levine was a true original. In newspaper and maga-
zine stories of the day, journalists enjoyed pulling out all the stops
in describing him. Paul O'Neil of *Life* painted a typical word por-
trait: "He is dark-haired, moon-faced, hoarse, excitable, splendidly
profane, and—since he weighs 214 pounds but is only 5 feet 4
inches tall, he is also rather round." Many writers compared him
to a Buddha, but all agreed there was nothing Zen-like in his
personality. Instead, Levine in the 1960s was known as a super-
salesman, a master showman with a gift for pulling coins out of
thin air. (He was in fact an adept amateur magician.)

Born in 1905, Levine was raised on Boston's Billerica Street, in
a slum neighborhood packed with immigrant families. When he
was four, his father died, leaving his mother with six needy chil-
dren. She got married again, to a tailor with a violent streak and
seven youngsters of his own. Decades later, Levine would explain
his girth as a reaction to his years of hunger. From an early age he
was shining shoes and selling newspapers to help make ends meet.
Education was a sometime thing. Movies, in those dark times,
were his refuge.

As an adult he'd figured out how to make a tidy profit by
distributing foreign-made movies. Philip K. Scheuer detailed for
readers of the *Los Angeles Times* how Levine got rich by adapt-
ing the principle of the floating crap game: "He glommed onto a

picture no other distributor wanted, had hundreds of prints made, moved into a town with saturation bookings and full-page ads and was on his way to the next burg before his bemused customers knew what struck them." Adhering to his own dictum that "exhibitors and the public have to be told before they can be sold," Levine used every trick in the book to call attention to his product line. This included wining and dining the press corps, as well as staging elaborate stunts (like displaying $1 million in rented thousand-dollar bills) to convince exhibitors he'd spend lavishly to promote the films they booked.

Inevitably, Levine began moving into the business of motion picture production. His big breakthrough came in 1958, with a cheap Italian sword-and-sandal epic called *Hercules*, starring a hunky Muscle Beach weight lifter named Steve Reeves. Though the story was weak and production values were nil, Reeves looked impressive (especially with his shirt off) when stopping runaway horses and slaying lions with his bare hands. Levine was convinced that with his own genius for marketing he could make *Hercules* into a major hit. He dubbed the film into English, poured money into improving its special effects, and provided the ballyhoo that lured the public away from their television sets. Where a self-promoter like Levine is concerned, I tend to consider all financial figures suspect. But Paul O'Neil of *Life* reported that, after a round of TV advertising, Levine opened *Hercules* in six hundred theaters at once. The film ultimately played in 11,465 theaters in all, was seen by 24 million Americans, and grossed $5 million, a huge sum back then. (It would be in the neighborhood of $41 million today.)

There's no question that Levine could be crass. Sam O'Steen, whose innovations in the editing room hugely enhance *The Graduate*, was later hired to help satisfy Levine's demand for adults-only sexual content in his movies. O'Steen has elegantly described this new assignment as "cutting fuck scenes into a picture [Levine] bought." Still, despite his well-deserved schlockmeister reputation, Levine also sought respect. While continuing to present such dreck as *Jack the Ripper*, *Sodom and Gomorrah*, and a whole raft of *Hercules* sequels, he sought artistic credibility by allying himself with the great Italian filmmakers of the day. He had no screen credit on Vittorio De Sica's powerful 1960 World War II drama, *Two Women*, but his savvy handling of the film's distribution in the US helped foster ecstatic reviews and an Oscar for Sophia Loren, the first ever awarded for a foreign-language performance. Part of Levine's strategy was to delay an English-language version until word of mouth built among the art-house crowd. As he explained to *Life*, "I nursed the picture like a baby. When Sophia won the Academy Award last April it had been running for six months but the public was still waiting. It made money before the Award dinner but it's grossed a million since."

In the early 1960s Levine had moved beyond distribution and begun racking up producer credits, not only providing funding for movies but also sometimes finagling the opportunity to make artistic decisions. A film version of Harold Robbins' sexy *The Carpetbaggers* bears his name, as does a screen adaptation of Eugene O'Neill's not-sexy-at-all *Long Day's Journey into Night*, with Sidney Lumet directing Katharine Hepburn, Jason Robards, and stage great Ralph Richardson. Levine was an uncredited executive producer on

Darling, which means he underwrote—without fanfare—the 1965 John Schlesinger/Frederic Raphael tale of Swinging London that made an international star (and an Oscar winner) out of Julie Christie. Such big-league successes helped Levine feel like a genuine player. Larry Turman is convinced that it was the chance to rub shoulders with Broadway's Mike Nichols that persuaded Levine to take a gamble on *The Graduate.*

Around the time that Turman approached Levine about financing his film project, the self-proclaimed "simple guy" was opening his New York offices, which occupied an entire floor of the brand-new J.C. Penney building at 1301 Avenue of the Americas. Features of the office suite included such modest details as a screening room for fifty, decorated in Greco-Roman style, a cocktail lounge, a private kitchen, a steam bath, and a dramatic replica of his old Billerica Street front door, complete with mailbox. Levine could also boast a ninety-eight-foot yacht, which was anchored off Twenty-Third Street. To support his various filmmaking ventures, his staff now numbered 420. Ambition was something he had in spades. But Turman, looking for a backer and not an artistic partner, worked hard to negotiate a deal with Levine that would give himself and Mike Nichols total creative control. Ultimately, Levine's screen credit on the film would become a sticking point. In his *So You Want to Be a Producer,* Turman recalls how "I was rabid and intransigent in my conviction that if he had an executive producer credit it would devalue me. I can't believe I was ready to blow this last-stop-on-the-line deal over Joe's credit issue, but either I was or Joe thought I was. He finally acceded to my heated argument, after which he turned to his assistant and

said, 'I like this kid . . . I wish my salesmen were as passionate as this guy Turman.'"

Joe Levine may have admired Turman's moxie, but the good feelings were doomed not to last. Fairly soon Levine was taking pains to let it be known that he (not Lawrence Turman) was the man in charge. For instance, in early 1965 he told the *New York Times* that he had personally persuaded his buddy Mike Nichols to direct a small film called *The Graduate*.

Larry Turman would beg to differ.

3

The Script

"I was trying to find a word that summed up a kind of stultifying, silly, conversation-closing effort of one generation to talk to another. Plastics was the obvious one."
—**Buck Henry (1992),** *The Washington Post*

Soon after he optioned *The Graduate*, Larry Turman started jotting down ideas in a brown spiral notebook. His cryptic notes, preserved in the Turman archive at UCLA, reveal what he considered important back in the days when the project was merely a gleam in his eye. "Do film just like the book," he wrote on the first page. "Important keep bizarre quality—otherwise value of book is lost." Turman methodically noted the Charles Webb scenes he especially liked, but pondered whether Ben should be inserted into other situations, like trying to hold down a job in his father's law firm. Should Elaine's Berkeley boyfriend play a bigger role, he mused, or should he be removed from the story altogether? And, highly important, how

should the audience feel about Ben's free-floating angst? Was it necessary that viewers understand exactly what's bothering this well-heeled, well-connected high achiever?

It's been over fifty years since Larry Turman jotted in that notebook. In his distinctively cramped handwriting he doodled lists of potential writers, directors, and actors. The notebook reveals that Turman was mulling over the names of such up-and-comers as George Roy Hill, Stanley Kubrick, Robert Mulligan, and Arthur Penn to direct *The Graduate*. His screenwriter list leaned heavily toward famous novelists and playwrights, including Philip Roth, Joseph Heller, Edward Albee, and William Inge. Vladimir Nabokov of *Lolita* fame was on Turman's list too, along with Mike Nichols' famous comedy partner, Elaine May. But all of this was clearly a kind of daydreaming. Once Mike Nichols came on board as director, Turman needed to make a wide-awake deal.

In hiring a screenwriter, Turman spoke first to a talented novelist-friend, William Goldman. Goldman would soon win acclaim for scripting 1969's *Butch Cassidy and the Sundance Kid* and would go on to become a Hollywood screenwriting legend. But Goldman found Webb's novel unappealing, which is why Turman began looking elsewhere. He paid New York playwright William Hanley $500 for a draft that hewed closely to Webb's original, retaining a lengthy (and, to me, highly annoying) digression in which Benjamin takes to the road to commune with "simple people that can't even read or write their own name." Hanley's long, slow, dialogue-heavy take on Webb's plotting in no way addressed what Turman has often described as Webb's biggest fault: "In the book the character of Benjamin Braddock is sort of a whiny pain

in the fanny you want to shake or spank." Looking for an experi-
enced screenwriter who could render his leading character more
vulnerable and sympathetic, he turned his attention to Calder
Willingham. Then all hell broke loose.

Calder Willingham, born in Georgia in 1922, eventually came
to make his home in New Hampshire. From a young age he was
recognized for his darkly comic novels, like *Eternal Fire,* which
dealt frankly with sex and other controversial matters. No stranger
to Hollywood, Willingham had written several screenplays, in-
cluding one for Stanley Kubrick's powerful antiwar drama, *Paths
of Glory* (1957). For Kubrick he also contributed a screen adap-
tation of Vladimir Nabokov's challenging 1955 novel, *Lolita.* My
friend and colleague, writer F. X. Feeney, has clued me in to what
he's learned from many frank after-the-fact conversations with
Lolita's producer, James B. Harris. Because Nabokov's own mas-
sive screenplay proved far too unwieldy for the production team
to handle (or even lift), recognizable chunks of Willingham's early
draft of *Lolita* were quietly incorporated into the 1962 shoot-
ing script by Kubrick and Harris. Despite this appropriation of
Willingham's material, Nabokov himself was nominated for an
Oscar as the film's sole credited screenwriter. Disappointments of
this sort, always tough on a writer's fragile ego, may well have
contributed to Willingham's prickly attitude in the days ahead.

In the case of *The Graduate,* Willingham made it known
from the start (via a long string of memos to Turman) that he
was disappointed with the financial terms of his deal and that he
heartily disliked "this goddamned schizophrenic and amateurish
book" that he was charged with reworking for the screen. To put

his own spin on the material, he transformed the character of Mr. Robinson into a grotesquely doting father, one who dresses daughter Elaine in skimpy bikinis and personally brushes her nails with gold lacquer prior to her date with Ben. In addition, as Ben traverses California in search of his lady love, Willingham contributed two new would-be comic characters (a charter airplane pilot and a lady cab driver) who represent blatant gay stereotypes. These changes struck Larry Turman as "vulgar and salacious" rather than funny, and they were removed in subsequent drafts. But Willingham stubbornly clung to his conviction that Mrs. Robinson, just prior to the film's climax, should promise to tell Ben the location of Elaine's nuptials if he agreed to slip between the sheets with her one last time. As Willingham put it in a note to Turman—one that discounted any possibility of human depth in Mrs. Robinson's character—"My belief is that the wicked witch should again try to enchant the hero."

In part, Willingham's crankiness stemmed from the fact that his work was being overseen by Larry Turman and not by Broadway's new darling, Mike Nichols. Because Willingham's New England home was not terribly distant from Nichols' New York digs, the early plan was that they'd be teaming up to polish the screenplay before going into production in the summer of 1965. But no one could have foreseen that Nichols would be invited to direct Elizabeth Taylor and husband Richard Burton in the film adaptation of Edward Albee's controversial Broadway hit, *Who's Afraid of Virginia Woolf?* Turman (not stopping to worry about his director possibly being poached away for good) readily agreed to delay his own project and let Nichols have his first filmmaking

experience on someone else's dime. While Nichols collected accolades (including an Oscar nomination) for his screen debut, Willingham fumed. He also sat down and typed a long, angry letter (now housed in Turman's archives), titled "SOUFFLÉ VERSUS SIRLOIN," in which he lambasted Charles Webb's "clumsy, stumbling first novel" and praised his own efforts to give it substance. Willingham foretold that "this book—believe me because I speak the truth—will die a very quick and merciful death unless someone of real talent (myself, Mike Nichols, *some*one) disinters it from the grave into which it has already fallen." Continuing the morbid metaphor, he vehemently proclaimed that he had "been hired to breathe life into a corpse."

Through all of this ranting and raving, Larry Turman struggled to keep his equanimity. When I asked him in 2007 if it was hard to deal with a writer who had so little affection for the material he was being paid to adapt, Turman sourly noted, "Yeah, I guess he had affection for *money*." It was not, however, until the release of *The Graduate* was imminent that Turman discovered how calculating Calder Willingham could be.

Meanwhile, after finally giving the egregious Willingham his walking papers, Turman turned briefly to a former client, young screenwriter Peter Nelson. Nelson's brisk, lightly comic version of the story contains one eccentric addition: a glimpse of Mrs. Robinson knitting. (I'm honestly not sure if this was Nelson's attempt to domesticate the script's antagonist or whether he was making a sly allusion to Dickens' murderous Madame Defarge.) Then, on July 4, 1965, Nichols bumped into Buck Henry at a lavish Malibu beach party hosted by Jane Fonda. There, surrounded

by representatives of Hollywood old and new, they bonded over a shared resistance to the charms of Southern California living. As youngsters they had rubbed shoulders briefly at New York's tony Dalton School, but now they were about to become close collaborators on *The Graduate*.

Unlike Calder Willingham, Buck Henry warmed to Charles Webb's novel immediately. For him the appeal of the project was obvious. Said he years later in an interview with Sam Kashner for *Vanity Fair*, "I always thought *The Graduate* was the best pitch I ever heard: this kid graduates college, has an affair with his parents' best friend, and then falls in love with the friend's daughter. Give that to twenty writers and you've got twenty scripts." Beyond the outrageousness of the premise, Henry also sparked to the snap and crackle of Webb's dialogue. And he was able to identify at once with the central character. In fact, he pointed out to Kashner that "Turman, Nichols, and I related to *The Graduate* in exactly the same way. We all thought we were Benjamin Braddock."

Henry's sense of himself as an outsider stemmed from an unusual upbringing. Born in 1930 as Buck Henry Zuckerman, he was the son of a mother (known professionally as Ruth Taylor) who had been one of Mack Sennett's Bathing Beauties and a father, Paul Steinberg Zuckerman, who was an air force general turned stockbroker. Buck spent many childhood hours among glamorous movie folk, but also attended a Los Angeles military academy before heading East, ending up at Choate and then Dartmouth. Henry looked the part of a buttoned-down Ivy Leaguer, but had an impish sense of humor and a talent for improv. After serving in an entertainment unit during the Korean War, he found civilian

work as both a writer and performer for television personality Steve Allen. He also made a small splash as G. Clifford Prout, the deadpan spokesperson for a bogus organization protesting the indecency of unclothed animals. (As Prout, he made the rounds of TV talk shows, and even appeared on the *CBS Evening News with Walter Cronkite*.)

In 1964 Henry was an integral part of TV's short-lived satirical revue *That Was the Week That Was*. The following year, he helped Mel Brooks devise an award-winning comedic spy series, *Get Smart*. Billed as *Get Smart*'s official story editor, Henry was the bearer of one of those nebulous titles that implies nothing much to those outside the entertainment industry and has a shifting meaning within Hollywood's charmed circle. (Since I myself spent nearly a decade as story editor for B-movie maven Roger Corman, I should know.) Because Henry considered himself the cocreator of this hit series, he felt he'd long been denied the credit he deserved. Now he, like Calder Willingham, had something to prove.

Over a period of six months, Henry and Nichols spent six hours a day working on the script of *The Graduate*. Nichols has admitted that three out of the six hours were spent goofing off, "making up horrifying stage directions for what Benjamin might be doing while he was driving along, playing with himself." But from the first, Henry was contributing important insights about the novel's morose protagonist. One of the problems the two men faced was how to make visible what was bothering him. The diving suit received by Ben as a twenty-first birthday present had been part of the story from the beginning, but it was Henry who quickly grasped its full symbolic implication. Charles Webb and

the screenwriters who preceded Henry had shown Ben opening the box containing the gift and exploring its contents. Henry scrapped all of that, preferring the element of surprise. In his first draft, the audience is suddenly confronted with Ben in full scuba gear, lumbering gracelessly toward the pool, looking as though he's drowning in the affection of his parents and their friends. By then assuming Benjamin's own subjective point of view from behind the mask of the diving suit, Henry's version allows viewers to experience Ben's sense of being held incommunicado by those who love him.

In this and many other ways, the Buck Henry screenplay arouses the audience's sympathy for Ben by showing (as Webb mostly does not) the suffocating environment in which he maneuvers. Henry also pruned and sharpened Webb's dialogue and added that famous word of advice: "Plastics." Some critics have been underwhelmed by Henry's adaptation of Webb's novel. Chief among them was Richard Corliss of *Time*, who accused Henry of sticking so closely to Webb's original that his script "was less rewriting than retyping." As an admirer of skillful screen adaptations of literary materials, I vigorously protest. There's true art, when adapting a novel or short story for the screen, in knowing what to keep and what to throw away.

In his 1974 book, *Talking Pictures*, Corliss is also the rare commentator who feels the story of *The Graduate* should have been altered to take into account the social upheaval of the era into which the film was released: "Henry could have tried to update Ben's predicament, given him the guerrilla appearance and rhetorical skills of the late-sixties collegiate, and just possibly written

a film that would have deserved the praise *The Graduate* actually received. Instead, he simply doctored Webb's novel—padding his own role (as a suspicious hotel desk clerk), and adding clever tag lines to several scenes—and was given credit for writing the largest-grossing comedy of all time."

An early Henry draft in fact makes a stab at reflecting the hottest topic of the day. On his first pass, Henry tried adding a scene that shows Ben leaving a local hamburger joint in time to notice a young man in army uniform wistfully checking out his spiffy Alfa Romeo convertible. It seems they attended high school together. Then, while Ben was off winning honors at his East Coast college, this young man and his not-college-material peers were being drafted to fight in Vietnam. From this character's perspective, "If it weren't for the dumb guys like us the smart guys like you would have to go. The way I look at it is: it's a case of all the dumb guys making the country safe for all of the smart guys." This Vietnam-era G.I. Joe is shocked and angered when Ben suggests he desert. Henry tries giving him a speech (later crossed out) in which he explains his own particular brand of patriotism: "Fifty years ago, my grandfather was in the war killing white guys. Twenty-five years ago my father was killing white guys and yellow guys. Now I'm going over to kill some yellow guys. Now that's some kind of progress, isn't it?"

Henry and Nichols must have understood that this scene, added for the sake of social relevance, was serving only to muddle Benjamin's story by injecting new elements that were extraneous to Ben's particular state of mind. If the realistic threat of military service in Southeast Asia had been added to his anxieties, *The*

Graduate would have felt entirely different. For one thing, given the tensions of the times, it would have suddenly seemed much more urgent to be historically accurate. In the summer of 1967, while the film was being shot, President Lyndon Johnson signed a revamped Selective Service Act, signaling that within the year military deferments for most graduate students would come to an end. And if a young, healthy male was not in college, he was definitely draft fodder. So the notion of Ben lounging in his parents' swimming pool without fear of his draft board was rapidly becoming an anachronism. And in 1967 life was changing so quickly—with the rise of hippies, campus radicals, Black Power, and other disruptive social movements—that it would have been impossible to keep pace on film. That's why it was canny to sidestep such hot-button particulars and focus on a general malaise with which most young people could relate, both in 1967 and also decades down the road.

Buck Henry insists that he never saw the various Calder Willingham drafts of *The Graduate*. One key scene illustrates the different approaches taken by the two writers. When Ben asks Elaine for a date at his parents' insistence, he works hard to be unreceptive to her attempts at pleasant chat. But once he realizes how thoroughly he's humiliated this very nice young woman by ushering her to a ringside seat at a strip club, he apologizes, admitting how much he loathes his own rudeness. Then the real conversation begins. Author Charles Webb had placed it at a Sunset Strip café. Willingham changed this to a drive-in restaurant—an intrinsically SoCal locale—where they chow down on burgers and fries. There Willingham tried to establish genuine communication between the two by having Elaine divulge secrets of her own

sexual history. (Says Ben, "You're too intelligent to be a virgin." She responds, "I thought it was just weak character.")

Buck Henry kept the drive-in locale (which I suspect Nichols had suggested to him), but in his version of the scene there is no such prying into Elaine's bedroom experience. Instead, Henry goes the opposite route. Ben has an effective new line: "It's like I was playing some game, but the rules don't make any sense to me. They're being made by all the wrong people." Elaine, her mouth full, nods in agreement. They continue talking, but are quickly drowned out by some noisy kids cranking the stereo in the next car. So Ben rolls up the windows, raises the top on his convertible, and encloses the two of them in a cocoon, inside of which we can be sure they are earnestly exchanging their views on life. Cleverly, Henry has sealed the two characters off from us, as from the rest of the world, and we hear nothing they say. All we know is that young love is blooming. If Elaine remains a mystery to the audience, that's appropriate for this particular story. In the film version of *The Graduate*, even more than in Webb's novel, we stay almost exclusively inside the head of Benjamin Braddock. Elaine is Ben's dream girl, as much as she is a flesh-and-blood person, and events will show that he understands her inner self no better than we do.

4

The Cast

"There is no piece of casting in the twentieth century that I
know of that is more courageous than putting me in that part."
—**Dustin Hoffman (2000),** *The New Yorker*

When you cast a movie," Larry Turman told me in
2015, "you're panning for gold. You look at all
the pebbles in your path, and you hope you find
your nugget." By the start of the year 1967, Turman and Mike
Nichols had sifted through a great many pebbles without striking
it rich. A small article had just appeared in the *New York Times*,
disclosing that despite a nationwide talent search, the filmmak-
ers casting *The Graduate* were coming up empty-handed. Mike
Nichols was quoted as predicting that the male leading role "will
make a star of the actor who is chosen." But the right young man
had yet to be found.

The article was picked up in newspapers across the country, and
soon the film's Lynn Stalmaster—a casting director whose career

went back to TV's classic *Gunsmoke* series (1955–1964)—was in-undated with mail from would-be thespians dreaming of Holly-wood success. Mothers endorsed their sons for the role of Benjamin Braddock; young men sent in their graduation photos and offered lengthy character analyses of the part they hoped to win. In all, over three hundred amateurs personally contacted Stalmaster, de-tailing their acting credentials and their conviction that "Benjamin Braddock, c'est moi." Some were cocky: "I expect it's only a mat-ter of time before I work with you because basically I am a star." Some were modest: "Previous acting experience—none, however my quality of personality is above average." Some were openly crass: "I mean, what's wrong with being rich and famous?" Some were downright pathetic: One neatly handwritten note explained that "if you truly do not want a 'Hollywood image' of a college boy, you may be interested to know I am slightly overweight and also wear (when the occasion calls for it) a hearing aid."

Although Stalmaster's assistant told candidates that Mike Nichols personally reviewed every submission, the casting process was in fact far more decentralized. Stalmaster combed through photos and résumés of young Hollywood actors, while in New York Michael Shurtleff, a casting expert who'd been told to look for a new Jimmy Stewart, surveyed up-and-coming stage perform-ers. Among those who didn't make the cut were some who would go on to long, successful Hollywood careers, including John Glover, Edward Herrmann, and Harvey Keitel (he was judged "too ma-ture and stolid" for the role of Ben). Actors who appeared prom-ising were interviewed by Turman and Nichols, both of whom spent much time on airlines flying between the two coasts. The

hopefuls were all asked to read from the Buck Henry script opposite an actress, Joanne Linville, standing in for Mrs. Robinson. No one seemed exactly right. At one point, Nichols turned to his producer and said, "Turman, you SOB, you got me into a movie that can't be cast!"

Among the letters cramming Stalmaster's in-box, a smattering of submissions came from young women who hoped to play Ben's love interest. And a New Jersey housewife volunteered herself for the Mrs. Robinson role: "As outlined, I fit the part perfectly. . . . I am 38 and homely—isn't that what you want?" (Her assumption speaks volumes about Hollywood's traditional attitude toward older women with sex on their minds.) But fortunately for the production team, by the end of 1966 the female lead was already signed, sealed, and delivered.

The role of Mrs. Robinson, the desperate housewife who begins her seduction of Ben on the night of his homecoming, was considered from the start the film's most bankable. Turman and Nichols were looking for someone with name recognition, an actress who could lure audiences into seats while luring the young graduate into bed. Turman, always a fan of casting against type, early on approached Doris Day, whom he could envision as an out-of-the-ordinary seductress. His idea was to subvert Day's wholesome, bubbly image by showing her in rebellion against the social rules that governed her earlier films. Day has long maintained that she turned the part down because it offended her values. But Turman insists that when he sent her Charles Webb's novel, it was withheld from Day by her husband and manager, Martin Melcher. Fittingly for a woman whose on-screen persona

defines the fifties, Day's course of action was predetermined, in this and other matters, by the domineering man she married.

The sultry Patricia Neal, who'd deservedly won an Oscar for *Hud*, was an attractive candidate for the role, but the aftereffects of the major stroke she'd suffered in 1965 took her out of contention. Nichols has described how he met with Ava Gardner in her suite at New York's Regency Hotel. At forty-four she was still so gorgeous that his heart began pounding. But he realized she was perhaps not mentally up to the part when she tried to phone her old friend Ernest Hemingway, who had committed suicide five years before. Another name that was briefly floated was that of Jeanne Moreau, in keeping with the French cinematic tradition of sophisticated older women initiating naïve young men into sexuality. Later Joseph E. Levine took credit for talking Nichols out of committing to Moreau, thus again finding a way to aggrandize his own contribution to the film's success. The fact is: Turman and Nichols easily decided between themselves that *The Graduate* was an all-American story, which is why (despite rumors to the contrary) Moreau was never offered the role.

The fantasy casting list recorded in Turman's brown notebook contains such glamorous Old Hollywood names as Lana Turner, Susan Hayward, Rita Hayworth, and Shelley Winters. Anne Bancroft was not mentioned. She was, though, a logical choice. No question that she had the acting chops. As Helen Keller's teacher, Annie Sullivan, in *The Miracle Worker*, she had won a Tony award, and then—when the hit Broadway play became a Hollywood film—an Oscar. She nabbed a second Oscar nomination in 1964 for a British psychological drama, *The Pumpkin Eater*. Word circulated that she was growing tired of playing heroes and

martyrs and was looking for a dress-up role. Mike Nichols, who had once dated Bancroft briefly, claimed he at first hadn't thought to consider her as Mrs. Robinson because of her age (she was only thirty-five at the time she was cast). But he later praised her to film historian Mark Harris as "a beautiful, exciting, wonderful, angry young woman," one who could certainly grasp Mrs. Robinson's complex emotional makeup. Did she really need to be talked into the role by her new husband, funnyman Mel Brooks? That's the legend, though Larry Turman calls this "news to me."

When it comes to the casting of a film that ends up a megahit, the rumor mill continues to churn for decades to come. To this day, stories circulate about famous actors who were offered the part of Benjamin Braddock, but—for one reason or another—turned it down. Charles Grodin, who later found fame as the star of Elaine May's second directorial effort, *The Heartbreak Kid*, honestly believes he was chosen to play Benjamin but then quit or was fired, or both. Larry Turman flatly labels this "revisionist history." Yes, Grodin was very much in the running for this plum role. After all the interviews, Turman and Mike Nichols narrowed their search to six top candidates. Each was invited to the Paramount Studios lot (where the production had rented space) for a full day of screen-testing. Grodin, whose reading in *The Graduate*'s offices had highly impressed everyone who heard it, was one of those final six. Turman told me, "Mike loved him, a little more than I. Because it *was* a brilliant reading, but he had less of the emotional underpinnings for me." Nichols too had his doubts, admitting in retrospect that "Grodin got very close. . . . But he didn't look like Benjamin to me."

So what should Benjamin Braddock look like? The filmmakers

began with the same assumption Dustin Hoffman had made: that Benjamin needed to be tall, blond, and California handsome. This made the role seem ideally suited to rising star Robert Redford. At the outset, the Santa Monica–born Redford clearly had the inside track because of his WASP good looks coupled with his leading role in Mike Nichols' hit Broadway comedy, *Barefoot in the Park*. He was an intelligent and gifted actor and wanted the part badly. But both Turman and Nichols slowly arrived at the realization that their film would not be funny unless Benjamin came off as a lovable bumbler, age twenty-one going on sixteen. The oft-repeated story—which I'd love to think is true—is that Nichols, trying to explain to Redford why he wasn't right for the role, inquired about the last time the young actor had struck out with a member of the opposite sex. Asked Redford, totally nonplussed, "What do you mean?"

In any case, both Grodin and Redford were scheduled for a day at Paramount, where each was screen-tested opposite a young actress hoping to play Elaine. (Redford's aspiring love interest was Candice Bergen.) One more finalist was Tony Bill, a boyishly handsome actor who'd starred in the screen version of Neil Simon's *Come Blow Your Horn* and would go on to win an Oscar for producing *The Sting*. Other candidates included TV actor Robert Lipton and someone whose name no one involved can now recall. And then there was the last of the six, a nervous young man who'd taken a short leave from an Off-Broadway production of a British farce, *Eh?*, in order to fly out to Hollywood. His offbeat performance as a schizophrenic night watchman had recently been hailed by the *New York Times* as "a sort of cross between

Ringo Starr and Buster Keaton." (High praise indeed, but this didn't make him an obvious Benjamin Braddock.)

By the time Dustin Hoffman was screen-tested for *The Graduate*, he was considered a fixture on New York's Off-Broadway stages. But it was not always so. Dustin Lee Hoffman was born in Los Angeles in 1937, which meant he was nearly thirty at the time that he auditioned to play the newly adult Benjamin Braddock. His mother, Lillian, a movie fan, had named her first son after Ronald Colman and her second after a silent-screen cowboy star, Dustin Farnum. His father, Harry Hoffman, had worked as a set decorator at Columbia Pictures before eking out a precarious livelihood in the furniture business. Dreaming of becoming a movie director, Harry never got over his sense of personal failure. That's why, when his son played the lead in a 1984 Broadway revival of Arthur Miller's *Death of a Salesman*, he used his angry, bitter father as his model for the role of Willie Loman. Unhappy at home, young Dustin grew up hypersensitive about his ethnicity, his short stature, his prominent nose, and his mediocre academic skills. For a time he was set on becoming a jazz pianist, but he eventually drifted into acting.

Once he made the move to New York, where his roommates included future stars Gene Hackman and Robert Duvall, Hoffman began to find his way. Paying gigs were at first rare: He did janitorial work and served as an attendant in a mental hospital while diligently studying his craft at the Actors Studio. Eventually he got the occasional understudy assignment, TV role, or commercial, including a mildly comic spot (now visible on YouTube) in which—with deadpan sincerity—he pitches the convenience of

a Volkswagen Fastback. Better still, he was starting to be cast in some colorful character parts. Mike Nichols was among those who'd seen him convincingly impersonate a hunchbacked German transvestite in Ronald Ribman's stage play, *Harry, Noon and Night*. The following year, his role as a fussy middle-aged Russian clerk in Ribman's *The Journey of the Fifth Horse* won him a top Off-Broadway accolade, an Obie Award. Though not a singer, he had also been persuaded by casting specialist Michael Shurtleff to audition for Mike Nichols, who in 1966 was directing a new Broadway musical, *The Apple Tree*. The part went to Alan Alda, but Hoffman's funny, intelligent reading lingered in Nichols' mind.

By the time *The Graduate* became a possibility, Hoffman was moving into motion pictures too. He'd become friendly with a Greenwich Village neighbor, Mel Brooks, who invited him to appear in his upcoming debut film, *The Producers*. So Hoffman could have played the outrageous role of playwright Franz Liebkind, author of *Springtime for Hitler*, that ultimately went to Kenneth Mars. When interviewed by Craig Modderno in 2016, Brooks colorfully described how Hoffman—upon being cast as Benjamin Braddock—came to his apartment building late at night and threw pebbles at his window, because he had no other way of reaching him. Recalled Brooks, "Dustin told me he had to drop out of my film, a movie I had spent years trying to get financing for, because he was going to Los Angeles to star in *The Graduate*. I yelled at him so loud it woke up my fellow renters." Knowing that his new wife, Anne Bancroft, had accepted the role of Mrs. Robinson, Brooks screamed at Hoffman, "You mean you're de-

serting me to spend the summer in Hollywood making love to the love of my life?" Then, giving the young actor his blessing, he added, "Good choice!"

But by then Hoffman was no longer a movie novice. In 1966, he had traveled to Europe to star in a Spanish/Italian feature produced by a bottom-of-the-barrel filmmaker named Sidney Pink. In *Madigan's Millions*, a would-be wacky farce about a mild-mannered US treasury agent sent to Rome to retrieve a mobster's ill-gotten gains, Hoffman plays a nebbish with thick glasses and a Jerry Lewis overbite. Fortunately for him, the film did not surface in the US until 1969, at which point the newly famous star of *The Graduate* is said to have tried to get it shelved. He would not have been well served by this clumsy sampling of his talents. On the other hand, his thirty-second role in a small 1967 farce starring Anne Jackson and Eli Wallach, *The Tiger Makes Out*, gave Nichols and Turman a tiny on-screen glimpse of Hoffman as a neurotic young man kissing off his live-in girlfriend: "I'm the one who has to carry the *guilt* around. It's *me* who's the guilty one. . . . Goodbye, Rosi Krieger."

Although Hoffman was clearly not opposed to making movies, the opportunity to read for a leading role in a Hollywood production had him thoroughly rattled. In his mind, mainstream romantic leads ought to look like Rock Hudson or Tab Hunter. When Mike Nichols approached him about auditioning for the role of Benjamin Braddock, he instantly felt that "this is not the part for me. I'm not supposed to be in movies. I'm supposed to be where I belong. An ethnic actor is supposed to be in ethnic New York in an ethnic Off-Broadway show. I know my place." Hoffman

recalled many years later that he'd associated the Benjamin of Webb's novel with the copy of *Time* magazine then lying on his coffee table. On January 6, 1967, *Time* had named "Twenty-five and Under" its "Man of the Year," including the entire Baby Boom generation in the designation. The central figure sketched on *Time*'s "Man of the Year" cover was an earnest, short-haired, clean-cut young male (in jacket and tie) looking something like the actor Matt Damon. But when Hoffman pointed out to Mike Nichols the fact that he himself bore no resemblance to this Super-WASP, Nichols quickly understood what he was driving at: that Benjamin Braddock was hardly Jewish. Said Nichols, reassuringly, "Maybe he's Jewish *inside*."

In the late 1960s, Jewish contributions to the arts were every-where. Playwright Neil Simon was the toast of Broadway. Barbra Streisand's portrayal of Fanny Brice in *Funny Girl* made her a star on the Great White Way and soon had her heading for Holly-wood. Novelists Bernard Malamud, Saul Bellow, and Philip Roth were winning accolades and prizes. Humor (especially on televi-sion) was practically a Jewish monopoly. Among edgier comics, Lenny Bruce had died in 1966, but Woody Allen was moving from stand-up into films. On records and in concert halls, parodist Allan Sherman was a big fat hit. Their ubiquity notwithstanding, Jewish entertainers frequently based their acts on their distance from the public at large. "Otherness," a sense of being apart from the mainstream, was a continuing theme for many Jewish writers and performers. If Dustin Hoffman felt himself an outsider, he was tapping into an emotion that had wide resonance for many Americans, Jews and non-Jews alike.

Hoffman was not the only one connected with *The Graduate* who was shaped by his ethnic identity. Larry Turman, though acknowledging that most of the film's major movers and shakers came from Jewish backgrounds, told me he viewed *The Graduate* as "a quintessential WASP movie." But several of those involved felt otherwise. Hoffman, who wondered for decades how he came to land the role of Benjamin Braddock, discovered belatedly that Mike Nichols recognized in him an alter ego. When interviewed by fellow actor Alec Baldwin for a 2015 podcast, Hoffman explained that Nichols "felt like he was me, on the periphery, out of it, and he was casting himself, the funny-looking guy." As for Nichols, he frankly admitted in 1999 just what drew him to Hoffman's screen test: "Dustin has always said that Benjamin is a walking surfboard. And that's what he was in the book, in the original conception. But I kept looking and looking for an actor until I found Dustin, who is the opposite, who's a short, dark, Jewish, anomalous presence, which is how I experience myself."

Mike Nichols was, beneath his self-confident exterior, both the ultimate Jewish outsider and a funny-looking guy. When he was four years old, a reaction to a faulty whooping cough vaccine permanently removed all his body hair, and he was forced to wear wigs thereafter. And when he was only seven, he and his three-year-old brother became refugees, crossing the Atlantic without their parents to start a new life in America. Nichols—formerly Michael Igor Peschkowsky—had been born in Berlin in 1931. It was not a good time or place to be Jewish.

Nichols' family occupied a prominent niche in Berlin's intellectual circles. One grandmother did the translation of Oscar

Wilde's *Salomé* that was used as the libretto for Richard Strauss's opera. Grandfather Gustav Landauer was a well-known writer and political activist. He was brutally murdered by German troops in 1919, and his grave would be desecrated when the Nazis came to power. In 1938 Nichols' father, a physician who had been born in Russia, used his international connections to travel to the US and establish a medical practice on New York's prosperous Upper West Side. His two young sons arrived in New York City early the following year, but their mother (held back by illness) didn't rejoin the family until 1941. Even though young Mike found safety in America, he wasn't especially happy or comfortable. It was not until he entered the University of Chicago that the possibilities of life opened up to him. But he forever retained his outsider status, feeling both blessed by the acuteness of what he called his "immigrant's ear" and cursed by the sense that he didn't truly belong.

So Nichols identified with Dustin Hoffman's view of himself as a Jew in a gentile world. Yet this doesn't fully explain how Hoffman won the role of Ben over Charles Grodin, who was also Jewish and also no model of conventional WASP good looks. The story of Hoffman's screen test has been told so often, and with so many variations, that all of its details arouse skepticism. This may be myth-making in action, but Hoffman himself recalls a grotesque scenario. Flying across the country, he couldn't sleep, and had no luck memorizing the lines of the special Ben-Elaine audition scene that Buck Henry had concocted at Nichols' request. On the morning of the test, he was marched into the makeup chair, where experts worried over his thick eyebrows, muscular neck, and

less-than-perfect features. Hoffman can still hear Nichols fretting, "Can we do anything about his nose?"

Two hours later, when he went before the camera alongside Katharine Ross, matters got worse: "The idea that the director was connecting me with someone as beautiful as her, it became an even uglier joke. It was like a Jewish nightmare." Trying to ease the tension between them, he pinched or patted Ross's buttock (accounts differ), leaving her furious. Nor did his reading of the role of Benjamin run smoothly. Just before the film's release, when Ross was asked about her first impression of her future costar, she pulled no punches: "He looks about three feet tall, so dead serious, so humorless, so unkempt." She clearly remembered thinking back then, "This is going to be a disaster." The crew members filming the screen test obviously agreed. The story goes that when the test was finally over, Hoffman pulled his hand out of his pocket and several New York subway tokens fell to the ground. A prop man handed them back to him, saying, "Here, kid, you're gonna need these." Hoffman insists that at the end of the production period, this crew guy gave him a present, a framed arrangement of subway tokens that he still treasures.

On the soundstage, Hoffman's helter-skelter approach to the material had hardly inspired confidence. But when Turman and Nichols pored over the edited footage of all the screen tests, Hoffman and Ross seemed the right pairing for the film. Anyone looking today at the Criterion Collection's 2016 DVD reissue of *The Graduate* would probably make the same choice. The Criterion extras include footage from the three surviving screen tests of hopefuls vying to play Ben and Elaine. In the tests featuring

Tony Bill and Robert Lipton, paired with actresses Jennifer Leak and Cathy Carpenter, the mood is melodramatic, with the Elaine character lugubriously weepy about Ben's apparent "rape" of her mother. The Dustin Hoffman/Katharine Ross test can't fairly be compared to the others, since it spotlights a different section of the long audition scene, but it's unquestionably the most vivid of the three, with Ross appealingly feisty, Hoffman charmingly awkward, and the possibility of humor very much present.

Back in 1967 Turman spotted in Hoffman's filmed performance a "sweetness and goofiness" that he felt could counteract the pain-in-the-ass qualities of Webb's original character. As for Nichols, he recognized in Hoffman's confused panic the essence of Benjamin Braddock. Stage actress Elizabeth Wilson, who would play Ben's mother in *The Graduate* and then work with Nichols on several more films, has said that "Mike's great gift is in casting." In choosing a short, dark Jew to play a role that seemed better suited to a tall, blond Anglo-Saxon type, Nichols was essentially taking his cues from Benjamin's psyche and its proximity to Hoffman's own inner core. Years later, Hoffman admitted, "I was a paralyzed person. I had come from a paralyzed background—the suffocation of that family: I was not acting."

The casting of Hoffman shocked many production insiders. Film editor Sam O'Steen, upon seeing his screen test, immediately referred to the film's newly hired Benjamin Braddock as "this ugly boy." Stuart Byron and his colleagues on Joseph E. Levine's publicity staff were so flummoxed by the thought of Hoffman playing a romantic lead in Levine's new picture that all feared the company would go bust. But Buck Henry (not a decision-maker,

but someone who was always present) felt certain that "the soul was there" in Hoffman's performance, and that "the test he did made everybody else seem really uninteresting." Henry has always enjoyed explaining, tongue in cheek, just how Benjamin Braddock came to be such a mismatch with his own parents: "There *is* a genetic thing that happens—I don't know how it happens and I think science should investigate it—is that the darkest and most exotic Jews moved to Southern California and in one or two generations all the children are blond and tall and blue-eyed. What happens? Sand gets in the genes." As for Benjamin himself, "It's a genetic displacement. . . . He's a throwback to previous generations."

In any event, with the casting of Benjamin's role, all the other parts fell into place. Stage actors Elizabeth Wilson and William Daniels would play his parents. (There's no truth to the rumor that Daniels was initially cast in the supercilious desk clerk role that eventually went to Buck Henry.) Hoffman's old pal Gene Hackman, only seven years his senior, would be Mr. Robinson, the cuckolded husband of Ben's paramour. Katharine Ross, who reminded the quickly smitten Nichols of his first wife, was the obvious choice for Elaine. Her Berkeley flame, Carl, would be played by Brian Avery, a tall and strapping blond who was everything that Dustin Hoffman was not.

Bit players too were carefully cast. They included Norman Fell (who ten years later would make his mark in TV's *Three's Company*) as Benjamin's surly Berkeley landlord and Lainie Miller (wife of diminutive character actor Dick Miller) as the stripper who shows off her tassel-twirling skills. Future Oscar winner

Richard Dreyfuss got a pittance ($175 a day, with a two-day guarantee) to play a Berkeley rooming house resident urging Fell to call the cops. The production team seemed to take special pains with the members of the Singleman family, whose gala social event at the Taft Hotel is nearly crashed by a bumbling Benjamin. To play the chatty Mrs. Singleman, veteran comic actress Alice Ghostley earned a relatively generous salary ($1,250 per day), along with a per diem and first-class airline travel from New York to L.A. and back. The role of her dithery sister, Miss DeWitte, went to octogenarian Marion Lorne, for whom *The Graduate* would be a final film role. (She died on May 9, 1968, when *The Graduate* was still in first-run.) One actress was cast for reasons that were largely emotional. When Turman and Nichols were looking for a distinctive woman to sit beside Elaine on a Berkeley bus that Benjamin's desperately trying to catch, they found themselves interviewing Eddra Gale. Wearing a black wig, she had been the voluptuous La Saraghina, who danced unforgettably on an Italian beach in Federico Fellini's *8 ½*. Turman explains in his book that when he and Nichols learned of her Fellini connection, they "hired her that instant as much for good luck and homage as anything." (For her nonspeaking appearance she took home a flat $250 and was the final entry in the film's brief end-credit list—clearly a sentimental gesture.)

Then, when cast and crew seemed to be coming together nicely, Gene Hackman was suddenly fired from his role as Mr. Robinson.

And Dustin Hoffman was convinced he was next.

5

The Shoot

"This is laid back. This is sunny and hot and quiet. . . . the tempo of *The Graduate* is very L.A.. The slowness of the pool . . . of the whole thing . . . it's exactly right. Mike got it right."
—**Richard Sylbert (1998), *Wide Angle***

Mike Nichols' artistic life was shaped by the presence—and the absence—of his father. In 1939, when seven-year-old Michael Igor Peschkowsky and his younger brother landed in New York Harbor, their father (who had renamed himself Paul Nichols) was there to meet their ship. But with the boys' mother still in Berlin, the senior Nichols had no idea how to be a good parent. He soon farmed his sons out to an English family who treated them like boarders. Matters didn't improve much when their mother finally arrived in 1941. Their father's flagrant infidelities were part of the reason the Nichols household was an uneasy place to be. (The two adults fought constantly, and their mother too looked for companionship

outside the marriage.) Once, in the heat of anger, Paul Nichols snarled at his sons, "I'll be glad to get rid of you two." Yet he also told hilarious stories, and when in a good mood would sometimes amuse his offspring by dancing for them in his underwear. Years later, Nichols remembered, "He was the Russian as entertainer. . . . What I loved him for—even when he wasn't noticeably loving me—was that he had great vitality and joy of life."

Then, when Mike was twelve, his father died suddenly, at age forty-four. It was one more devastating loss in a young life that had already had many: loss of hair, loss of homeland, loss of language, loss of name. For a while he thought of becoming a doctor, in order to remake himself in Paul Nichols' image, but even while expanding his horizons at the University of Chicago he felt a serious sense of displacement. Later, the acclaim of the Nichols and May era didn't entirely help. When, however, Nichols took on the responsibility of being a stage director, he discovered a way of life that served to fill the empty space inside him. Years afterward, he told theater critic John Lahr that once he started rehearsing the Broadway cast of *Barefoot in the Park*, "I had a sense of enormous relief and joy that I had found a process that both gave me my father back and allowed me to be my father and the group's father."

As the father figure in charge of *The Graduate*, Nichols sometimes had to make tough choices. Firing Gene Hackman just before shooting began was surely not easy. No one, including Larry Turman, seems able to pinpoint anything specifically wrong with Hackman's grasp of the role of Mr. Robinson. But Nichols quickly replaced him with actor Murray Hamilton. Nichols was obviously satisfied with the switch: He would praise Hamilton's "incredible

sadness" in the scene wherein he, as a cuckolded husband, confronts Benjamin in his Berkeley rooming house. (Hackman himself recouped nicely, moving that same year into the featured role of Buck Barrow in *Bonnie and Clyde*.)

Whatever Nichols' reason for the last-minute cast change, he surely had the good of the production at heart. At the same time, his obsessive nature was not easy on cast and crew. When interviewed in 1990 at the Museum of the Moving Image, Nichols admitted that early in his filmmaking career, he had been so determined to control every aspect of a project that he was not terribly nice to those around him. Elsewhere he acknowledged "that lunatic you become when you're shooting, that you can't be pleased by anything," and confessed that—although he had grown more gracious over time—he had started out in movies as "a prick on the set." To some extent, this was an outgrowth of his fear of showing weakness, but it had the effect of terrifying others.

The person who most directly felt the fallout from Nichols' displeasure was the film's leading man, Dustin Hoffman. A close friend of the departed Hackman, he also continued to be unsure about his own suitability for his role. Desperate to please his director, he went through his paces in a state of constant anxiety, while Nichols often seemed to be looking for ways to keep his star off balance. In the words of film editor Sam O'Steen, who was frequently present on the set, "Nichols ate him alive, he just chewed him up and spit him out."

Nichols, calling upon his stage background, had chosen to rehearse his actors for three full weeks before filming began on April 24, 1967. From that point onward, the process moved very

quickly by Hollywood standards, thanks to the fact that almost every screen moment had been painstakingly worked out in advance. In one case, Hoffman's smart suggestion that a key exchange between Ben and his mother be moved from Ben's bedroom to the bathroom of the Braddock home triggered Nichols' decision to build a brand-new set. And improvisations encouraged by Nichols during rehearsal sometimes led to unexpected bits of comic business, especially in the intimate scenes between Benjamin and Mrs. Robinson. Still, Hoffman (who was grappling with his own father issues, along with director issues) insisted just after the film's completion that "I never had the feeling he was happy with what I was doing. Oh, he would throw out a cookie occasionally, but I always felt like a disappointment."

Betty Rollin, a reporter from *Look* magazine, captured the tension between director and star when she visited a rehearsal session. The actors had reached the pivotal scene in which Mrs. Robinson menaces Benjamin by saying she's prepared to tell her daughter, Elaine, all about their affair. Nichols first deftly pumped up Anne Bancroft's triumphant anger: "You threaten him with something so terrorizing that you know he has to do what you want." As Bancroft rubbed her hands with glee, he turned to Hoffman, whose face (in Rollin's telling) turned ashen: "Now, Dusty . . . It's like you just won an award, say, for that Spanish picture you just did, and I say, 'Listen, I have permission from SAG to see that you never work again.'" Hoffman nodded glumly, then sprang from his chair and started "jumping rope like a madman."

The presence of a jump rope on the set was not as strange as it may have seemed. Hoffman, who knew that his role would make

many physical—as well as emotional—demands, had brought along the rope as a way to stay in shape. Later, it briefly became a prop for the body double who was hired to stand in for Anne Bancroft in the scene where Mrs. Robinson bares herself to entice the highly conflicted Benjamin. That body double, an amiable exhibitionist, was encouraged by the crew to try jumping rope in the buff. And so she did, for five long, bouncy minutes.

Another moment of levity involved two topless dancers flirting with *The Graduate*'s appreciative male cast and crew on the film's rehearsal stage. The point of this event remains unclear. Was it some sort of boys-will-be-boys celebration? In 2015 Larry Turman was dubious that he'd had a part in any such thing. He did, however, recognize his broadly smiling younger self in candid photos I'd copied from his own vintage files. Clearly the filming of *The Graduate* was not always as tense as Hoffman has recalled it to be.

In fact, despite the unease felt by Hoffman, creative juices were flowing. Nichols was prodding Hoffman to remember the awkwardness of his own first sexual encounters and was helping Bancroft recognize that "Mrs. Robinson was using sex as a way to diffuse this rage inside of herself." He was also exploring how to use his own feelings about Los Angeles to make visible one source of Ben's angst. Webb's novel had contained little sense of place. But like many creative types, before and since, who've been lured to Hollywood by the promise of wealth and power, Nichols had a deep-seated mistrust of Southern California's siren song. A confirmed New Yorker, he frequently told interviewers that *The Graduate* was a cri de coeur against "the Los Angelesization of the world . . .

in which things take over a person's life." The film's veteran production designer, Brooklyn-born Richard Sylbert, turned out to be the perfect collaborator for Nichols in this regard. Together they loaded the film's set design with water, glass, and mirrored surfaces, the better to suggest the narcissism of the culture as well as Ben's entrapment in a human-sized aquarium: He can see and be seen, but remains forever cut off from the world into which he was born.

Sylbert (who would go on to design such quintessential L.A. films as *Chinatown* and *Shampoo*) found his inspiration for *The Graduate* while doing location research in the air above Beverly Hills. Film scholar Robert L. Carringer, exploring the depictions of Los Angeles in Hollywood movies, learned that "the story crystallized for [Sylbert] when the helicopter pulled up and suddenly revealed before him an entire city of backyard swimming pools." Riffing on Southern California as a swimming-pool culture, Sylbert suggested to Nichols that when Mrs. Robinson shrugs off her clothing the audience should plainly see the strap marks of her bathing suit on her tanned skin. And Sylbert's fascination with a landscape of swimming pools led to plans for a bravura artistic moment. The idea was to start underwater, with a diving-suited Benjamin on the bottom of the Braddock pool, then move back into an elaborate and expensive bird's-eye view of the entire neighborhood, revealing one pool after another. This would certainly have made a point about conspicuous consumption, SoCal style. But producer Larry Turman, who'd successfully sweet-talked the city of Beverly Hills into allowing itself to be filmed from a low-flying chopper, ultimately realized that ending the scene on

Benjamin in an underwater close-up would have a far stronger emotional impact. Nichols agreed with this logic, and the $5,000 helicopter stunt was scrapped.

Though he loved being the man in charge, Mike Nichols was always open to suggestions by others on the creative team he'd assembled. But one aspect of *The Graduate* sprang from his own fertile imagination, combined with his sophisticated literary tastes. While musing about the film, he'd been reading Henry James' "The Beast in the Jungle," the story (first published in 1903) of a young man trapped by his own confused expectations about his future. In James' tale, the beast in question is purely metaphoric, but it occurred to Nichols that here was a motif that could work to give his antagonist, Mrs. Robinson, a visual mythic dimension. Within her home, she generally lurks on her sunporch, with its kitschy decorator touches and a tangle of tropical plants just outside the sliding glass door. Nichols has admitted he was nearly carried away by such ideas: "At one time I was almost going to send an ape through. Then they talked me out of it." Along the same lines, Mrs. Robinson's wardrobe—from her coats to her lingerie—evokes tigers and zebras and giraffes. She also wears extravagant furs, including a Somalian leopard-skin wrap. And so, said Nichols, "all her clothes are animals."

Mrs. Robinson's wardrobe, as well as the nouveau riche fashions sported throughout *The Graduate*, are the work of Patricia Zipprodt, whom Nichols had lured away from Broadway musicals (including *Fiddler on the Roof* and *Cabaret*) to design her first motion picture. Zipprodt's sharp eye for fashion gives us the full range of California leisurewear. She is the creative force behind

Mr. Braddock's jumpsuits and cabana sets, as well as the eclectic garb of the guests at the Braddocks' birthday barbecue, where (as described in Buck Henry's script) the adults' clothing is much too young for them and the kids' outfits look too mature. To be honest, I found some of the poolside ensembles worn by background characters totally over the top. No matron ever showed up at one of my family's swim parties wearing a Chanel knockoff or a Little Lord Fauntleroy getup complete with wide collar, floppy bow tie, and kneesocks. But then, of course, the notion of parents gifting their newly adult son with full scuba gear and demanding that he perform for their friends is outrageous in its own way, so perhaps some exaggeration in the guests' attire is all too appropriate for this film.

On-set continuity photos snapped by the production's wardrobe department show Benjamin Braddock evolving from a buttoned-down East Coast preppy into a slightly scruffy California kid. Many of these snapshots (used to confirm exactly how a shirt was buttoned, and whether the bracelet was worn on the right arm or the left) also provide a whimsical gauge of the mood on a set. It's easy to see Anne Bancroft, in particular, having a ball vamping in Mrs. Robinson's slinky duds. Though Elizabeth Wilson, as Mrs. Braddock, is far more restrained in her poses, the shots help to highlight the wit and whimsy of her costumes, which include lacy cover-ups, filmy negligees, dizzying black-and-white op art tops, and an outrageously flower-petaled plastic bathing cap.

As a product of Broadway, Mike Nichols naturally gravitated toward actors, like Wilson, whose work he knew from the New

York stage. The fact that Anne Bancroft and William Daniels, in particular, sound like native New Yorkers on camera well suits the social milieu that *The Graduate* represents. Southern California has always been a destination for people seeking to reinvent themselves. In the years after World War II, thousands of ex-GI's flooded into the Los Angeles area, looking for opportunity and generally finding it. Both Mr. Braddock and Mr. Robinson doubtless served in the military, then earned their law degrees via the GI Bill. Their business success has allowed them and their families to enjoy what they consider glamour under the California sun. That may be why production designer Richard Sylbert, searching out exterior locations, chose for the Robinsons a faux-Tudor minimansion: Ersatz Californians would naturally gravitate toward an ersatz traditional style that conveys a sense of dignity and decorum.

When Sylbert, under Mike Nichols' supervision, addressed the daily surroundings of the Braddocks and Robinsons, he went so far as to design their houses' interiors (solidly built on Paramount soundstages) as mirror-images of each other. The same black-and-white color scheme predominates in both, and similar striped awnings shade both backyards. But the Braddock home is white, bright, and straight-edged, while the Robinson abode, usually seen after dark, features sinuous curves, "exotic" tchotchkes, and surfaces painted a seductive black. Sylbert's other goal was to give the Beverly Hills lifestyle a sense of insularity that does not give way until Ben puts pedal to metal in his Alfa Romeo Spider 1600 for a drive up the coast. (Larry Turman notes that his personal deal with Chrysler could have saved the production much-needed money, but Nichols insisted that the Braddocks would

not settle for anything less than a sleek foreign sports job. Sylbert, newly back from Europe, knew just the car to recommend.) Once Ben begins driving north toward Berkeley and Elaine, the marked claustrophobia of the L.A. scenes finally dissipates. Then, thanks to stunning helicopter shots of the little red car zooming up a road rimmed by pines and then traversing a mighty bridge high above the Pacific Ocean, the whole wide world opens up to him.

Nichols and company naturally hoped to shoot on the famous Berkeley campus of the University of California. The production team tried hard to gain permission, even enlisting a Paramount exec who considered himself an active Cal alumnus to plead their case with the school's chancellor. Not-so-subtly referencing the raucous Free Speech Movement that had disrupted the campus two years earlier, the exec noted the potential benefit to the school of a film crew's presence: "The intended beauty of color photography would place the University in a better light contrasted with the hours of newsreels recording only Sather Gate Plaza. Berkeley would appear as the stable, respectable, educational community it is." The appeal didn't work, and—as generations of students have noted—the campus scenes in *The Graduate* were mostly filmed at the University of Southern California. Still, a small crew headed for the Bay Area to shoot Ben roaming Berkeley's Telegraph Avenue, Ben and Elaine catching a bus to the San Francisco Zoo, and Ben's convertible zipping across the Bay Bridge, traveling (as any San Franciscan will tell you) in the wrong direction. They also covertly shot a silent scene of Elaine ambling across Berkeley's busy Sproul Plaza, just to see if they could get away with it. Turns out they could.

Looking back over the decades, Katharine Ross would marvel at the ironic fact that, while filming a novel published in 1963, "we were sort of still in the fifties mentality." At the very time that cast and crew were shooting in Berkeley, "the Summer of Love happened in San Francisco, and Vietnam was about to blow the country apart and change us all forever." Berkeley in the summer of 1967 was not yet the hotbed of antidraft activism that it would soon become, and in any case Mike Nichols was not much concerned with capturing the mood of the moment. (As for Larry Turman, he insisted to me that in visualizing the movie he wanted to make, "I never thought about the year. Never.") Yet some of the production team felt this film was ahead of the curve in recognizing that the times they were a-changing. Before working on *The Graduate*, production designer Richard Sylbert had spent several years living abroad. When he returned, he was shocked by the rise of an American youth culture opting out of middle-class values. Young people, he had discovered, were accusing their parents of making too much money. To Sylbert, "*The Graduate* is part of the revolt, but it's a story done in a much different way. [Benjamin] is a passive version of that." Sylbert specifically compared *The Graduate* to *Medium Cool*, the Haskell Wexler feature film that would convey, with cinema verité fidelity, the violent aftermath of the protests at Chicago's 1968 Democratic National Convention. *Medium Cool* was unquestionably focused on youth in revolt. For Sylbert, at least, *The Graduate* was "a very sophisticated, very carefully planned, very conscious movie about the same revolution."

I'm tickled that Sylbert mentioned the work of Haskell Wexler. Wexler, then a rising cinematographer, had won an Oscar

for his vivid black-and-white cinematography on Mike Nichols' *Who's Afraid of Virginia Woolf?* He hoped to work with Nichols again on *The Graduate*, but my 2008 conversation with the elderly but still feisty Wexler clarified what went wrong. Wexler actually shot for Nichols the screen tests of Redford, Hoffman, and others. But the staunchly political Wexler overtly disliked what he saw as Buck Henry's frivolous script, and Nichols told him, "Look, Haskell, you said you're never gonna do a film that you don't really want to do, and obviously you don't want to do it." So Wexler was done in by his own high-minded principles. In the long run, he wasn't sorry, remarking, "Except for the shot when she flashed the audience, I didn't think the film was as revolutionary as other people did." (With his schedule for 1967 suddenly wide open, Wexler ended up as director of photography on the racially charged *In the Heat of the Night*, and he made his directorial debut with *Medium Cool* two years later.)

Wexler's replacement as cinematographer on *The Graduate* was old-timer Robert Surtees (1906–1985), who'd photographed 1959's *Ben-Hur*, among scores of other films. Like everyone else on the crew, Sylbert was lavish in his praise of Surtees: "He was brilliant. He was absolutely the most charming, well-read, easy-going personality for that picture." Part of what made Surtees great was his willingness to adapt to ideas that were brand-new to him. Mike Nichols was attracted to the razzle-dazzle techniques invented by European filmmakers like Fellini, Michelangelo Antonioni, and François Truffaut. Surtees, more familiar with the "invisible style" of Hollywood, was happy to expand his own cinematic vocabulary. Suspecting that Nichols would want to experiment, he

warned his crew early on to "be prepared because you're going to do some way-out shots."

Surtees was quite right. To achieve Nichols' vision, he pulled out the full bag of cinematographic tricks: hidden cameras, long lenses, pre-fogged film. In a 1967 article he wrote for the Directors Guild magazine, Surtees described how Nichols "wants each shot to capture and express a mood, a feeling, an emotion." This meant, for instance, deliberately overexposing the plants at the rear of the Robinson house, so they'd "appear white hot and oppressive, like an encroaching jungle about to take over and choke the inhabitants."

At times Surtees needed to get inventive: "Thank goodness, I was not just starting out in the business because if I had been I could not have done the picture. It took everything I had learned over thirty years to be able to do it." To photograph Benjamin's nocturnal wild ride on an L.A. freeway, he equipped both Ben's Alfa Romeo and two adjoining cars with special airplane landing lights to illuminate the road. He also put a cameraman on a pool raft, and later had a camera-wielding Nichols himself ride in the sports car alongside Hoffman, capturing Ben's face in his rearview mirror while Ben spies on Elaine from a distance. To meet Nichols' last-minute demand for a downpour in another key driving scene, Surtees stationed a rainmaking device directly over the vehicle, then shot the actors with a 500-millimeter telephoto lens. This blurred the background so the audience couldn't tell whether or not water was truly dripping from the sky to the pavement.

The creative collaboration between Nichols and Surtees led to some offbeat ideas. Early in the film, when Benjamin—rattled

by Mr. Robinson's unexpected homecoming—runs downstairs to escape Mrs. Robinson's clutches, we see him only as an out-of-focus shadow in the rear of the shot. In the foreground, beautifully lit, is the whiskey glass he'll soon clutch to give the appearance of casual ease. And in a once-popular 1972 textbook for aspiring filmmakers, Louis D. Giannetti describes how Nichols, Surtees, and Sylbert joined forces to capture Mrs. Robinson at the moment she realizes that her secret life with Benjamin is lost forever. To illustrate her state of mind, "a separate set was constructed, with an oversized doorway towering above her. With the camera at a high angle, a vast expanse of white wall to one side, and a huge empty doorway at the other side, Miss Bancroft was literally reduced to insignificance."

One of the film's most iconic visuals, that of Ben framed by Mrs. Robinson's arched leg, owes something to Dustin Hoffman. Because Nichols had coached him to be frank about a young man's active libido, Hoffman admitted on set that when this sexy and short-skirted woman hoists a shapely limb onto a bar stool, Benjamin would probably not be able to resist sneaking a peek at her crotch. Nichols laughed and ordered the camera lowered to shoot between Bancroft's legs as punctuation for the key line, "Mrs. Robinson, you're trying to seduce me." It's a moment—long remembered, frequently parodied—that lives on in film history.

Hoffman appreciated the chance to give input on his character and on the film in general. Yet during the making of *The Graduate*, he himself faced input of an unwanted sort. For the first week of filming, he tried living at home with his parents, but was quickly unnerved by his father's eagerness to somehow get into

the act. That's why he joined other cast members at the Chateau Marmont, a romantic but slightly tawdry hostelry on the Sunset Strip. Harry Hoffman, though, remained determined to visit the film set. Dustin resisted until the day when the company was shooting in the lobby of the stately Ambassador Hotel, standing in for the film's Taft Hotel. Because there would be scores of extras, along with security guards to keep looky-loos at a distance, he figured it was safe to invite his parents. But as Mike Nichols was setting up a dolly shot, "I see my father ducking under the rope and walking right up to Mike, and he gets right in his face and says, 'No, no, *this* is what you want to do.'" The humiliation was so hard on Dustin Hoffman that he spent much of that day hiding out in the men's room. His complex interrelationship with his real dad (as well as with Nichols, his movie-set dad) was threatening to derail his equanimity.

Benjamin Braddock would have understood completely.

6

Post-Production

"Cutting is almost the greatest pleasure. That's when you can make things happen you failed to do before."
—**Mike Nichols (1968),** *Look*

Benjamin Braddock, decked out in cap and gown, is standing at a lectern in a campus sports stadium, delivering a solemn address to his fellow college graduates. His topic is "the purpose for all of this demanding work, the purpose for the sacrifices made by those who love us." What exactly is this purpose? Just as he starts to spell it out, the pages of his carefully crafted speech are caught by a breeze and blow off into the unknown. Cut to Ben in close-up, waking on an airplane about to land in Los Angeles.

This is how *The Graduate* begins—at least in Buck Henry's script. Larry Turman assured me that the graduation speech was shot, but Mike Nichols and his team later concluded that it wasn't needed, that it rendered the source of Ben's anxiety much too

specific. And so Nichols and company edited it out of the finished film. Movie folk make decisions of this sort well after the cameras have stopped rolling. That's what the post-production period is all about.

Though the opening moments of *The Graduate* underwent a major change in the editing room, the film's ending remained fairly intact, though it too deviated from Buck Henry's script in several key ways. Once again the story's final moments benefited both from Nichols' inventiveness and from his ability to collaborate with the production's creative staff. First there was the matter of searching out an appropriate church in which to stage Elaine and Carl's wedding. Production designer Richard Sylbert found in an architecture book a photo of the United Methodist Church of La Verne, California, about thirty miles east of Los Angeles. Its bland white modernity and extensive use of glass seemed a perfect complement to Benjamin's sense of being cut off from the rest of the world. This church also nicely suited Mike Nichols' perception of Southern California style: "There's all this nature, but you're completely separated from it by glass."

Only problem: The church elders in La Verne were not interested in renting out their facility for a movie shoot. Larry Turman quickly sprang into action. He called a meeting, at which he forcefully argued that "our script is sexually provocative, but deals with the very issues the church itself should be dealing with in today's world." Permission was duly granted, but when Dustin Hoffman—high above the wedding guests—bellowed Elaine's name while hammering his fists against the huge plate-glass panels separating the balcony from the sanctuary below, the church's spiritual leader began to panic. Those panels had been the gift

of a generous congregant, and the minister was ready to oust the film crew on the spot rather than risk the possibility that the glass might suffer damage. That's why the film shows Ben in a cautious hands-up pose, tapping rather than pounding. Over the decades, both critics and audiences have mistaken his posture for a deliberate crucifixion reference, to the amusement (and occasional annoyance) of *The Graduate*'s cast and crew.

Mike Nichols had come up with a small but radical idea for that wedding scene. In both Charles Webb's novel and Buck Henry's script, Benjamin intrudes upon Elaine's nuptials just before her vows with Carl are finalized. This would have put *The Graduate* in line with many other famous movie moments in which a protagonist realizes in the nick of time that he or she is about to wed the wrong person. (One of my favorites is the ending of Frank Capra's *It Happened One Night*, in which Claudette Colbert flees from the altar and into the arms of her true love, Clark Gable. And then there's *Girl Shy*, in which Harold Lloyd, discovering that the woman he loves is moments away from wedding another, commandeers a car, then a horse, then a tram, then a policeman's motorcycle to ride to the rescue.) But while returning from a San Francisco location scout, Nichols announced to Larry Turman that he wanted to see Ben arrive too late, seconds after Elaine has—with apparent equanimity—become someone else's wife. This was a bold move for 1967, when the sanctity of marriage was rarely questioned, but Turman went along with Nichols' outrageous plan. And he later, as the director's self-confidence was wavering, urged him to stick to his guns. Nichols' audacious choice ensured nationwide controversy in pulpits and letters to the

editor, but it also helped convince young audiences that here was something new, not just Hollywood as usual.

The location of the church and the timing of Ben's intervention were planned out well before filming began. (What was *not* planned was that the brouhaha became so intense that Anne Bancroft collapsed and paramedics had to be summoned.) But the last three minutes of *The Graduate*—that final bus scene that Nichols himself considered the film's proudest achievement—came about through the kind of serendipity that the motion picture medium makes possible. Buck Henry, interviewed by Terry Gross on *Fresh Air*, has aptly called it "a happy ending with a little slice of lemon in it." Once Ben and Elaine, he in torn jacket and she in her wedding finery, have boarded the public bus, Henry's script almost exactly follows Charles Webb's novel. Benjamin, having fished out of his pocket the coins to pay the fare, demands of the driver, "Let's go. Let's get this bus moving!" Ignoring the stares of the passengers, he and Elaine take their seats at the rear. A few moments later, she looks at him and asks, "Benjamin?" He answers, "What?" She takes his hand, and the bus pulls out, going we know not where.

In filming this short scene, Nichols decided to dispense with dialogue. Then he found himself growing unaccountably irritable while setting up the all-important finale of his movie. He barked at his actors, Dustin Hoffman and Katharine Ross, "Look, we've got traffic blocked for twenty blocks, we've got a police escort, we can't do this over and over. Get on the bus and laugh, God damn it." They were naturally ill at ease, and he himself wondered why he was torturing two exhausted young performers who were doing

their best. Then he saw the dailies, and all became clear. What was conveyed through their expressions and their body language was not joy and hilarity, but rather a terror of the unknown. Nichols was to realize that the characters have every right to feel unnerved by the step they've taken: "It seems to be perfectly possible that in two more miles Elaine may say, 'Oh, my God, I have no clothes.'" As for Benjamin, he "has many choices open to him, but people die and people leave each other and people calcify and one or all of those will happen to him." In other words, Ben and Elaine have made an impromptu commitment that will shape the rest of their lives, for better or for worse. As Nichols discovered in the screening room, every bit of that anxiety about the future shows up in the two actors' faces. He realized, "This is the ending that really was created by my unconscious. . . . That was *me* scaring the crap out of them before we did it. And I didn't know what I was doing, but I did." Ben and Elaine's fraught moment signals, I believe, the end of the happy ending, a recognition of the fact that all's not necessarily well that ends well.

Many thoughtful viewers of *The Graduate* agree that this postscript at the film's tail end is essential to its meaning, that it beautifully encapsulates the tension between youthful optimism and the realities of the adult world. Said filmmaker Steven Soderbergh, chatting with Nichols on the fortieth anniversary DVD reissue, "If you don't have this, then the movie is like a sham." To which Nichols replied that the experience had helped him shape a new directorial philosophy: "You shoot until something happens that no one could have predicted, and then you go on to the next thing." Film editor Sam O'Steen, who was to be closely allied with

Nichols over the course of twelve films, had a unique perspective on how the unexpected ending came to be. He was actually a passenger on the bus, sitting in for Nichols, who would have been instantly recognizable by many moviegoers. As O'Steen remembered it, "when the scene was supposed to end, Dusty and Kathy just sat there for a long time and looked at each other, not knowing what to do." The fact was that Nichols had forgotten to cue O'Steen to say, "Cut!" What seemed like an omission turned out to be a gift.

Sam O'Steen's duties on *The Graduate* involved far more than riding on buses. Nichols—violating every unwritten rule about who belongs on a movie set—wanted him present during the filming process to help decide, from an editor's point of view, what specific angles would later be useful in the cutting room. Sometimes this involved unconventional choices that pumped up both the film's drama and its humor. Take the case of the early moment when Benjamin, standing in Elaine's pink-and-white bedroom, turns his head to discover that Mrs. Robinson has entered, and that she's stark naked. After surveying the developed footage, Nichols selected several of Ben's reaction shots, as well as closeups of Mrs. Robinson's face, breasts, and belly. But the assembled sequence was not in the least funny. Going back into the editing room, O'Steen tried something out of the ordinary. To convey Ben's sense of shock (which should mirror the shock felt by the audience), he thrice repeated footage of Ben whipping his head around to take in the gob-smacking sight of his father's partner's wife in the altogether. Then, instead of moving logically between the faces of the scene's two participants, O'Steen found an outtake of Ben, staring wildly, as seen from over Mrs. Robinson's bare

shoulder. He intercut this with lightning-quick flashes—just a few frames apiece—of the taboo areas of her anatomy. The result is what has come to be called "subliminal cutting," a trend that first surfaced in Sidney Lumet's *The Pawnbroker* and had been considered by O'Steen and Nichols for *Who's Afraid of Virginia Woolf?* To make the would-be seduction scene unforgettably hilarious, O'Steen concentrated exclusively on the buildup of Benjamin's panic as he tries without success to keep himself from staring at the private parts so boldly on display. Sixties audiences, most of them unprepared for even such minuscule glimpses of on-screen nudity, erupted into guffaws and nervous giggles.

O'Steen helped create some of *The Graduate*'s most memorable moments. It was he who suggested the striking use of camera focus in the revelation scene, in which Elaine suddenly discovers that Benjamin has been sleeping with her mother. The focal point is Elaine, blissfully unaware of what's to come, until Ben—over her shoulder—spies the haggard face of Mrs. Robinson, framed in the doorway. In this instant, the film flouts a basic principle of cinematography: Elaine diminishes into a blur as her mother's haunted features come into sharp focus. It is only gradually that the focus shifts again, to capture Elaine's own dawning awareness of what's going on.

Here's how the radical nature of the shot is explained by veteran cinematographer Philip D. Schwartz, who spent many years as a focus puller (assistant cameraman) and who now teaches in the famous USC School of Cinematic Arts:

> In the "revelation" scene, the highly unorthodox choice made by Nichols with respect to the timing of the "focus

pull" (shifting of focus) to Elaine violates one of the cardinal rules taught to camera assistants. Traditionally, this shift would occur when a person in the foreground, who is in focus, turns away from camera to face a person in the background, who had previously been out of focus at the start of the shot. At that point, we would be seeing the back of the foreground person's head, out of focus, and the person in the background would be "sharp." As soon as Elaine, in the foreground, turns towards the camera to face Benjamin, the camera assistant would normally shift the focus back to her on the head turn. As she is much larger in the frame, one's attention would automatically shift back to her, and we would expect her to be "sharp." However, in this iconic scene, Elaine remains out of focus for several beats, until her terrible revelation dawns, and the slow shifting of focus back to her underscores this realization.

A few of O'Steen's contributions were modest indeed. Take the fact that in high-stress moments throughout the film Benjamin emits a plaintive and very funny little "yip." This was Dustin Hoffman borrowing one of Mike Nichols' own nervous mannerisms, and audiences have always found it endearing. Yet only a single distinctive whimper actually occurred on-set, while others were inserted into the film during the sound editing process. For a skilled editor, such an insert is a simple matter. But Nichols and O'Steen were to work long and hard on another editing feat: the complex montage at the film's center. This is the section in which Ben's aimless summer is conveyed (to the strains of Simon and Garfunkel

ballads) via shots that move him back and forth between his parents' swimming pool and Mrs. Robinson's bed. A key component of this editorial legerdemain is the use of a black pool raft that has been skillfully match-cut with the black headboard of the Taft Hotel guest room where Ben and Mrs. Robinson stage their trysts. In one particularly virtuoso moment, Ben thrusts himself onto the raft, which instantly transforms into Mrs. Robinson's supine body. At which point, he and we are startled by his father's voice, asking, "Ben, what are you doing?" It takes a moment to realize that Mr. Braddock is standing at poolside, not invading Benjamin's hotel sanctum. This example of pre-lap dialogue (another of the film's inventive editing features) vividly suggests the ways in which Benjamin's two worlds have merged.

From the start, O'Steen was cutting the film to tracks on early Simon and Garfunkel albums. The acoustic duo, with their poignant harmonies and wry wit, had become favorites of college students like me, who heard in their tunes the melancholy of the era. Mike Nichols had been introduced to Paul Simon's music by his younger brother. He quickly became obsessed by "The Sound of Silence," which he found himself playing incessantly while preparing for his day on the set. The ominous quality of the song, he felt, captured the mood at the beginning of *The Graduate*. And to him the duo's mournful lyrics nicely conveyed the inner voice of Benjamin Braddock: "It was so clearly Dustin's voice, because Paul Simon was obviously a great songwriter, but he hadn't yet quite found his absolutely articulate voice. He was still searching, which to that extent made the songs more like Benjamin." While O'Steen was using such Simon and Garfunkel

tunes as "Scarborough Fair" and "April Come She Will" as temp tracks in the editing room, Nichols hired Paul Simon to write three brand-new songs. Only one emerged, and Nichols didn't feel that the new "Punky's Dilemma" enhanced the pool-and-bed montage. He did, however, like a little ditty with which Simon had been toying. It began with the line "And here's to you, Mrs. Roosevelt," and didn't go much further. Simon swapped out Mrs. Roosevelt for Mrs. Robinson, added a soupçon of Jesus and some *whoa whoa whoas*, and the scrap of a tune became traveling music to accompany Ben's drive up the California coast. (It wasn't until April 1968 that a fully written version of "Mrs. Robinson" appeared, along with "Punky's Dilemma," on Simon and Garfunkel's *Bookends* album, which promptly became an enormous hit.)

Nichols' ultimate decision to use familiar Paul Simon songs as the basis for his film's score was not without controversy. Although Joseph E. Levine accepted the involvement of the duo he referred to as Simon and Schuster, he expected them to be creating new music especially for *The Graduate*. When Turman and Nichols showed Levine the finished film, Levine assumed that the soundtrack's Simon and Garfunkel "oldies" (from as far back as 1964) would soon be replaced. Assured that the score was complete, he bellowed, "Every kid in America knows these old songs. You'll be laughed off the screen." Despite Levine's emphatic "You can't," Turman and Nichol could and did, with consequences that were to alter Hollywood's whole approach to film music.

Meanwhile, apart from the Simon and Garfunkel songs that conveyed secret glimpses of Benjamin's psyche, *The Graduate* needed source music, like the sultry Latin strains that fill the air

when Mrs. Robinson—in full seduction mode—flips on the hi-fi system next to her home bar. Turman approached John Williams, a full decade before *Star Wars*, but when the not-yet-legendary Williams showed no appreciation for the material, he was quickly given the heave-ho. Young jazz pianist and composer Dave Grusin (who would one day earn an Oscar for his film scoring work) then stepped in to write what Turman calls "satiric, sometimes almost gauche music, to reinforce the crass materialism and shallowness of the parent characters." Such Grusin compositions as "The Singleman Party Foxtrot" and "Sunporch Cha Cha Cha" contribute to the humor of *The Graduate*; they have enjoyed a prolonged life cohabiting with "Scarborough Fair" and "The Sound of Silence" on the film's bestselling soundtrack album.

With the addition of music, *The Graduate* was complete. It was time for the filmmakers to find out if anybody cared.

7

The Release

"It had hit some wind that was circling the earth, something that nobody could have predicted, and had just been lifted beyond what we ever could have imagined."
—**Mike Nichols (2007), fortieth anniversary DVD**

Joseph E. Levine, master marketeer, thought he knew exactly how to publicize *The Graduate*. As Dustin Hoffman remembers it, Levine was so worried about the movie's general appeal that he contemplated booking it exclusively on the art-house circuit. Which meant, in those days, playing up European-style arty nudity. Arranging a poster shoot, Levine called for Hoffman and Anne Bancroft to pose naked, she seated on a bed facing forward, he standing in front of her, with her hands cupped around his bare buttocks. But Mike Nichols, far from pleased at this prurient exploitation of his actors, quickly derailed Levine's train of thought.

Nichols and Turman together chose the logo (created by British graphic designer Richard Williams) that was to become a key

part of *The Graduate*'s marketing campaign. Though far more subtle than what Levine had in mind, the sketch of a cap-and-gowned young man as seen through the arch of a woman's bare leg promised sexy fun. The leg graphic would soon surface on all sorts of promotional materials. Some iconic publicity photos were also taken at this time, including the now-famous shot of a pensive Benjamin, fully dressed except for his shoes and socks, watching a nylon stocking slide up a woman's shapely gam. (The leg in the photo belonged not to Bancroft but to future *Dallas* star Linda Gray, who then made her living from modeling gigs.) Bancroft herself posed for a series of sultry glamour photos in which she sports a lacy black bra, a black fur stole, and a come-hither look. Though the shots are unabashedly gorgeous, she evidently refused to allow them to circulate, so they live on only in Larry Turman's archives (and in my memory banks).

While photographers were snapping pictures, others on the marketing team were working out the language for advertising materials. On those early mock-ups, Buck Henry was listed as *The Graduate*'s sole screenwriter. Because Henry had never been shown Calder Willingham's rejected drafts and had used the Charles Webb novel as his exclusive source of ideas, there seemed no reason to credit Willingham's work. As a matter of courtesy, Turman notified Willingham that he was to be excluded from the film's credit roll. That's when Willingham went to the Writers Guild of America and demanded arbitration. The WGA duly noted that both men's work used as a starting point Webb's characters and basic situations. And the Guild traditionally gives precedence to the initial writer on a project. So Willingham, who had made

clear his disdain for everything to do with *The Graduate*, enjoyed first-position screenplay credit on the film itself, as well as on all ads and posters. For Buck Henry, this naturally rankled, but not for long. The insiders who controlled the writing jobs in Hollywood all knew who had written *The Graduate*. And as Henry later claimed—perhaps disingenuously—to Sam Kashner of *Vanity Fair*, "I never gave a shit about credit. Give me the money, credit whom you want."

One item nowhere to be found on those first ads and posters for *The Graduate* was any indication of the film's rating. In 1966 the Motion Picture Association of America, under new head Jack Valenti, had tossed out the antiquated Production Code, with its goofy rules about what could and couldn't be shown on screen. (It was this code, fundamentally fearful of sexuality, that had led to the oddball depiction of married couples in separate beds. And for years any portrayal of a sexual relationship not sanctified by marriage was required to end unhappily, or risk being denied the all-important code seal.) Valenti promised a new rating system, but it was not to emerge until November 1968. In the meantime, films with adult content were encouraged to adopt a "Suggested for Mature Audiences" designation. This, however, was in no way enforced. Besides, Joseph E. Levine's tiny Embassy Pictures was not yet an MPAA signatory. So *The Graduate* was at first free to market itself to anyone—of any age—who had money to pay for a ticket. Ironically, despite the film's reputation for being outrageously adult, when it was rereleased in 1977 its rating designation was a mild PG. As Larry Turman would write, "In the wink of an eye, society had undergone a dramatic change, and the movie

industry quickly followed suit." Yes, suddenly sex had come out of the closet. On screen, as in the real world, everyone seemed to be doing it, whether or not wedding bells had chimed.

Dustin Hoffman was such an unknown commodity in 1967 that one of the earliest sample ads in Larry Turman's files lists him as Dustin Farnum, momentarily confusing him with the long-ago cowboy star for whom he was named. As the time approached to release *The Graduate*, Hoffman was featured in several magazine articles designed to drum up interest in the film by introducing its new star to the viewing public. A major publicity coup was a photo story by David Zeitlin in *Life*, then a ubiquitous general-interest magazine. An eye-catching headline read, "A Swarthy Pinocchio Makes a Wooden Role Real," and the profile focused on the actor's decidedly un-Hollywood features: "If Dustin Hoffman's face were his fortune, he'd be committed to a life of poverty. With a schnoz that looks like a directional signal, skittish black-beady eyes and a raggedy hair-cap, he stands a slight 5-foot-6, weighs a mere 134 pounds and slouches like a puppet dangling from a string."

This was one of many colorful mentions in the press of Hoffman's supposed unattractiveness. He was called "a homely non-hero" in the *Life* piece, and such popular magazines as *McCall's*, *Time*, and *Playboy* were equally brutal. *Time*, for instance, described his physical shortcomings almost lyrically: "The hair is from a thatched roof in Cambodia, the nose and chin from a 1948 Chevrolet, the hooded eyes from a stuffed hawk. Even the voice seems assembled, an oboe with a post-nasal drip." Understandably, Hoffman's feelings were bruised. He told film historian Peter Biskind that "I felt there was a kind of disguised anti-Semitism.

They would describe me in the way that the cartoons in Nazi Germany in the Thirties pictured Jews—beak-nosed, squinty eyes. And nasal." In his future career, Hoffman would show his determination to strike back, proving to the world that he was an actor, rather than a nebbish who happened to be in the right place at the right time. As he acknowledged, "Revenge is always a good motive in creativity."

In a way, Joseph E. Levine was exercising his own form of revenge when he put together what's often called a press book. This is a glossy pamphlet full of ad samples as well as brisk, catchy articles intended to help local exhibitors publicize a film within their territories. For instance, an item titled "A Real Sparkler" announces that Anne Bancroft, in the role of Mrs. Robinson, sports $25,000 worth of furs and $150,000 worth of jewels, including a ten-carat marquise cut diamond engagement ring. (In today's terms, her luxury accessories would be worth over $1 million.) There are also profiles (accompanied by photos) of the film's major players, among them a highly flattering piece on director Mike Nichols, citing *Newsweek*'s recent assessment of him as "America's most sought-after director, its only star director at the moment." As is traditional, the press book's lead article is a breezy history of the production itself. It describes how Nichols and Larry Turman joined forces to make a film out of Charles Webb's novel, but reserves its greatest praise for none other than Joseph E. Levine, who "with his usual sense of showmanship and motion picture potential . . . agreed to support the undertaking." This opening article is crowned by a large smiling photo of Levine, and its headline refers to "Joseph E. Levine's *Graduate*" as "a tale of today's youth."

Additional headshots and stills from *The Graduate* abound
throughout the press book, but the face of producer Larry Turman
is nowhere to be seen. It's easy to speculate that Levine, who had
been denied by Turman the title of executive producer on *The
Graduate*, was going out of his way to diminish Turman's own role
in the film's achievements. For his part, Turman made clear to me
that the association with Levine was a mixed blessing: "The movie
would not have been made had he not financed it. So I'm a fan in
that regard. And he proved to be the right person to finance it in
terms of promoting it and advertising it. But he was a crass, vulgar
guy who tried to cut me out of any connection with the movie in
terms of publicity and credit and fame." And, down the road, he
would try to chisel Turman out of his profit participation share.

Such are the ways of Hollywood, and Levine played the game
as well as anyone. But he also, as Turman acknowledges, was smart
about selling his product. He knew that college students like
me—inclined toward rebellion against parents and other author-
ity figures—would be ripe for this film's messaging. That's why
his press book prominently reminds exhibitors that "college news-
papers, where possible, should be considered as an integral part
of all advertising and publicity campaigns." Later, he would pay
Nichols and Hoffman to tour college campuses across the nation
in order to help drum up word of mouth. He would capitalize on
the release of a Simon and Garfunkel soundtrack album, as well
as on the reissue of Webb's novel in a Signet paperback edition. Its
cover would be embellished by the film's leg logo and emblazoned
with a provocative new blurb, far less somber than the one that
had promoted the hardcover edition. It touted *The Graduate* as

"the zany misadventures of a well-heeled young man who gets a thorough postgraduate education from a worldly woman. Now a Mike Nichols–Lawrence Turman Motion Picture."

Levine was canny enough to recognize that young people and their discontent would be the key to marketing *The Graduate*. The bright-eyed, well-groomed "Twenty-five and Under" who had been named *Time*'s "Man of the Year" back in January 1967 was rapidly being replaced on the American scene by a much shaggier, much angrier member of the Baby Boom generation. Singer-songwriter Janis Ian, in her 2008 autobiography, relates heady memories of the huge pot-infused, acid-powered countercultural gatherings (like San Francisco's Human Be-In and New York's Central Park Be-In) that started up early in that very same year. In Ian's recollection, "You knew who your friends were by the way they dressed and the length of their hair. Not since the French Revolution had youth held such power, and we were just beginning to flex our muscles." She further added, with the hindsight of 2008, "It's hard, in this day and age, to realize how divisive things were in 1967. The country was already polarized by Vietnam and the civil rights movement; people like me split it still further. The world was divided into 'us' and 'them.'"

Larry Turman and Mike Nichols had never thought of their film as an exploration of what was starting to be called the Generation Gap. Nor did they ever view the tale of Benjamin Braddock as reflective of any particular era. Said Nichols in a 1968 interview for a British film journal, "It just seems to me that whatever is in the picture about living your life and making certain choices, applies to more than just people of a certain age. *The Graduate*, as far

as I could make it, is about my own age also and I'm 36." Still, the film was released at a time when American culture looked to be coming apart at the seams. Idealistic concerns about racial inequality (exemplified by Janis Ian's own "Society's Child," a hit ballad about the taboos of interracial romance) were giving way to bloody riots in the ghettos of Newark and Detroit. The newly founded National Organization for Women was starting to get Americans thinking about a profound shift in traditional gender roles. The enormous University of California system was being rocked (how well I remember!) by incoming California governor Ronald Reagan, whose crackdown on campus dissent paved the way for a host of accelerating clashes between students and administrators at colleges across the nation. In August, Abbie Hoffman and his colorful band of pranksters created pandemonium by showering dollar bills onto the floor of the New York Stock Exchange, thereby (in the name of a group that would soon dub itself Yippie!) expressing young people's impudent contempt for the materialism of their elders. But of course the biggest issue for American youth was 1967's rapid escalation of the Vietnam War, which brought on acts of draft resistance that were passionate and sometimes violent.

Whatever their level of activism in 1967, young Americans went to the movies. Although Hollywood continued to trot out lighthearted fare (this was the year of *Thoroughly Modern Millie* and Disney's animated *The Jungle Book*), the disappearance of Production Code strictures encouraged some in Hollywood to look to the bold films of Europe for their inspiration. This was the decade when college students like me discovered art-house

cinema, which did not shy away from sex, stylistic experimentation, or intellectual rigor. The impressive American box office for Antonioni's English-language *Blow-Up*, a film blending frank nudity with baffling metaphysical conundrums, suggested changing times. *Blow-Up* was first seen by a puzzled Hollywood press corps on December 14, 1966, which coincidentally was the night before the death of the legendary Walt Disney. We fervent young moviegoers had grown up on Disney confections in theaters and on television, but now we were ready for more challenging entertainment that took on the world as we knew it.

By 1967, Hollywood itself was slowly starting to broach subjects central to the American experience. To be honest, several mainstream hits addressing the nation's racial divide—among them *In the Heat of the Night* and *Guess Who's Coming to Dinner*—were not overwhelmingly daring in their conception and execution. But *Bonnie and Clyde*, though at first almost buried by the brass at its releasing studio, Warner Bros., ultimately galvanized young audiences who had never seen the impact of violence treated so creatively and so frankly. Given the generational stresses in their own lives, many youthful moviegoers identified with attractive young outlaws Bonnie Parker and Clyde Barrow in their no-holds-barred assault on the status quo. Viewers of my age also accepted as one of our own Paul Newman's rebel-without-a-cause title character in 1967's *Cool Hand Luke*, who fell victim to society's failure to communicate.

December 1967 brought with it the usual glut of family-friendly movies, including an elephantine Rex Harrison musical, *Doctor Dolittle*, billed as "Twentieth Century-Fox's Christmas

Present to the World." Other December releases ranged from a stunning but grim real-life drama, *In Cold Blood* (not exactly holiday-appropriate) to a sex-and-drugs soap opera, *Valley of the Dolls,* that today is adored in some quarters as a camp classic. *The Graduate* was slated to open very late in the year. Prior to the official opening, industry insiders had their chance to see what Turman and Nichols had wrought. Levine's New York friends were not impressed. Nor was the invitation-only crowd at the Directors Guild in Hollywood. Dustin Hoffman clearly remembers hearing from Turman that Hollywood mogul types had pronounced the film brilliant, "if you hadn't miscast the lead."

There were, though, two sneak previews for the general public. The first, in Chicago, went well, though Sam O'Steen had to eject the burly crew guy assigned to run the volume control because he'd shown up dead drunk. The following night, the *Graduate* gang screened their movie on New York's Upper East Side. The huge Loew's auditorium at Eighty-Sixth Street and Third Avenue held nearly three thousand people. It was an evening Mike Nichols would never forget. As he described it to Nora Ephron, "We were showing our work print, with all the splices in it. And I had a box in my lap, running the sound, because we hadn't dubbed it yet. The theater was packed, and . . . I spent all my time saying to everyone around me, 'Is it too dark? Is it too light? Is it too loud? Should I make it louder? Can you hear it? It's too loud now, isn't it?'" Eventually he stopped, shocked by the audience response: "It sort of sounded like a prize fight. I had never heard an audience make that noise before. Laugh like that. Shout like that. Yell like that. And for the last five minutes of the picture they began to

cheer and they didn't stop. And I was very taken aback, and in my own bizarre way, pleased. And then I ran the hell out of the theater." What did he do then? "I went home and got mad at myself that I hadn't stayed."

While Nichols was fleeing out into the night, Dustin Hoffman was accosted in the theater lobby by Radie Harris, longtime writer of the "Broadway Ballyhoo" column for the *Hollywood Reporter*. Pointing her cane at him, she proclaimed, "Life is never going to be the same for you from this moment on." But the real test would come with the film's official opening. This occurred simultaneously in Los Angeles and New York, on December 21, 1967. The L.A. location did not look promising. The desirable venues then were in Westwood Village, home to tens of thousands of UCLA students, but *The Graduate* was stuck with the Four Star, a nine hundred-seat mid-Wilshire stand-alone far closer to seedy downtown L.A. than to the trendy Westside. (The Four Star, built circa 1930 as part of the United Artists chain, later became a Mitchell Brothers porn house and then a Korean megachurch, before being demolished in 2014.) Though *The Graduate*'s inner circle referred to the Four Star as the "Death Theater," we young people somehow found it, and—in an era when popular releases played at a limited number of theaters and tended to stay put for long periods of time—it remained the film's single L.A. home for many months to come.

In New York City, *The Graduate* was booked into both the Coronet Theatre at Fifty-Ninth Street and Third Avenue and the Lincoln Art Theater at Fifty-Seventh Street east of Broadway. The word spread via enticing one-sheets plastered throughout the

New York transit system. A pristine set of three of these original subway posters is today considered a collector's item. The first bears the familiar leg graphic. The second, featuring the photo of our hero as seen standing behind Mrs. Robinson's stockinged leg, announces, "This is Benjamin. He's a little worried about his future." The third contains a snatch of dialogue from the film itself: "Benjamin—do you find me undesirable?" "Oh no, Mrs. Robinson. I think you're the most attractive of all my parents' friends." This third poster, which incorporates a classic shot of Ben and Mrs. Robinson between the sheets, was reportedly ordered removed from buses and subways at the urging of a New York City councilman who worried about the harm being done to public morals.

But of course it was too late. Audiences—mostly young— flocked to watch what promised to be a spicy entertainment.

When the houselights dimmed, and we'd settled back into our upholstered seats, popcorn at the ready, this is what we saw. . . .

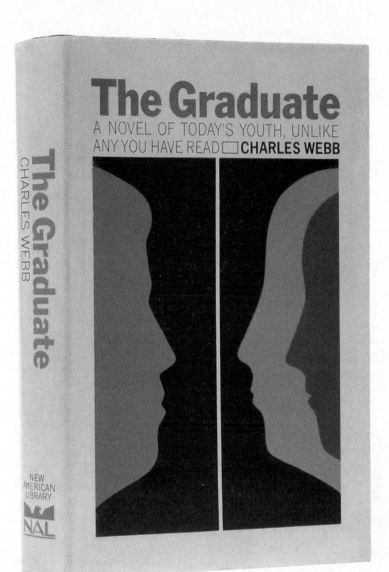

The original 1963 book jacket for Charles Webb's novel *The Graduate*. The cover design is by Milton Glaser, the graphic artist who would soon become famous for his iconic Bob Dylan poster, as well as other images reflecting the popular culture of the 1960s.

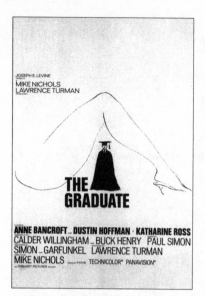

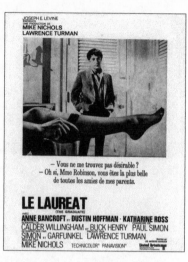

Early movie posters advertising *The Graduate*. CLOCKWISE FROM TOP LEFT: The original poster design; the French poster, incorporating the film's most well-known visual; a Japanese poster emphasizing young love; a publicity shot of Dustin Hoffman studying a poster bearing the bedroom image that was banned from the New York transit system.

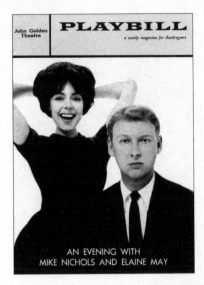

A playbill for the 1960–1961 Broadway hit *An Evening with Mike Nichols and Elaine May.*

Nichols on the set of *The Graduate*, accompanied by production financier Joseph E. Levine.

Novelist Charles Webb (center), visiting the set of *The Graduate*, kibitzes with producer Larry Turman (left) and screenwriter Buck Henry (right).

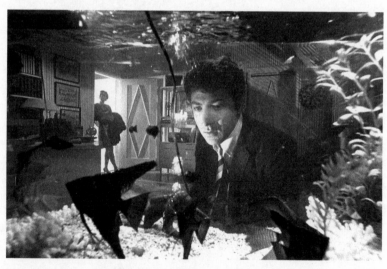

This on-set photograph shows Benjamin Braddock (Dustin Hoffman) as glimpsed through his bedroom aquarium, one example of the film's inventive use of water and glass. Mrs. Robinson (Anne Bancroft) lurks in the doorway, holding her mink coat. The aquarium's tiny diver figure is barely visible.

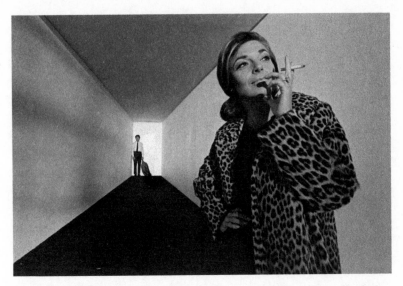

A staged publicity photo, using the oversized hallway built for the scene in which a much-diminished Mrs. Robinson says good-bye to her bedmate. This imaginative shot reduces Benjamin to insignificance, while also showing off the lady's fabulous fur jacket.

In rehearsal, Bancroft and Hoffman find the fun in working out their characters' sexual give-and-take.

PART II

The Screening Room

8

Benjamin Braddock Comes Down to Earth

I just want to say one word to you. Just one word.

What a difference a logo makes! *The Graduate*, in its original theatrical form, opens with a glimpse of a very plain black-and-white emblem, somewhat resembling a Frisbee. This was hardly the sort of bold image viewers of the day expected, like a spinning globe, a lady with a torch, crisscrossing searchlights, or a roaring lion. It was not, in other words, the grand insignia of one of the vaunted Hollywood studios. In 1967, most major American motion pictures still found backing within the legendary studio system. But *The Graduate* announces in its opening moments that it is simply, modestly, an Embassy Pictures release.

Even while we regard the plain-vanilla Embassy logo, our ears

pick up the mechanical sound of an airplane's landing gear locking into place. The camera then shifts into a Technicolor close-up of Benjamin Braddock staring straight ahead, his eyes glazed. (His giant close-ups at intervals throughout the film remind us that this story is very much being told from this young man's perspective.) We discover that Ben is ensconced in an airline seat, among rows of equally lethargic travelers. He blinks into consciousness as an authoritative male voice announces that the plane is beginning its descent into Los Angeles. The local skies are clear, we learn, and the temperature is a comfortable 72 degrees Fahrenheit. This means that fair weather awaits the new graduate as he comes down from the clouds. But returning home is never easy. Now that the high-flying triumphs of his college years are only a memory, Benjamin must reacclimate to the world he had temporarily left behind.

Cut to Ben, neatly turned out in jacket and tie, trailed by his shadow as he steps onto a moving sidewalk at Los Angeles International Airport. His expression is solemn, even shell-shocked. Travelers scoot past him on foot, but he pays them little heed. Instead, his eyes keep darting anxiously upward, presumably toward overhead message boards offering directions. Direction, we gather, is something he sorely needs. He is shown almost entirely in profile, gliding slowly in front of a sterile-looking white tile wall on which will be superimposed, in emphatic black block letters, the movie's main title sequence. But before the credits appear, we're already hearing a familiar acoustic guitar riff, while two intertwined young voices bid a musical welcome: "Hello, Darkness, my old friend." This—along with the repeated PA announcement about

holding handrails and passing on the left—is the soundtrack for our entry into Benjamin Braddock's Southern California.

The mood grows increasingly ominous as Simon and Garfunkel warble about turning a collar to the cold and damp. This familiar lyric from "The Sound of Silence" does not overtly suit a sunny L.A. afternoon. Still, the chilly bleakness of Paul Simon's words hints at Benjamin's suppressed emotions as he faces his homecoming. (We college students of the sixties, returning home from far-flung adventures, knew precisely what he was feeling.)

By the time Simon's songs are acknowledged in the credits, we've shifted our focus to Ben's tidy black suitcase gliding down a slanting conveyor belt, reinforcing our image of Ben himself being propelled inexorably forward on his moving sidewalk. Threading his way through a crowd of preoccupied fellow travelers, he heads toward the doors that will discharge him into the outside air. We see him through the glass of a pair of automatic doors while Lawrence Turman's producer credit flashes on the screen. Just as Simon and Garfunkel begin to wail about words falling like silent raindrops, an automated voice solemnly intones, "Parking in this area is limited to three minutes only. Please do not leave your car unattended." For Southern Californians of the late sixties, this had already become a familiar litany, both a reminder of the region's burgeoning car culture and an apt sampling of the petty annoyances of local life.

Meanwhile, Benjamin is suddenly fixing a broad smile on his face and tentatively raising his right hand in a gesture of greeting. Dustin Hoffman recalls that during the filming of this scene, it took a number of tries to capture the mixed emotions of the

instant when, through the glass walls of the baggage enclosure, Ben spots his parents' luxury sedan pulling up. We don't see the car itself, but it's clearly ready to transport the graduate back (through the gridlock of L.A. traffic) to his childhood haunts. At this precise instant, new words come on the screen: DIRECTED BY MIKE NICHOLS. And Simon and Garfunkel arrive at the last line of their song, signaling that Ben—having survived such dehumanizing forces as airplanes, mechanical walkways, conveyor belts, automatic doors, and repetitive public address announcements— is now at last truly homeward bound, come what may.

As THE VOICES of Simon and Garfunkel fade away, the very next shot is a straight-ahead close-up of Benjamin, deep in morose contemplation, in front of a large bedroom aquarium full of languid tropical fish. His chatty father intrudes on his aquatic solitude to tell him that the evening's guests have arrived. Benjamin, though dressed in party attire, tries explaining that he needs to be alone to mull over his future. In a word, he wants it to be . . . *different*. But Mrs. Braddock's sudden arrival with the news that the Carlsons have driven all the way from Tarzana to greet the new graduate puts an end to such philosophical musings. This is a family that places a high value on social connections. As the three descend the staircase, Mrs. Braddock is busily straightening her son's jacket collar and patting down his cowlick, signifying both her affection for her young prodigy and her concern about keeping up appearances.

At the base of the stairs Ben quickly finds himself in a feeding frenzy, surrounded by gaudily dressed middle-aged women. In

their shimmering finery, they encircle him like a school of fish eager to swim in his wake. Their husbands too seem impressed, both by Ben's accomplishments and by the tangible fruits of his success, like "the little red wop job"—an Alfa Romeo convertible—his parents have lavished upon him as a graduation gift. (Once the film hit it big, an ad hoc group calling itself Americans of Italian Descent hotly protested the ethnic slur, but it remained in place, offering a quick snapshot of the casual arrogance of the Braddock circle.) A hearty fellow named McGuire pulls Ben poolside for a Dutch-uncle conversation about the road ahead. With all the solemnity of an oracle revealing to a young acolyte the secrets of the universe, Mr. McGuire intones two magic syllables: "Plastics." This, from McGuire's perspective, is where the future lies. Ben earnestly promises to consider the elder's sage advice, but it's clear to viewers that this is hardly the "different" future about which he's been dreaming. As more guests rush to embrace him, he flees toward the sanctuary of his own room.

Benjamin feels, we gather, like some exotic but glassed-in sea creature, placed on exhibit to dazzle his parents' friends. His childhood bedroom is decorated with pictures and models of airplanes, suggesting a boy's-eye view of high-flying freedom. But there's also that fish tank: Its small-fry occupants (much like Ben himself) swim in a confined space for the delight of larger folk. Benjamin, trapped inside his personal aquarium, is not hearing the mermaids singing, each to each. Instead he's literally gasping for air—but he *does* hear his door open, and suddenly Mrs. Robinson stands before him.

She claims to be looking for the bathroom, but quickly makes

herself at home, discombobulating Benjamin by lighting a ciga-
rette and—in the absence of an ashtray—casually flicking her
burnt-out match onto his bedspread. Says she, in amused re-
sponse to his obvious discomfort, "Oh, I forgot. The track star
doesn't smoke." While he's awkwardly rustling up a wastebasket
for her use, she quizzes him about why he seems so upset. Her
question hints that she's perceptive in ways that the Braddocks'
other guests are not. And the fact that she wonders aloud about
his possible romantic crisis—"Is it a girl?"—suggests that she's
once again found the means to make Ben feel very young and
very inexperienced. He's also, from the look of his clothing and his
immaculate room, a habitual neatnik. Her cigarette is defiling
his private space, insinuating a disturbingly unclean element into
his pristine surroundings.

Now Mrs. Robinson has a request: She wants him to drive her
home. He resists, instead proffering the keys to his new car so that
she can drive herself. But he feels the need to ask, "Do you know
how to work a foreign shift?" The question indicates his genuine
naïveté: Someone of her generation (assuming she's about forty
years old in 1967) would most certainly have learned to drive on a
car lacking automatic transmission. But she's conniving enough to
shake her head sweetly, indicating that a "foreign shift" is beyond
her skill level. As a polite young man, one who continues through-
out the film to address grown-ups as "Mr." and "Mrs.," Ben can't
bring himself to abstain from helping a damsel in distress. "Let's
go!" he says, whereupon she startles him by deliberately pitching
his key ring into the aquarium, toppling its tiny frogman figurine.
The result: He must roll up the sleeve of his crisp white shirt for

a brief fishing expedition. It's the first strong hint that this elegant lady is capable of surprises. Through the glass of the fish tank, we see them leave, but the little deep sea diver has been felled for good.

THE HEADLIGHTS OF Benjamin's sports car split the darkness as he pulls up in front of Mrs. Robinson's spacious home, with its glowing porch lamp and wide front lawn. Yet again, Ben finds himself the victim of his own well-mannered upbringing. Bowing to Mrs. Robinson's tacit expectations, he hands her out of his car, and then is easily persuaded to escort her to the sunporch, with its well-stocked bar. Once she has thrust at him an unwanted bourbon on the rocks, flicked on the stereo, and made it clear that her husband will not be back for hours, Benjamin finally gets the picture. That's when she coquettishly lifts one shapely leg onto an adjoining stool, allowing her short skirt to ride high. He's framed by that arched leg as he splutters, "Mrs. Robinson, you're trying to seduce me. . . . Aren't you?"

Her strategy here is to laugh, gently scolding him for leaping to naughty conclusions. Which prompts him to plunge—polite boy-man that he is—into a series of abject apologies: "Mrs. Robinson, will you forgive me for what I just said? . . . It's the worst thing I ever said to anyone." His apologies continue while she takes him upstairs to see daughter Elaine's portrait, asks him to unzip her dress, and accuses him of the unthinkable: "Would you *like* me to seduce you?" As his discomfort level rises, she veers between amusement and flashes of anger. Throughout, there's a nagging sense that she's not a sexual predator so much as an all-powerful

mother, mercurial in her demands, while he's a well-meaning but baffled son. During the rehearsal period, Mike Nichols had required his actors to improvise a two-family barbecue at which Ben is a prepubescent boy and Mrs. Robinson a glamorous young mom. Something of that intergenerational dynamic animates the give-and-take of this sequence.

Still trying to mollify his father's partner's wife, Ben dutifully brings her gold clutch bag upstairs and deposits it in Elaine's bedroom. Then he spots, reflected in the glass fronting Elaine's virginal portrait, Mrs. Robinson's undraped body. She has entered the room stark naked, boldly offering herself to him. He panics, especially because a squeal of tires has just announced the arrival of the master of the house. When Mr. Robinson makes his entrance, toting a golf bag, Ben is perched on a bar stool, desperately trying to look at ease.

Mr. Robinson's ruddy face, labored breathing, and confident swagger (not to mention his noisy arrival) all hint that he's had more than a few at the nineteenth hole. He's delighted to see Ben, whom he jovially thanks for taking his wife home and for "standing guard over the old castle." (Does he mean, by this flippant reference, his house or his spouse?) Insisting that Ben join him in a nightcap, he asks, "Scotch?" Then, totally ignoring Ben's request for bourbon, he proceeds to pour Ben his own drink of choice. This small gesture reinforces a major motif throughout the film: the failure to communicate, especially between the generations. During the evening of Benjamin's homecoming festivities, Ben has endlessly been assaulted by adults (his parents, Mr. McGuire and the party guests, the Robinsons) who address him enthusiastically, then don't bother to listen to what he has to say.

Instead, Mr. Robinson launches into his own form of advice. His theme: "You'll never be young again." Doubtless hinting at his personal long-term regrets, he sucks on his cigar and advises that Ben "sow a few wild oats, take things as they come." He's endorsing, in other words, the kind of slacker lifestyle we'll see from Ben later in the film, with all-too-dramatic consequences.

By way of urging Ben to develop a social life, Mr. Robinson announces that his daughter, Elaine, will be home from Berkeley soon. Ben promises to phone her, then quickly marches away from the house as the Robinsons stand together in the doorway, with Mr. Robinson's arm possessively encircling his wife's shoulder. As far as he's concerned, she's all his. But she calls after Ben, "I'll see you soon, I hope." Her words sound casual, but there escapes from Ben's lips another of those plaintive little yips that signify his confusion and stark terror.

9

Getting In
Over His Head

*I think you're the most attractive of all my parents' friends.
I mean that.*

On a bright Southern California summer day, we're in the family backyard, and Mr. Braddock (dapper in shorts ensemble, jaunty hat, and sunglasses) is alerting the deeply tanned guests around the swimming pool that it's time for the afternoon's feature attraction. As his wife beams approval from her post at the barbecue grill, Mr. Braddock makes like a circus ringmaster, asking the assembled for a big round of applause "to bring this boy out here. No, wait a minute—let me amend that. To bring this *young man* out here, because today he is twenty-one years old!"

So Benjamin, crossing the magic threshold into adulthood, is expected to celebrate by performing for his parents' friends.

He's reluctant, but his father plays on his ingrained willingness to please, hissing, "You're disappointing them, Ben." Again the ringmaster voice: "Let's hear it now for . . . Benjamin Braddock!" At which, the kitchen door swings open, and there—between the up-to-date cooktop and side-by-side refrigerator—stands Ben in full frogman regalia, including mask, breathing apparatus, and diving spear. In his rubber swim fins he awkwardly flaps his way toward the pool. As his proud parents beckon him forward, the camera shifts into Ben's perspective, looking outward through the faceplate of the diving mask. And the audio track is dominated (three months before the same stylistic trick was featured in *2001: A Space Odyssey*) by the mechanical sound of his filtered breathing, completely shutting out the excited chatter of the poolside crowd.

With a splash, Ben enters the water. Still in his perspective, we see (but do not hear) his parents laughingly shoving him beneath the surface. They're not trying to drown their wonder-boy, but merely showing off his scuba gear, an expensive birthday gift that allows them to underscore both their love for their son and their easy affluence. Suddenly there's a shot of Benjamin standing at the bottom of the pool, spear in hand, looking for all the world like the tiny diver in his bedside aquarium. The camera slowly retreats until we see him full figure, surrounded by the sun-spangled blue water that separates him from his eager admirers. This is isolation of the most visual sort. No wonder, after this humiliating display, that he seizes the bait offered by the one person in his life who represents a departure from the grotesque camaraderie of his family circle. His parents' good-natured penchant for treating him

as their trophy son has had the perverse effect of goading him to strike out on his own.

While his diving-suited self is still on camera, we hear him hesitantly making a telephone call to someone who offers a more adult form of recreation.

From a telephone booth at the stately Taft Hotel, a nervous and *verklempt* Benjamin has phoned Mrs. Robinson, awkwardly offering to buy her a drink. Leaving the booth, he takes a drag on a cigarette, a quick clue that the former track star has changed his clean-cut ways. While the folks at home insist on infantilizing the new graduate, Mrs. Robinson's blend of sexual allure and a mother's talent for emotional manipulation has clearly made him rethink his core values.

As he approaches the Taft's lobby, Ben politely holds the door for what turn out to be two dozen graying oldsters, all gussied up (lots of corsages and fur stoles) for a formal shindig. Before he himself can enter, he is brushed past by several festive young couples in prom attire, chirping excitedly about their night on the town. This is the circle of life, SoCal style, with Ben tacitly feeling himself disconnected from all the others. Then a desk clerk with a carnation in his lapel rattles his nerves by inquiring, "Are you here for an affair, sir?" Under the silent scrutiny of this clerk (played by screenwriter Buck Henry with just a hint of a sneer), Benjamin tries to camouflage his intentions by attaching himself to an innocent social event. But by ducking into the receiving line for the Singleman bash in the main ballroom, he once again finds himself uncomfortably out of place.

Director Mike Nichols has taken special pains to make Ben's encounter with the Singlemans a singular one. Just inside the ballroom, Benjamin is stopped in his tracks by a welcome committee headed by Mrs. Singleman, played with gusto by veteran comic actress Alice Ghostley. She makes the most of her few lines, vainly searching the guest list for the name Braddock and then brightly suggesting, "Not Braniff? We *have* a Braniff!" While a flustered Ben is mistaking young Jeffrey Singleman for the paterfamilias, additional humor derives from the presence of the charmingly befuddled Marion Lorne, playing Mrs. Singleman's spinster sister. Though it's dawning on the rest of the Singleman group that Benjamin is an interloper, Lorne sends him on his way with a cheery "I've enjoyed meeting you, Mr. Braniff." This is well-played comedy, but it also makes a thematic point. Since he's returned from college, Benjamin's identity has been in flux, and he's simply not sure who he is, or how he fits into the larger social picture.

Beating a hasty retreat from the ballroom, Ben enters the Taft's cocktail lounge, where cheesy tango music tinkles in the background. Tropical foliage behind glass makes the room look something like an extension of the Robinson sunporch. When Mrs. Robinson appears, resplendent in a leopard-skin jacket, we first spot their dual images upside down in a glass-topped table, upon which rest Ben's highball and an ashtray full of cigarette butts.

With the arrival of Mrs. Robinson in the cocktail lounge, Benjamin finally has a purpose, but it's not one he's entirely ready to embrace. The distinctive cinematography of Robert Surtees (with its emphasis on reflections and odd angles) clues us in to the fact that Benjamin is literally feeling quite upside-down about

the step he's about to take. Perhaps they should just chat? Here's
where Mrs. Robinson takes charge. Despite that leopard coat well
befitting a jungle feline, she doesn't at first come across as a female
on the prowl. Instead, she reverts to her other role in life, that of a
mom schooling a growing child in the ways of the world. There's
a hint of maternal compassion in her voice when she murmurs,
sotto voce, "You don't have to be so nervous, you know." Benjamin
can't get the busy waiter to take her drink order? She shows him
how it's done. He hasn't booked a room? She gently nudges him
into action. When he rises, bumping their table on his way to the
reception desk, the expression on her face is easy to read. She finds
his youthful clumsiness wholly endearing.

Next comes another fumbling encounter with that same unc-
tuous desk clerk. After a false start, Benjamin tries to tweak his
identity by adopting the name "Gladstone" when he signs the reg-
ister. Stopping the clerk from summoning a bellhop to retrieve his
nonexistent luggage, he succeeds in booking a room for himself
and his toothbrush. To inform Mrs. Robinson, he again phones
her from the lobby, obsessing over the clerk's possible suspicion
and agreeing to a plan whereby the two of them will separately
make their way upstairs. (Benjamin may be about to violate the
laws of social propriety, but it's not yet in his nature to do any-
thing brazen.)

When both finally hang up, there's a tender smile on her lips.
Through the glass wall of the lounge Mrs. Robinson has been
watching her conquest speaking to her from a glassed-in telephone
booth. This is hardly the first time in the film we've seen Benjamin
associated with transparent enclosures—a tropical fish tank, the

mask of a scuba suit—that underscore his sense of isolation from the world around him. Mrs. Robinson is plainly not irked by his eccentric stabs at ensuring privacy. Instead she seems both proud of Ben's efforts and amused by his naïveté. No matter, then, that it falls to her to cover the bar tab he's left behind.

HAVING MADE A show of entering the lobby with his toothbrush, yawning hugely, and wishing the desk clerk a good night, Benjamin approaches his destiny in the form of Room 568. We see him inexorably moving toward us, in a dramatic wide-angle shot, along a dimly lit corridor that seems both ominous and covertly sexual. He's breathing audibly as he enters the room, switches off its light, then methodically shutters its several windows. (Darkness, he hopes, will be his friend.) He next moves to the bedside table, where he quickly deposits in a drawer a mysterious something that Mike Nichols has identified as an entire tin of condoms. After this, he retreats into the bathroom and—as if to justify the whole toothbrush discussion with the desk clerk—proceeds to vigorously scrub his teeth. (For him at this crucial juncture, cleanliness still remains a virtue.) Just as he's emitting one more of those nervous little yips, there's a businesslike rap on the door.

Mrs. Robinson enters, glances around, and flicks on the light. Benjamin, though, promptly turns it back off, foreshadowing the play of light and darkness in the later scene wherein Ben will insist that sex be preceded by an actual conversation. At the current moment, however, he's not much interested in talking. He strides across the room to where Mrs. Robinson is smoking a cigarette, clears his throat, and leans in for a romantic kiss, only to discover

(in a bit of shtick reminiscent of a Nichols and May routine) that her mouth is filled with smoke. Briefly she tries to keep up the teacher/pupil relationship, stipulating (when he doesn't know how to respond to her plan to disrobe), "Why don't you watch?" Now that they're alone together, it's clear she's impatient to move beyond mentoring and get to the action. But Ben's having a hard time taking the initiative. When she requests a hanger for her jacket, he agonizes over whether to choose wood or wire. When he boldly grabs her breast, she's too busy rubbing at a spot on her blouse to take notice. Thoroughly discouraged, Benjamin moves away and begins banging his head against the hotel-room wall.

This comic byplay came straight out of the rehearsal period, when Mike Nichols quizzed Dustin Hoffman about his own early moments of sexual embarrassment. In a video conversation marking the film's twenty-fifth anniversary, Hoffman relates how he'd described to Nichols the junior high school gambit of trying to "accidentally" touch a girl's breast while putting on his jacket. (He failed miserably at this, and was laughed at by his intended target.) Elsewhere he says he evoked for Nichols the memory of a "sweater feel" backstage during a junior high school talent show, in which young Dustin was scheduled to play the piano and a female classmate was waiting to perform an Al Jolson tribute in blackface. For fear of smudging her makeup, he couldn't risk a kiss, but reached instead for her budding breast. Discussing this indelible episode with a series of journalists years later, Hoffman unconsciously demonstrates how recollections of things past are not always to be trusted. In some tellings, his advances were welcomed by the young lady; in others his clumsy manhandling (or,

rather, boyhandling) of her breast was firmly rebuffed. At least once he recalled to a film historian that *he* was the one wearing blackface.

At any rate, during rehearsal of the scene leading up to Ben and Mrs. Robinson's first sexual intimacy, Nichols privately suggested to Hoffman that he try emulating his younger self by pawing one of the breasts of his leading lady. Given no advance warning, Bancroft responded in character by paying more attention to the state of her clothing than to her suitor. To prevent himself from laughing, Hoffman turned his back and thunked his head against the wall of the rehearsal space. Much amused, Nichols told him to keep the moment in the film. And so he did.

After the head-banging, Ben tries to call the whole thing off, plaintively evoking matters of morality and his parents' certain disapproval. As a young man accustomed to making his elders proud, he remains uneasy about the thought of sexual mischief. Perhaps, he suggests, there's something else they can do together in the dark: "Mrs. Robinson, would you like to go to a movie?"

It's then that Mrs. Robinson takes control. She gently asks a key question: Is this his first time? The Benjamin of Charles Webb's novel had sexual experience aplenty: The reader learned that he had casually bedded prostitutes on the road trip that was cut from the screenplay early on. In the film version, it seems obvious that Ben, for all of his campus achievements, has had little in the way of intimate connections with the opposite sex. His masculine pride, though, is clearly injured by Mrs. Robinson's line of questioning. Shrugging off his loud indignation, she turns sympathetic, suggesting that since this is his first time, nervousness

is nothing to be ashamed of. After all, "just because you're inadequate in one way . . ."

With this casual but calculated challenge to his manhood, she's finally hit home. Mothers, of course, well know how to goad discombobulated kids into action. Now Benjamin is finally ready to rise to the occasion. "Don't move," he commands, and heads for the bed. Just before the fade to black, we see a look of triumph in her eyes. Mom has won.

10

Chillin'

How about art?

A black screen—hello, Darkness!—gives way to a brilliant shot of sunshine dappling aquamarine water. As Simon and Garfunkel sing of visions left behind in sleep, we catch a glimpse of a deeply tanned Benjamin Braddock, his eyes shielded by black sunglasses, dozing on the diving board of his parents' backyard pool. His sun-kissed image dissolves into more shots of sparkling blue, and then he reappears, supine on a pool raft, holding a can of beer that he hoists to his mouth for a languid sip.

This, the film's most surreal section, has something of a phantasmagoric Fellini quality. It contains no dialogue, but is scored with great precision to familiar Simon and Garfunkel tunes. Following the close-ups of Ben floating on the water, the camera pulls

back to include a view of his parents, busy as always, preparing their barbecue grill for a poolside meal. Ignoring their presence, Ben alights from his raft and exits the pool. As he approaches the house, he shakes off the water droplets still clinging to his torso and pulls on a white dress shirt. In the next instant, he's emerging from the bathroom at the Taft Hotel, wearing that same shirt, now fully buttoned. Passing Mrs. Robinson, who's facing away from him as she shucks off her jewelry, he silently lies on his back on the white-sheeted bed. Now she, in black brassiere and jungle-print slip, is bending over him, unbuttoning his shirt and appreciatively rubbing her hands over his smooth brown chest, while he barely bothers to glance in her direction. The point, of course, is to show Benjamin Braddock passing his summer in a state of perpetual lethargy, in which sex and swimming-pool lounging meld into a single continuous fever dream.

The scene imperceptibly shifts to Ben's home, where (still in that same clean white shirt) he lazily rises from a sofa to head for the kitchen. There, through an open doorway, he spots his parents enjoying a light meal, complete with candles, wine, and flowers. Recoiling from their intimacy, he closes the door as they look up with concern. Paul Simon's lyric captures Benjamin's jaundiced view of the world, in which idle social chatter obstructs genuine communication. But Ben, indulging in his own postadolescent funk, is contributing to the sound of silence. Having shut out his parents, he returns to the cozy family den with its Americana touches and settles in front of the television set, the mid-twentieth-century American's classic method of tuning out any form of life beyond himself.

As he leans back, "The Sound of Silence" segues into the slightly perkier "April Come She Will." It's a tender, romantic ballad, one that traces a love affair from spring to fall, giving a hint of the passage of time. In Southern California, though, summer seems eternal. Ben is still watching television, beer can in hand, but now he's in bed at the Taft Hotel. Mrs. Robinson repeatedly crosses in front of the TV screen, first in lingerie, then while slipping on her blouse, then fully dressed in a dignified, dark suit that represents her chosen public persona. She exits the room without looking back. As Ben puffs on a cigarette, it gradually becomes clear that he's been transported to his own boyhood bedroom. He rouses himself and prepares for a swim, yet another plunge into the waters of oblivion. In the downstairs hallway he passes his mother (dressed in pristine white) fussing with an arrangement of white carnations, but he can't be bothered to offer a greeting. While she watches her son head away from her, Benjamin mounts the diving board, splashes into the blue water, then slides onto the pool raft that magically transmogrifies into Mrs. Robinson's embrace. This startling juxtaposition signals that in both halves of his life he remains adrift, cut off from true human contact.

Though the lady on the bed seems uncharacteristically blissful, Benjamin's face—as always—is a blank.

Mr. Braddock, apparently walking in on his son's sexual tryst, is in fact standing poolside, staring down at Benjamin on his raft. From Ben's perspective, his father looms large, backlit by the afternoon sun. No longer the jovial master of ceremonies, he's now a stern authority figure, demanding to know what's going on in the life of his prize-winning offspring. When Ben admits that he's

no longer considering graduate school, Mr. Braddock asks tartly, "Would you mind telling me, then, what those four years of college were for?" Ben replies (in a defiant Buck Henry phrase that sums up the feelings of many a graduate), "You got *me*."

It's worth noting that the Braddocks seem never to have tried to dictate Ben's career path. Numerous parents in my era were quite up front when it came to wanting to brag about "my son the doctor" or "my son the lawyer." Since Mr. Braddock is a attorney himself, he doubtless would like to see his son and heir join the family firm. (My own dad, who managed against great odds to put himself through law school, did a good deal of arm-twisting in trying to persuade his stubborn daughter to follow his lead.) To their credit, the Braddocks have embraced their son's apparent preference for the more austere life of a scholar. The Halpingham award for graduate study has validated Ben's choice of profession. But now that they're proud of his status as a bona fide intellectual, he's suddenly decided to chuck the whole thing. How's a parent—especially one who's been footing the bill for an expensive education—supposed to feel?

Mr. Braddock's rising fury is stifled by the appearance of his wife, who announces an impromptu visit from the Robinsons. Now both couples are towering over Ben, their faces obscured by the brilliant sunlight. It's an apt picture, from a young man's perspective, of the older generation looking down on the new adult. Ben's mother blithely chirps, "Say hello to *Mrs.* Robinson, Benjamin." He and she exchange stiff greetings. Her eyes concealed behind oversized sunglasses, Mrs. Robinson stares straight ahead. Her tone is cool, even frosty. It's hard to imagine that these two, Mrs. Robinson and Ben, have anything at all in common.

MRS. ROBINSON'S IMAGE dissolves into that of Benjamin, always careful about his physical appearance, shaving in a befogged bathroom. The door opens, revealing a woman in a filmy black peignoir, waving away clouds of steam. At first the intruder looks to be Mrs. Robinson, because black is decidedly her color. But instead it's Ben's mother, come to quiz him about his late-night sorties. Her hairstyle in this scene, her bared shoulder, and the fact that her garb is a departure from her usual shades of white all remind us of her position as Mrs. Robinson's opposite number. The two women may be worlds apart in their behavior toward Benjamin, but in age and social status they could be twins. Dustin Hoffman remembers being advised by Mike Nichols to think of Ben in the film's sex scenes "as having an affair that's almost incestuous." So his mother's presence in this intimate setting underscores a key fact: that in sleeping with Mrs. Robinson, Benjamin is still in bed with his parents' generation, in more ways than one.

Like Mrs. Robinson on the prowl, Mrs. Braddock is fully versed in mom strategies. There's no question that she feels a loving bond with her son and that she's seriously worried about his mysterious behavior. At first she's gently apologetic about meddling: "You don't have to tell me if you don't want to." Then, when he proves evasive, denying that his late-night forays involve anyone other than himself, we see a flash of anger: "It's your business—I won't play games with you." Finally, inevitably, she pulls out the guilt card: "I don't want to pry into your affairs, but I'd rather you didn't say anything at all than be dishonest. Good night." It's enough to get under Benjamin's skin, leading to second thoughts that quietly advance the plot by pinpointing his dissatisfaction with his loveless love affair.

THIS IS A young man who may yearn to live his own life but would never choose to overtly displease his mother. As Mrs. Braddock turns her back and leaves him to his own devices, he shouts after her, "Wait a minute!" Then he says in a softer tone, "Will you wait a minute, please?" and we recognize that we've jumped to the familiar guest room at the Taft Hotel, its only light filtering in through half-opened blinds. The bedside lamp flicks on to reveal Benjamin leaning across the sheet-draped body of Mrs. Robinson and asking, "Do you think we could say a few words to each other *first* this time?" Her blunt response: "I don't think we have much to say to each other." And off goes the lamp again. In chiaroscuro we watch Ben's shadow arise from the bed to begin adjusting the blinds, letting more light into the nearly black room. This play of light and darkness, mirroring the pattern of white-and-black décor seen throughout the film, suggests many things: day and night, truth and lies, secrets that are hidden away and then belatedly come into view.

The room's light, though, is not enough to reveal bared private parts. Despite all the frank sexuality built into the script, both Bancroft and Hoffman remain essentially shielded from our gaze both by bedsheets and by careful camera framing. To a large extent, of course, this is a nod to the unwritten rules of the period: Though Hollywood's standards of screen modesty were evolving, *The Graduate* could never be mistaken for a European art film of its day, in which buttocks and bare breasts were a familiar sight. But there's also a symbolic point to the concealment. The bodies of the two lovers remain hidden; so do—more importantly—their souls.

By asking for a conversation, Ben is making a stab at uncov-

ering the inner life of his paramour. In darkness she proposes a topic—art—but then stonewalls further discussion. Finally, he thinks to catechize her about how she pulls off her double existence. It's easy, apparently, because she and her husband occupy separate bedrooms. Taking it all in, Benjamin surmises that they no longer sleep together.

So why did she marry him? When she taunts, "Think real hard, Benjamin," he slowly arrives at the startling discovery that, in the language of the day, they *had* to get married, for the simple reason that she was pregnant. The lamp snaps on again. Finally turning to look at her bed partner, she says with some urgency, "Don't tell Elaine." While he's still wrestling with the facts of Mrs. Robinson's social transgression, one that inevitably led in that day and age to a hurry-up wedding, she tries to return to the real (monkey) business at hand. But Ben can't leave the subject alone. He drags from her the fact that Mr. Robinson was then a law student, and Mrs. Robinson was a college student too.

When Ben, continuing to probe, asks what her major was, she rolls away from him. What we see is a medium close-up of her face, a bare-chested Ben resting on his elbow behind her, as she utters a single word: "Art." This choice of major surprises him, given her insistence that she knows and cares nothing about the subject. Finally he ventures, "I guess you kind of lost interest in it over the years." A world of pain washes over her features as she answers with a small sigh: "Kind of." It's the closest we ever come to understanding the anger inside her. Surely, it stems from years of following society's dictates about love, sex, and marriage. A middle-class young woman who had the bad luck to find herself

with child was essentially required, in an era when abortion was still firmly illegal, to trade in her ambitions for the role of a housewife. In Mrs. Robinson's case, it's been a gilded cage, one against which she's been beating her wings for years.

Oblivious, Benjamin presses on, eager to bring to light the sordid doings of his parents' generation. Again she flicks off the lamp, signaling that he's gone too far. But he's already gleaned from her one fascinating detail about the location of the trysts that produced Elaine. In the darkness, he gloats about the banality of it all: "So old Elaine Robinson got started in a Ford!" A Ford is, of course a far cry from Benjamin's own sleek Alfa Romeo. Yet cars of all stripes are important in this film, both as a symbol of Southern California life in the middle of the twentieth century and as a suggestion of the upward mobility that is both a blessing and a curse.

Benjamin's mention of Elaine Robinson shifts the tone of the pillow talk between himself and his partner. When Mrs. Robinson makes it clear that he is not to talk about Elaine, his curiosity is once more aroused. Not used to thinking much beyond himself and his own needs, he demands—like a petulant child—that she explain why her daughter is now a taboo subject. Finally, he resorts to a power play: "Well, I guess I'll have to ask her out on a date and find out what the big deal is." Instantly the lamp clicks on, and she's grabbing his hair, pulling his head back sharply as she threatens, "Don't you ever take that girl out!" The thought occurs to him: "I'm good enough for you but I'm not good enough to associate with your daughter. That's it, isn't it?" Now he's angry. Violently pulling the bedclothes away from her (presumably) naked body, he loudly repeats himself: "ISN'T IT?" She slowly covers

herself once again with the sheet, then looks him full in the eye while she gives him her bitter answer: "Yes."

Most commentators have taken this admission at face value. They see Mrs. Robinson as a woman who loathes herself but still wants to protect her innocent young daughter from harm. I admit this may be true, but there's yet another facet to her determination to keep Elaine out of Ben's clutches. Elaine possesses two things that Mrs. Robinson has long since lost: youth and hope. She may love Elaine, but she also feels profoundly jealous, knowing she can never compete with Elaine's fresh beauty. That's, I'm convinced, what's truly driving her to keep her young daughter and her young bedmate apart.

Benjamin, though, sees only that she considers him unworthy. Stung to the quick, he makes it clear that he's getting the hell out. It falls to her to become contrite, apologizing (for the first time in this film) that she's conveyed the wrong impression about his suitability for Elaine: "I don't think you'd be right for each other. I'd never say you're not as good a person as she is."

This gives him pause. But, standing fully dressed near the doorway to the room, he's surprised to notice she's now sitting on the bed, rolling sheer black stockings up her shapely legs. (They're in the iconic pose reproduced in the poster art and mimicked countless times since.) Mrs. Robinson says, with resignation in her voice, "It's pretty obvious you don't want me around anymore." Now he's the one making amends: "I enjoy it, I look forward to it, it's the one thing I have to look forward to." "May I stay, then?" She asks this humbly, the camera capturing her from Ben's perspective, seated on the bed, looking rather small and fragile.

Yet as soon as he's agreed that he wants her to stay put, she flips back her hair and begins to assert herself once more: "But you won't ever take Elaine out, will you?" Exasperated by the whole discussion, he nonetheless promises. Now they're at opposite sides of the frame; with his back to her, he's starting to remove his clothing once again. She calls his name with surprising tenderness, but he grumpily rebuffs her: "Let's not talk about it. Let's not talk at all." There's a long pause in which she twists away from him and both focus on silently undressing.

So a scene that began with Benjamin's desperate desire for a conversation ends with two people turning their backs on each other. Sexual intimacy, which at its best can be described as nonverbal communication between two bodies and two souls, is reduced here to the scratching of a physical itch. This, the film's most wintry moment, ends with a true sound of silence.

11

The Beast Defanged

Ben, this whole idea sounds pretty half-baked.

And a silence marks the following scene, which takes place not in a dark hotel room but in the Braddocks' sunny white-on-white kitchen. As Ben's mother (again wearing one of her lacy white caftans) scrambles eggs, his father looks up from his coffee and cigarette to note that Elaine Robinson is back from Berkeley: "I think it might be a nice gesture if you asked her out." Both Braddocks eye their son as he sullenly continues spooning his cereal, pretending not to hear.

Cut to the three in the backyard pool. Although autumn must be approaching, it's still swimming weather. Ben, wearing his diving mask, continues trying to isolate himself from parental pressure. Mr. Braddock sounds annoyed, but it's his wife, in an

amusingly petaled bathing cap, who has the last word. Putting her mom-wiles to good use, she laughingly announces, "If Ben absolutely refuses to take her out, then I will simply have to invite *all* the Robinsons over on Thursday." At the jaw-dropping notion of a social evening with Mrs. Robinson in his parents' home, Ben slips from his raft and escapes into the water. His features, as we see them through the faceplate of the mask, wear a haunted look.

DING-DONG! MR. ROBINSON is admitting Ben to his home, but the camera is slowly pushing in on Mrs. Robinson, ensconced on her sunporch. For the first time in the film, she's casually dressed and wearing no makeup, so it's as though we're looking past the veneer and glimpsing her authentic self. With a profusion of tropical plants visible through the sliding glass door behind her, Mrs. Robinson looks something like a cornered jungle animal. But there's an afghan spread across her lap, and we sense that she's feeling chilled. Ostensibly she's watching TV's *The Newlywed Game.* In fact, though, Mrs. Robinson is staring straight at Ben, silently chiding him for having come to take her daughter on a date.

The perennially convivial Mr. Robinson offers Ben (as always, nicely turned out in jacket and tie) what he calls "a short one." He asks, "Scotch still your drink?" but then—as before—seems not to hear Ben's request for bourbon. After chuckling at the connubial silliness on the TV screen, Mr. Robinson goes upstairs to fetch Elaine. His absence allows Ben to whisper to Mrs. Robinson that this date was hardly his idea. She will have none of that: "I'm *extremely* upset about it, Benjamin." Their confab is interrupted by the sudden appearance of a poised young lady in powder pink.

Ben politely rises to greet her, stunned by her wholesome beauty. If Mrs. Robinson suggests the chill of autumn, Elaine is pure springtime. Her matchmaking father offers paternal advice: "I want you to keep your wits about you tonight. You never know what tricks Ben picked up back there in the East." (It's the classic assumption that folks living on the eastern seaboard are far more sophisticated than their homespun California cousins.) Mr. Robinson is jocular here, but the camera remains fixed on his spouse, who radiates quiet fury.

There follows a harrowing freeway ride in Ben's sports car. Elaine, trying hard to be friendly, gets only monosyllabic answers to her questions, the last of which is "Do you always drive like this?" Obviously Ben—for the first time in the film interacting with someone of his own generation—is not the least interested in communicating. Hands in pockets, he strides down L.A.'s flashy Sunset Strip at a rapid pace, with Elaine scurrying to keep up. These are what filmmakers call "stolen shots," taken with a hidden camera, and so the hordes congregating on the sidewalk outside the Whisky a Go Go are not dress extras, but rather actual young people waiting to get into the day's most famous music club. But, tellingly, Benjamin bypasses this popular youth mecca and instead hustles his date into a strip joint.

Elaine is confused and dismayed to be ushered to a ringside table. But Ben, with dark glasses shielding his eyes and a cigarette dangling from his lips, appears to fit right in to this tawdry environment. The stripper shows off her considerable skill at rotating the tassels that cover her nipples in opposite directions. Then

(with the crowd's raucous encouragement) she bends over and lets them brush against Elaine's auburn locks. It's not until Elaine's tears start flowing that Ben makes a belated stab at gallantry. Out on the sidewalk, his native politeness returns: He humbly admits that "I'm not usually like this. I hate myself like this." Suddenly, impulsively, he kisses her, and after a moment she's kissing him back.

We jump to a drive-in restaurant. Elaine, chowing down on a burger and fries, listens intently to what Ben has to say. No longer monosyllabic, he's speaking with passion to someone who seems to share his outlook on the world. As he puts it, "I've had this feeling ever since I've graduated, this kind of compulsion that I have to be rude all the time, you know what I mean?" In between bites of his own burger, he waxes philosophical, explaining that the rules by which the world is run make no sense to him. The words are flowing now, but they're beginning to be drowned out by the roistering young people in the next car. (Some critics of the day referred to them as hippies, but their clothing, their vehicle, and their very presence at a kitschy spot near the UCLA campus all confirm they're hardly that.) When Ben asks his noisy neighbors to turn down the volume on their car stereo, they impudently make it louder still. Not to worry. Ben and Elaine move their food trays inside the Alfa Romeo, roll up the windows, and hoist the convertible top. Enclosed in their own private refuge, while Simon and Garfunkel's hard-driving "The Big Bright Green Pleasure Machine" continues to crank on the soundtrack, they engage in animated conversation. So Ben is once again in a confined space separated by glass from the outside world. For the first time,

though, he's not alone. Instead, he has a lovely young someone to share his solitude.

NOW THEY'RE SITTING in Ben's car in front of the Robinson home. The suburban calm is a far cry from the hubbub of the drive-in, and, for the first time in the film, a genuine smile plays on Ben's lips. He refuses Elaine's offer of a cup of coffee in the Robinson kitchen, but agrees to a drink at the Taft Hotel. Yet Ben is hardly prepared for what happens in the Taft lobby. As he and Elaine make their way toward the Palm Room, every member of the staff—from desk clerk to bellhop to waiter to a tiny messenger in a smart red uniform—familiarly greets him as Mr. Gladstone. (In a comedic callback to the Singleman party episode, Marion Lorne as the befuddled Miss DeWitte hails him in passing: "Hello, Mr. Braniff.") His fake identity, it seems, is now catching up with him.

The two of them quickly return to the car, where Ben's long-submerged emotions finally burst forth: "Elaine, I like you. . . . You're the first thing for so long that I've liked, the first person I could stand to be with. My whole life is such a waste." Elaine is smart enough to intuit that he's having an affair. Sick and tired of secrecy, he admits to a covert liaison with a woman who's married, with a son. Elaine doesn't venture to moralize about something she sees as none of her business. But Ben solemnly swears that it's all over now.

On Elaine's doorstep, they're snacking on the remains of the french fries and whispering about plans for tomorrow. He leaves her in the doorway, then tosses her the bag of fries. (They're both

too young and too healthy to be worrying about empty calories.)
Her amused grin suggests that she is thoroughly smitten.

IT'S THE FOLLOWING day, and Benjamin is driving through a
steady downpour toward the Robinson home. As he approaches
the house, a figure in a black housecoat is seen running across
the soggy lawn toward the passenger door. It's not until she seats
herself next to Benjamin that he and we realize it's a thoroughly
drenched Mrs. Robinson, and she's on the warpath. She lays out
her demand that he never see Elaine again. If he disobeys, she's
ready to make matters quite unpleasant: "In order to keep Elaine
away from you, I am prepared to tell her *everything*." Slamming
on the brakes, he claims not to believe her, eliciting her instant
retort that "you'd better *start* believing me." In this scene, perhaps
more than any other, the complexity of Anne Bancroft's charac-
terization comes through on screen. She may have a sophisticated
air, but—if thwarted—she's going to bare her claws and fight like
a jungle cat for what she considers hers. (According to some who
knew her, Bancroft herself was marked by a similar duality. Dustin
Hoffman was to note on the fortieth anniversary DVD that, de-
spite her elegant way of speaking, "she's Anna Maria Italiano from
the Bronx.")

Now realizing that he's made a dangerous enemy, Benjamin
sprints through the rain toward the Robinsons' front door. Burst-
ing into the bedroom where Elaine is only half-dressed, he urges
her to meet him around the corner. But there's no time for that. As
Mrs. Robinson approaches, he realizes the need to quickly come
clean with the girl of his dreams: "That older woman that I told

you about . . . that wasn't just some woman." Before he can say another word, Mrs. Robinson—soaked to the skin and looking like death itself—becomes visible over Elaine's shoulder. As Elaine follows Ben's agonized gaze, the laughing girl slowly transforms into a horror-stricken young woman, one who shrieks at Ben to get out of her room and her life. The camera concentrates on Mrs. Robinson's face as the door slams behind Ben. Her expression is tragic as she softly murmurs, "Good-bye, Benjamin." Then we slowly zoom out, leaving her a much diminished figure at the end of a long, white hall. (It's the scene for which a special set was constructed, one that dwarfs Anne Bancroft in this climactic moment.) From Ben's perspective, the powerful and sexy woman who was prepared to fight tooth and nail has been reduced to a creature of unrelenting sadness. Her comfortable but empty life, in which her job is to be a decorative addition to her husband's household, has left her with nothing she can truly call her own.

IMMEDIATELY FOLLOWING THE climactic rift between Benjamin and the Robinson family, we hear the familiar strains of a melancholy love song, Simon and Garfunkel's rendition of the old folk ballad "Scarborough Fair." Its chorus, which combines images of war with the haunting reminder of a vanished love, nicely captures Ben's own sense of loss and regret.

At first, over the span of another nonverbal montage, Benjamin seems incapable of anything but mooning and moping. He fritters away the hours in his own room, which (with its striped wallpaper) is starting to feel more and more like a prison cell. Sprawled on his bed, inches from the captive fish in their aquarium, he idly

plays with the ashes of his cigarette, quite a contrast to that early moment when Mrs. Robinson's carelessly discarded match threw him into a tizzy. Then he's cruising the streets of his hometown, secretly spotting Elaine coming out of her house to greet Mr. Robinson, who's busily waxing his late-model sedan. Back in his room, Ben glumly stares out the window at his father skimming leaves from the family swimming pool. The men of the older generation are productively engaged in physical activity. This distinguishes them from Benjamin, the overgrown schoolboy, who can only watch and wait.

Concealed behind a bed of birds-of-paradise, he watches Elaine—in a stylish fall coat and boots—carry suitcases out to the car. She's headed back to Berkeley, with her father at the wheel. Mrs. Robinson, simply dressed in a white blouse and black slacks, emerges from the house to see them off. She steps forward, as if to exchange a few parting words. But the car glides off, leaving her standing alone, thin and haggard, bereft of all human contact. She seems at that moment the saddest woman in the world. The montage and the ballad that underscores it end with Ben loafing at his desk, where he's been struggling to find the words to write Elaine a letter.

IN THE FOLLOWING scene, there's a major reversal. It's early morning. A spruced-up Benjamin, his eyes bright with purpose, is standing in the Braddock kitchen, having just told his father that he's going to marry Elaine Robinson. Now that his life has fallen apart, marriage seems like the perfect solution, and he's heading north to Berkeley to move the process along. Mr. Braddock greets

the news with enthusiasm, and his wife indulges in a delighted mom-shriek. Then reality sets in as they discover that Ben's plans are unknown to his potential fiancée, and that, "to be perfectly honest, she doesn't like me." But, in his typically postadolescent way, Ben is less interested in strategizing than in taking immediate action.

Although, under the circumstances, Ben's gung ho determination to win Elaine may seem juvenile, from this point onward he is transformed from an idler into a man (or at least a boy-man) of action. This makes him substantially different from the polite, passive young graduate who began the film, one who could express his distaste for the rules of his parents' era only by way of covert rebellion. Now, as he speeds up the California coast, he's behind the wheel of his own destiny. Ben's little red convertible, though a graduation gift from his parents, is also a symbol of freedom, of escape from the confines of the adult world. Charles Webb's novel had Ben unceremoniously selling his pricey car to finance air travel between Berkeley and Southern California. But Mike Nichols and Buck Henry understood that a movie hero needs to be self-propelled. Ben's not enough of a social rebel to mount a Harley, and the music that accompanies him as he maneuvers the highways and bridges is the poignant "Scarborough Fair" (and later the jaunty "Mrs. Robinson"), not "Born to Be Wild." But his breezy driving scenes in the latter part of the film convey the kinetic energy of a young man who has discovered the existential thrill of being in motion.

Not every viewer has appreciated the film's tonal shift, and I fully recognize their sense of dislocation. Suddenly *The Graduate*

becomes less a social satire and more a romantic comedy. Now that Benjamin has left his parents' affluent Southern California neighborhood, the world around him is no longer mocked. He may still have his goofy moments as well as his periods of stasis, but the new Ben is driven by a sense of purpose that had previously eluded him. Elaine (whose name is appropriately Arthurian) represents his grail quest, and his goal in life is now to win his lady fair.

Informally dressed, Benjamin roams the leafy campus (USC standing in for the University of California, Berkeley), coming to rest on the lip of a grand fountain. He seems at home here, doubtless connecting this place emotionally with the eastern-seaboard college at which he'd enjoyed lofty triumphs just a short while ago. But he's also notably isolated from the bustle of campus life. There's a long zoom-back featuring Ben as a solitary onlooker, with an empty quad behind him and a stately library building rising in the distance. Then: a quick cut to the same quad filled with the to-and-fro of students. Ben, we suspect, doesn't notice. He's looking only for that special face.

Suddenly he spots Elaine emerging from the library, a few books in the crook of her arm. She's joined by one classmate and then another, indicating that she's part of a social universe in which Ben has no role. (This is also the scene in which Elaine's clothes best reflect the year 1967, because they came from Katharine Ross's own closet: She had worn the rain jacket, leggings, and boots ensemble to work that day.) When she's almost out of range, he chases after her, but in vain. Simon and Garfunkel continue to sing about a lost love, and their blended voices segue into a mournful flute coda.

Next we return, at long last, to a brief dialogue scene. Benjamin is climbing the steep stairs of an old-fashioned rooming house, following closely behind a cantankerous landlord, Mr. McCleery. The fact that Ben is not a student immediately arouses suspicion. McCleery demands to know whether he's "one of those outside agitators. . . . I hate that. I won't stand for it." This represents the rare moment when the film touches on Berkeley's reputation, going back to the Free Speech Movement of 1964–65, as a hotbed of student protest. (My own parents wouldn't have dreamed of letting me attend Berkeley, which they would have viewed as tantamount to handing me over to the forces of anarchy.) Responding to McCleery's paternal insistence that "I like to know what my boys are up to," Ben mildly explains that he's just passing through.

"Scarborough Fair" starts up once again as he shadows Elaine around the Berkeley campus. He watches her from a Telegraph Avenue café as she passes the landmark Moe's Books and steps onto a city bus. Soon he's sprinting along the sidewalk in hot pursuit before finally clambering aboard.

Cut to the Monkey Island of the San Francisco Zoo, where Ben is still tailing an increasingly frosty Elaine. Their non-conversation is interrupted by the appearance of Elaine's date, of whom Benjamin says, "He certainly is a good walker!" The young man in question is tall, blond, tweedy, and smokes a pipe. In fact, he seems to have sprung from the upper-crust WASP environment familiar to the novel's author, Charles Webb. In contrast to the self-confident Carl Smith, Benjamin Braddock looks very small and very much out of place. Elaine introduces them, explaining that Ben rode in with her on the bus. Carl heartily shakes Ben's

hand, then sweeps Elaine off, his arm familiarly draped around her shoulder. (It's easy at this point to remember Mr. Robinson's pose in the doorway of his "old castle," casually demonstrating his ownership of his wife.) Standing in front of a cage with a sign warning visitors not to tease the animals, Ben lowers his head in despair. In an ironic reversal, two monkeys seem to be making a mockery of *him*. Meanwhile, not far away, a large ape who looks like a refugee from Mrs. Robinson's sunporch stares off into the distance. Yet again, Simon and Garfunkel's "Scarborough Fair" captures Ben's woebegone state of mind.

12

Going to
Scarborough Fair

Why don't you just drag me off if you want to marry me so much?

en's at the sink in his Berkeley room, trying to shave.
(He's still not the stereotypically shaggy young late-sixties male enamored of facial hair, though by the
end of the film he may be moving in that direction.) Suddenly
there's a pounding at the door. It's Elaine, and she's soon pacing
the small room like a restless young animal, demanding to know
what he's doing on her turf. Ben, his face slathered in shaving
cream, protests, "Well, look, I love you!" She's hardly convinced:
"How could you do that, Benjamin? Do you just hate everything?
How could you possibly rape my mother?" (Her raw fury here is
far more dramatically interesting than the weepy way two audition
candidates chose to handle this same line.)

In the version of events that Elaine now relates, Mrs. Robinson had been innocently having a drink at the Taft Hotel bar with a friend. Benjamin tricked her into coming upstairs with him, then assaulted her. Elaine's awkward delivery of this tale may signal her outrage and embarrassment. But it may also hint that she can't fully hide her own skepticism about a parent whose conduct has probably given her pause from time to time. Still, she remains firmly on her mother's side. Ben is quick to point out that it happened quite differently. When he gets to Mrs. Robinson offering herself to him in her daughter's room, stark naked, Elaine has had enough: "This is my *mother*, Benjamin!" She lets out a blood-curdling shriek, then flings herself across Ben's bed, like a child having a tantrum. Which, of course, alerts Ben's landlord and his neighbors that something is afoot.

While Ben is fumbling to fetch Elaine a glass of water, McCleery appears, asking what the screaming was all about. An eager under-grad (a young Richard Dreyfuss) is all set to call the cops, but Ben fully opens his door to reveal Elaine, water glass in hand, smiling sheepishly from his bedside. McCleery dismisses his troops but stays to announce that he wants Ben to move out on the double.

Elaine, who by this time seems to have fully gotten past the notion of Ben as her mother's rapist, apologizes for screaming. She wants to discuss their relationship further, but Ben—uncharac-teristically evasive where Elaine is concerned—says, "Right now I don't feel like talking much." He does allow her to sit and watch as he gathers his few belongings in preparation for moving on. Still, as a former star student who's doubtless had no prior run-ins with authority figures, he seems morose and self-absorbed. Under

Elaine's barrage of questions, he admits that he has no intention of going back home, but that his future path is now uncertain.

In the doorway, Elaine surprises Ben by announcing, "I don't want you to go anywhere . . . until you have a definite plan." With that, she's gone. Ben looks after her with confusion, then from his window follows her lithe figure as she runs down the Berkeley street toward her own digs. Cue the sad music. Benjamin's bafflement makes sense here. Elaine began her visit to his room by insisting that he leave town; now she's insisting that he stay. Her mercurial change of mood will turn out to be characteristic of this particular young woman, one who simply isn't sure what she wants out of life. Producer Larry Turman, in discussing with me the character of Elaine, confided that Katharine Ross's role was particularly difficult to play, because "she's the only character in the movie that's passive throughout." But passivity doesn't fully describe her, either here or in the scene that immediately follows, where Elaine once again reveals a half-buried assertive streak.

It's late at night, and Ben is sound asleep in his room when he senses the presence of an intruder. It's Elaine, asking to be kissed. This midnight request can hardly be construed as suitable behavior for a well-brought-up young lady, but it gets the job done. The unlooked-for demand prompts Ben's half-awake proposal of marriage. As he stands with his arms around her shoulders, the cautious side of Elaine (the one I tend to call "the good-girl side") takes over. Regarding his proposal, her answer is variously "I don't know," "I might," "I don't see how we can," and "I'll think about it." Benjamin at this point has shoved past all the confusion tied to his long liaison with Elaine's mother. Now, as a proper son of

the post–World War II generation, he sees only certainty in the thought of a legal matrimonial union. Elaine, however, appears unconvinced. She darts away, leading Ben—once again alone in the dark—to exclaim in amazement, "Good God!"

FROM THIS POINT forward, it is Ben who becomes the pursuer, hounding Elaine from class to class, insisting that she agree to a blood test (in 1967 a California requirement for a marriage license) and a wedding date. Finally, as Ben camps at her side on the bleachers in a women's gym class, she looks at him in exasperation and asks why, if he wants to marry her so badly, he doesn't simply drag her off. This challenging question pinpoints something essential to Elaine's nature: her desire for a knight (or a caveman) forceful enough to help her make up her mind.

Soon enough, we learn just why Elaine is vacillating. It has little to do with the family situation back home. Rather, there's the small matter of Carl Smith, the bland, blond young man from the zoo. He's a medical student she's known for years, and she's agreed that she might marry *him*. As Elaine tries in vain to study in the school library, Ben badgers her about the details of Carl's proposal. Violating all rules of library etiquette, he hollers after her, "Where did he do it? . . . It wasn't in his car, was it?" Slightly later, as campus chimes toll the hour, Ben and Elaine are chastely kissing, but she refuses to commit to getting married in a day or two: "Maybe we are and maybe we're not." Still, although Elaine might not be sure about the time, the place, or the groom's identity, she appears to have accepted the fact that in the near future she'll become *someone*'s missus.

What is there about marriage that seems for both Ben and Elaine the solution to all their problems? For one thing, it's a rite of passage that traditionally confers adult status, one that signals entry into the world of grown-ups. And Ben, at least, has been raised in a home where his parents are so closely aligned that they often seem like coconspirators. So he knows full well that long-term compatibility is possible. Yet he has also seen—and Elaine has grown up with—the Robinsons, who drink too much, sleep in separate bedrooms, and are on the prowl (Mrs. Robinson certainly, Mr. Robinson quite possibly) for extramarital satisfaction. These two are hardly a good advertisement for the holy bond of wedlock. Perhaps that's why their daughter waffles, but in even considering Benjamin Braddock as a possible marriage candidate she reveals a startling naïveté. From a purely pragmatic standpoint, medical student Carl Smith is a much better choice. (Doubtless he'll have a lucrative career in plastic surgery.) Ben, quite apart from his sticky interpersonal situation, has thrown away all the career prospects, like the Halpingham award, with which he was endowed when the film began. I suspect Ben appeals to Elaine because his confusion mirrors her own, whereas Carl's cocksure manner is a wee bit too close to that of her father for comfort.

It's often been suggested that Benjamin Braddock and Elaine Robinson—in their clothing, their manners, and their outlook— are throwbacks to the 1950s. Elaine is hardly the classic Berkeley student of 1967. She seems not in the least political, and in fact it's easy to wonder what she's doing on a high-powered university campus. Certainly, she doesn't appear all that keen on education. She attends classes, but carries few books and presumably spends

little time in intellectual pursuits. And we haven't the slightest clue about her field of study. I can't resist citing a passage from *The World Split Open: How the Modern Women's Movement Changed America*, published in 2000 by Berkeley history professor Ruth Rosen. In considering the mind-set of the fifties, Rosen quotes one coed from that era who was very clear on her generation's long-range goals: "We don't want careers. Our parents expect us to go to college. Everyone goes. But a girl who got serious about anything she studied—like, wanting to go on and do research—would be peculiar, unfeminine. I guess everybody wants to graduate with a diamond ring on her finger. That's the important thing." Unlike Benjamin Braddock at the start of *The Graduate*, this sort of alumna had no worries about her future . . . so long as she was suitably mated.

Elaine Robinson, it's fair to say, may also be viewing college as a place to earn her MRS degree. And, much like Ben, she may be looking for a quick path to adulthood, and for the chance to find some certainty in a life that's recently been upended. The irony is that both are contemplating an adult act in the most childish of ways. When the Braddocks first hear about Ben's marriage plans, they are strongly enthusiastic. This is surely because they see matrimony as having the potential to make a man out of him, forcing their mysteriously troubled son to pull his life together and come up with some practical plans for the future. Mr. Braddock is right, though, when he concludes that Ben's decision is in fact "half-baked." Ben's dogged insistence on marrying straightaway appears totally whimsical, revealing his innocence about real-world necessities. Elaine, for her part, is no more attentive than Benjamin to

the social and economic issues that can block the path of a young couple without jobs or skills. Children of affluence, both Ben and Elaine seem to assume that once they make up their minds, life will neatly fall into place.

In the late sixties, a time when young people like me had come to question their parents' pragmatic materialism, Ben's juvenile impetuosity had its own appeal. He struck us as heroic, in that he was deliberately choosing romantic idealism in place of a well-thought-out strategy for success. This was something new: Though legally of age and primed to marry, the film's leading man boldly turns his back on conventional adult responsibility in favor of what some might call arrested development. For a lot of us sixties college types, this sidestepping of full-on adulthood seemed an enticing alternative to our parents' sober workaday existence. No wonder my generation viewed with fascination the childish sixties hijinks of the Yippies and Ken Kesey's LSD-fueled Merry Pranksters, even if we didn't feel compelled to join them in their antiadult antics. For me and many fellow Californians, dressing up for the annual Renaissance Pleasure Faire—or, eventually, planning a jaunt to Woodstock—was a shortcut way of getting ourselves back to the garden.

Another facet of *The Graduate*'s allure was that it came along when social norms, like those involving marriage, were starting to shift dramatically. Some of the college-age women who cheered for Elaine's romance with Ben were joining consciousness-raising groups dedicated to overthrowing the domestic shackles detailed in Betty Friedan's *The Feminine Mystique*. The National Organization for Women, founded in June 1966, was gaining tens of

thousands of members, all of them committed to gender equality. And late in the summer of 1968 (when *The Graduate* had been packing in audiences for almost nine months), radical feminists protested Atlantic City's long-established Miss America Pageant by ceremonially tossing into a trash can brassieres, girdles, false eyelashes, and other "torture" items symbolizing the objectification of women. (Nothing was set ablaze at that Atlantic City event, reportedly for lack of a fire permit, but the famous notion of "bra-burning" was born.)

If standards of female beauty, courtship, and marriage were being reassessed, so was sexuality. Most of us young women still felt societal pressure to "save ourselves" for marriage, but we were starting to rethink that time-honored notion. By 1967 the newly widespread use of the oral contraceptive pill was dramatically altering traditional assumptions that marriage was the only socially sanctioned venue for sexual intercourse. The oral contraceptive had been marketed in the US since 1960, but its adoption had at first been slow, in part because of legal challenges. Though greeted enthusiastically by many women and their partners, the pill was banned in some states until a 1965 Supreme Court decision permitted its use by all married women. The unmarried in numerous locales had to wait for a follow-up legal decision in 1972, despite the fact that young single women were finding creative ways to obtain their pill supplies. (Some sympathetic dermatologists were willing to prescribe it on the grounds—a bit of a stretch—that it cleared up acne.) Sex was supposed to be fun, and we wanted to get in on the action.

In 1967, the year that *Time* finally chose to write a cover story

on the phenomenon, Dr. Richard Frank, medical chief of Chicago's Planned Parenthood clinics, was quoted as saying that more than five million American women considered the pill their contraceptive of choice. Mrs. Robinson, whose life had been turned upside down by an unplanned pregnancy, might not have approached Ben so boldly without this handy and nearly foolproof way of covering her tracks. But amid all the social flux, neither Ben nor Elaine truly seems to be thinking about sex, nor about domestic liberation in any form. Rather, both are clinging to a dream of old-fashioned romance, leading to wedding bells and happily-ever-after.

Through a storefront window, we spy Ben conferring with a clerk in a Berkeley jewelry shop. Out comes a very young couple, he in a white-boy Afro and bushy muttonchops, she wearing a floppy hat and miniskirt. (This is the film's single glimpse of the emerging campus sartorial style of the late sixties.) She's holding a young baby, and the clear implication is that—though they've jumped the gun in terms of social propriety—they're belatedly shopping for a wedding ring. So is Ben, we gather. He leaves with a small box, whistling joyfully.

13

Untying the Knot

Sorry we won't be able to invite you to the wedding,
Benjamin, but the arrangements have been so rushed.

Ben sprints up the stairs of his rooming house, loaded down with gifts, as well as a large bouquet of white flowers. He enters his dimly lit room only to gasp in alarm. Looming large in the foreground is the ominous silhouette of a man smoking a long cigar. It's Mr. Robinson, and he seems to view Ben's misbehavior with his wife as a personal affront: "Do you have a special grudge against me? . . . Is there something I said that's caused this contempt, or is it just things I stand for that you despise?"

With icy politesse, Mr. Robinson spells out the consequences of Ben's transgression: He and his wife will be divorcing soon. Ben, completely missing the pain beneath Mr. Robinson's words,

expresses amazement. "Listen to me," he insists. "What happened between Mrs. Robinson and me was nothing. It didn't mean anything. We might just as well have been shaking hands." Mr. Robinson's voice drips with sarcasm: "Shaking hands! Well, that's not saying much for my wife, is it?" Ben, still oblivious to the sorrows of an older generation, lays his cards on the table: "The point is—I don't love your wife. I love your daughter, sir."

At this latest indignity, Mr. Robinson springs to his feet and stares Ben down. His threat is palpable: "I think I can get you behind bars if you ever look at my daughter again." Now that Elaine has been spirited out of Ben's reach, "you're to get her out of your filthy mind right now!" Fighting back tears of grief and anger, he adds (in a line inserted by Buck Henry to cap one of Charles Webb's strongest scenes), "You'll pardon me if I don't shake hands with *you*." In the doorway to Ben's room, Mr. Robinson finally allows his voice to rise above its former careful modulation: "I think you are filth! I think you are scum! You are a degenerate!" Then he hurtles down the stairs, brushing past an eavesdropping Mr. McCleery. Under these circumstances, the landlord is hardly sympathetic to Benjamin's desperate plea to give him change for the pay phone. (Remember those?) And so our hero races down the stairs and into the rain.

Since the start of *The Graduate* we've had the sense that Ben, living a fishbowl existence in his family home, is not truly understood by the members of his parents' generation. He's young, restless, and endearing, so we're on his side. But the scene with Mr. Robinson—surely one of the film's most poignant—reveals the extent to which Benjamin fails to recognize that his elders have

legitimate emotions too. Failure to communicate is everywhere. The anguish implicit in Mr. Robinson's fury suggests a powerful man whose carefully built domain is suddenly crumbling all around him. The old castle, it seems, is falling down. But because Ben cannot see beyond his own needs, Mr. Robinson's words, like Paul Simon's silent raindrops, have fallen in vain.

A HUGE CLOSE-UP, a cousin to that at the start of the opening party sequence, frames Ben's face as he gets the news that Elaine Robinson has left school. In another of those wide-angle shots made ominous by a forced perspective, her dorm roommate approaches down an endless corridor while we hear Elaine's voice read the contents of her note to Ben: "Please forgive me, because I know what I am doing is the best thing for you. . . . I love you, but it would never work out." Elaine cites the emotional strain on her father as the reason for her abrupt withdrawal from school. In allowing her parents and her boyfriends to shape her future, she's revealing the docility that has long been considered a virtuous female trait.

Elaine, of course, has just been through the trauma of learning that a young man she fancies has been sleeping with her mother, so she can perhaps be forgiven for behavior that verges on the passive-aggressive. Her rapid mood swings, her hair-raising shrieks, and her unwillingness to make decisions all signal that she's facing her own sort of desperation by falling back on what are sometimes called feminine wiles. But what does she really want? We're not exactly sure. There's an inkling, though, that in a subterranean way she knows how to goad Ben into making a stand on

her behalf. It may well be that one day she'll grow into the role of a manipulating mom, one who's deft (like Mrs. Robinson and Mrs. Braddock) at bending menfolk to her will.

IN THE MEANTIME, Benjamin is driving through the night, out to rescue his lady love from the powers of darkness, with Simon and Garfunkel wordlessly accompanying him on the soundtrack. Quickly he arrives at the Robinson home, hops the back fence, and easily slides open the glass door of the sunporch. He stumbles into the unlit room, then mounts the stairs like a knight in shining armor, hoping to find his princess at the top. Instead, there's the sorceress, Mrs. Robinson, coolly phoning for a patrol car to come arrest the housebreaker. In her own bedroom—fitted out with mirrors that would suit the vain queen in *Snow White*—she's packing for a trip. She taunts him with the offer of a drink and with the broad hint that a quickie marriage between Elaine and Carl is in the offing. Clearly, wedlock is being used by the Robinsons as both a punishment and a strategic ploy. Despite their own marital estrangement, they're working together to foil Ben's designs on the daughter who may be the one unsullied thing they share. And Mrs. Robinson, taking sweet revenge on her former bedmate, is thoroughly enjoying her role in this domestic drama.

There are hints aplenty that Elaine has always been a daddy's girl. Mr. Robinson has seemed to worry a great deal about her social life, and from the looks of Carl at the zoo, he's a take-charge kind of guy, one who'll follow her father's lead in keeping her under his wing. No surprise, then, that Elaine has agreed to the spur-of-the-moment wedding intended to put her out of Ben's

reach. By allowing herself to be pushed and pulled by her mother and by the men in her life, she's playing out what has always been the classic Hollywood-sanctioned good-girl role: that of a pawn in someone else's game.

AGAIN, BENJAMIN TAKES the wheel of his Alfa Romeo, this time driving northward up the California coast. As the sun comes out from behind the clouds, he's once more crossing the San Francisco–Oakland Bay Bridge. For the first time in the film, Simon and Garfunkel begin singing "Mrs. Robinson," a ditty with sassy lyrics that take vengeance on Ben's Public Enemy No. 1 by cheerfully consigning her to Jesus. Empowered by his own sense of mission, Ben pulls up in front of a Berkeley fraternity house. It's breakfast time, and the residents—most of them tall, blond, and hunky—are delighted to reveal that Carl Smith took off in the night to get married, doubtless "one step ahead of the shotgun." (This reflects the old joke that young bucks like these choose marriage only when roped into it by someone's outraged sense of morality.)

Pretending to enjoy the humor of the situation, Benjamin inquires about the wedding's locale, claiming that he's an invited guest. In the house's shower room, a frat brother confirms that "the make-out king" is getting hitched in Santa Barbara, maybe at his old man's house, or perhaps in the maternity ward. One strapping fellow devilishly asks Ben "to save a piece for me . . . of the wedding cake." Once again here's the jocular frat-boy vision of the male animal as a studly predator. Submerging his reaction to these bawdy jokes, Ben hits the road once more.

THIS TIME IT's daylight as he speeds the 323 miles from Berkeley to the gracious Southern California beach town of Santa Barbara. Exiting the freeway, he pulls into a gas station and rushes inside its modest office, desperately riffling through a tattered phone book to try to track down the family of Carl Smith. Making a phone call, he reaches the answering service of Dr. Carl Smith, Sr., who's off attending his son's wedding at a local church. Again Ben displays his new talent for smoothly improvising fake identities (as well as Buck Henry's talent for adding clever twists to Charles Webb's story line). Claiming to be Reverend Smith, the doctor's brother, just arrived from Portland to perform the nuptials, Ben elicits the name of the First Presbyterian Church on Allen Street. The gas station attendant provides directions, and then—as Ben races away—shouts after him, "You need any gas, Father?"

Alas, Benjamin does not realize that he's running on empty. As he skims along a rural road lined by citrus trees, a Paul Simon guitar lick mimics the sound of his Alfa Romeo limping to a halt. When we first met Benjamin Braddock, he was crossing the country by jet. We later watched him zip up and down the California coast in an expensive sports car. Now, however, he's reduced to the power of his own two legs. In one of the film's most famous shots, a long lens compresses distance, making it look as though he's running directly toward us, though hardly making any forward progress at all. It's a potentially bleak omen. But then—at last—a modernistic church rises before him, a vision in white stucco and glass. There's an austere cross on the façade, but otherwise the building looks as impersonal as an airline terminal.

He hurls himself toward the front door. It's locked, but his destiny awaits.

An undaunted Benjamin mounts an outdoor staircase leading to a glassed-in church balcony. Disheveled and sweaty, he looks through a huge plate-glass panel to see, far below him, the culmination of a wedding ceremony. The minister shuts his hymnal, and a formally dressed Carl gives Elaine, in full bridal regalia, a tender kiss. It's more than Ben can bear. In close-up, he laments aloud: "Oh Jesus God, no!" As a geriatric organist strikes up the familiar Mendelssohn "Wedding March," we see a wide shot of the sanctuary: It features a handful of well-attired guests, Mrs. Robinson (wearing a leopard-spot pillbox hat) looking appropriately solemn, and Ben high overhead with his hands, palms out, flush against the glass. Ben's eyes fill with tears. Suddenly, he begins madly tapping against the glass panel, then shouts with all his might the name of his beloved. And shouts it again. And again. And again.

Upon hearing her name bellowed from on high, Elaine turns to gaze upward. So do the guests in their hats and furs, all of them looking alarmed. The new Mrs. Carl Smith appears transfixed. We hear her father's urgent question: "What's he doing?" But Mrs. Robinson, sitting by his side, confidently replies, "He's too late." Her smile is perhaps surprising, given the circumstances, but it's easy to imagine her gloating over Benjamin's distress. If she can't be happy in her own life, she's pleased to deny this privilege to a young man who's blessed with a freedom of movement she can only envy.

Still Benjamin continues calling out Elaine's name, twenty

times in all. Mesmerized by his overt need for her, she begins to slowly head in his direction. Behind her, members of the wedding party are starting to worry. Elaine turns to her mother and sees—in grotesque but silent close-up—Mrs. Robinson profanely expressing outrage. Next she glances toward her father and beholds angry parental lips cussing up a storm. Finally, there's her brand-new spouse, who reprimands her furiously. That's when, at long last, she answers Ben's shout with a prolonged yell of her own: "Bennnnnnn!" Hearing her voice, he quickly heads down an inside staircase leading to the sanctuary.

What Benjamin has learned over the course of the film is self-empowerment. No longer content to loaf in his parents' swimming pool or in Mrs. Robinson's bed, he has finally found what he wants, and will now fight with all his strength to hold on to it. As for Elaine, what are we to make of her behavior? There's no doubt that her home life has not been a happy one. Has she, throughout the film, been waiting for a superhero to carry her away to safety? If Ben—morally compromised and without future prospects—is her ultimate choice, what exactly is she choosing? Surely part of Ben's appeal for her lies in the fact that he's the yin to her parents' yang. Unlike Carl, he offers the opportunity to turn her back on the decisions that the Robinsons have made on her behalf. He is, in other words, the anti-Establishment suitor, one who represents a thumbing of the nose at everything her parents' generation holds dear.

At the bottom of the stairs, Benjamin meets an enraged Mr. Robinson, who shouts, "You crazy punk!" They grapple, and Elaine's father finds himself painfully shoved against a wall with

a blow to the solar plexus. In the ensuing melee, Ben head-butts Carl, then grabs Elaine's hand. But Mrs. Robinson doesn't give up easily. Getting directly in her daughter's face, she shouts, "It's too late!" For a change, Elaine has an answer. She shouts back, "Not for *me*!" At which her mother tries to reassert her authority by slapping her—twice—with all her might. In response, Ben (with Elaine safely behind him) grabs a large brass cross and begins swinging it wildly in all directions. Carl's frat brothers and the other guests scramble as Ben and Elaine slip out the church's front entrance. Ben inventively shoves the cross through the door-handles, sealing the wedding guests inside. (For a change, *they're* the ones trapped behind glass.) All smiles, he and Elaine run to the street, where an old-fashioned city bus rumbles up. It looks a great deal like a school bus, reminding us that this young couple still has a lot to learn. The powerful jetliner of the film's opening and the fleet sports car of its middle section have now given way to the most plebeian kind of public transport. The bus may not be fast, but it offers an escape route. It stops, and Elaine's long train doesn't impede them from quickly clambering aboard.

Reaching into the pocket of his ripped Windbreaker, Benjamin pulls out some cash and stuffs it into the bus's fare box. The two then proceed up the aisle to the very back seat. They're oblivious to the stares of the other passengers, virtually all of them stolid oldsters. Ben and Elaine are both at first jubilant about their getaway from the forces arrayed against them. Elaine, still clutching her bridal bouquet, beams as Ben claps his hands with glee. Slowly, however, reality sinks in. Despite their best efforts to remain exuberant, their smiles fade as each seems to contemplate

the enormity of what they've done. For the last time, Simon and Garfunkel begin to croon, "Hello, Darkness, my old friend." Despite the fact that Ben and Elaine have made their escape together, each seems very much alone within the sound of silence. As the bus moves down the road, we spot their heads (each framed by its separate window) receding into the distance. They're going we know not where. Against a black screen, the credits roll.

Is the end of *The Graduate* a victory for young love, or does it signify something darker? Larry Turman quickly recognized that my question was "based on their faces going dead in the bus at the end. And that wasn't directed. That just sort of happened. . . . That's one of those wonderful happy accidents that seems to elevate the film and give it a complexity." When I asked whether he himself had imagined happily-ever-after or had pictured a far more ambiguous ending, Turman related a conversation he'd had during the production period with director Mike Nichols. Nichols assumed as a matter of course that they were suggesting a grim outcome for the young couple. Turman, though, strongly disagreed. He told Nichols, "Mike, you're a smart guy, but you're totally wrong. . . . The audience is going to take it as a *triumph*."

Nichols in later years was inclined to predict, when asked, that Ben and Elaine would end up becoming their parents. Turman, though, feels vindicated by the fact that early members of the viewing public invariably cheered when Benjamin snatches Elaine from the church. And most continued cheering right through to the final credits. In their minds, Ben's goal of making his future "different" had been achieved beyond their wildest expectations. It was only as these youthful moviegoers grew older, and absorbed

their own share of life's lessons, that some of them changed their perspective on how successfully Benjamin Braddock had forged a brand-new path.

Our lingering doubts about Ben and Elaine's long-term prospects as a duo add a layer of uncertainty that most romantic comedies, then and now, have never broached. We don't know whether these two will remain together, or whether (once the legalities are sorted out) they'll even consider matrimony as a future option. It's all part of the richness of a film that means many things to many people, both those who watched it in first-run and those who've discovered it over the years. But Benjamin Braddock's choice to escape from his parents' brand of adulthood—what Nichols liked to describe as a boy saving himself through madness—has marked our culture and its movies from that day to this. Over the decades *The Graduate* has remained an inspiration for those struggling to distance themselves from their elders' social values while searching for new ways to live authentic lives.

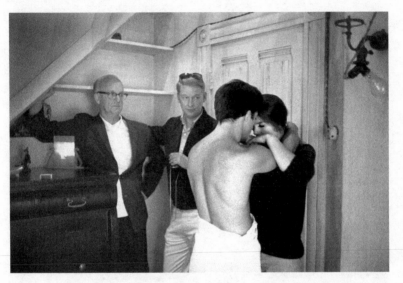

Veteran cinematographer Robert Surtees and director Mike Nichols watch Benjamin propose marriage to Elaine Robinson (Katharine Ross) in his Berkeley rooming house.

RIGHT: Benjamin, in the church balcony, assumes a hands-up pose that many viewers took to represent Jesus on the cross, while the Robinsons and other guests stare in astonishment at this disruption of Elaine's wedding.

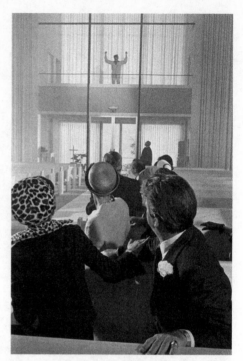

BELOW: Waiting for her cue in the climactic wedding sequence, Katharine Ross hangs out with screenwriter Buck Henry, who was always present on the set.

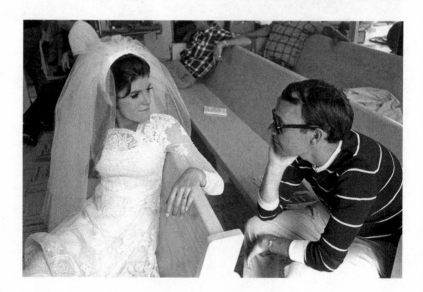

On April 10, 1968, Mike Nichols accepts his Best Director Oscar from presenter Leslie Caron.

Oscar nominee Dustin Hoffman arrives with Ellen McCarthy, daughter of Senator Eugene McCarthy. Behind them are Hoffman's former roommate Gene Hackman and wife Fay.

Publicity shot, circa 1964, of Paul Simon and Art Garfunkel, whose songs played an essential role in *The Graduate*'s success.

"Mrs. Robinson, are you trying to get me to listen to your podcast?"

Nationally syndicated cartoon, from 2008, by Harry Bliss.

Joe Dator's cartoon, published in the *New Yorker* on May 26, 2014. Dator commented in 2016, "Using a scene from a film is always a risk but I intuitively felt that this scene had become embedded enough in American culture that it could be the basis for cartoon, the jumping off point for a joke about modern life."

A scene from *Wayne's World 2* (1993), showing Mike Myers and Tia Carrere fleeing from her wedding in an elaborate parody of *The Graduate*. Note that Wayne has used an electric guitar instead of a cross to lock the wedding guests inside the church.

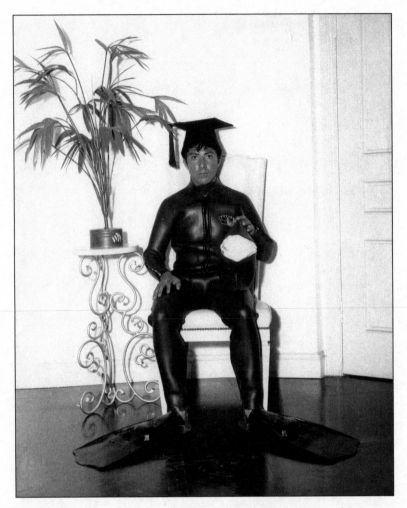

Publicity shot of Dustin Hoffman, as Benjamin Braddock, posing in a diving suit and mortarboard cap.

PART III

After the
Lights Came Up

14

The Hoopla

"No small part of the phenomenal success of *The Graduate* was that it gave expression—funny expression—to a youthful restlessness and dissatisfaction that was in the air like marsh gas, waiting to explode." **—Charles Champlin (1971),** *Los Angeles Times*

From the window of Hollis Alpert's Upper East Side apartment, he could see youthful patrons lining up to catch the latest screening of *The Graduate*. Alpert, the veteran movie critic for the influential *Saturday Review*, watched those long lines form—whatever the weather—over a period of six months. Even when it was a frigid eight degrees in New York City, no one seemed anything but cheerful. Wrote Alpert, "It was as though they all knew they were going to see something good, something made for *them*."

Though *The Graduate* at first attracted young moviegoers, many of whom returned to see it multiple times, their parents

and other social elders were soon buying tickets too. In his July 6, 1968, appreciation of the film, Alpert noted that it had earned $35 million at the box office (something like $238 million today) while playing in only 350 US theaters. By the end of that same month, producer Lawrence Turman was predicting that the take would soon reach $50 million (today's $350 million). Once the film had finally spread beyond major American cities, *The Graduate* turned out to be one of the greatest hits of its era, with its lifetime domestic gross of $104,945,305 approaching *The Sound of Music* territory. And it proved to be a huge draw overseas as well.

The critics of course had their say. This was a time when moviegoers like me commonly checked with their favorite reviewers before purchasing tickets, and not every assessment of *The Graduate* could be called positive. Richard Corliss of *Time* was flatly dismissive. At *Life*, Richard Schickel enjoyed Dustin Hoffman's performance, but griped that the film "starts out to satirize the alienated spirit of modern youth, does so with uncommon brilliance for its first half, but ends up selling out to the very spirit its creators intended to make fun of." Making a witty reference to a popular hair-care commercial of the day, Schickel concluded: "It's a shame— they were halfway to something wonderful when they skidded on a patch of greasy kid stuff."

Among the critics favored by intellectuals, there was even harsher rhetoric. Curmudgeonly John Simon, writing in the *New Leader*, led the pack. Viewing *The Graduate* as an example of Hollywood pandering to middle-brow tastes, he dumped on everything from Paul Simon's lyrics ("not so much rock as rock bottom") to what he deemed the pretentiousness of showing Ben

"crucified against the plate glass of the choir loft." Pauline Kael, whose recent championing of *Bonnie and Clyde* had made her a darling of young intellectuals, publicly despaired of persuading her fans that *The Graduate* was unworthy of their love: "How could you convince them that a movie that sells innocence is a very commercial piece of work when they're so clearly in the market to buy innocence?"

On the other hand, many widely read reviewers were delighted. Charles Champlin of the *Los Angeles Times* praised what Kael had denounced: the film's "curious, almost defiant strain of innocence and optimism." At the *New York Times,* venerable Bosley Crowther had been swept out of his film-critic post in the wake of his drubbing of *Bonnie and Clyde*. He wrote his very last review on *The Graduate*, relishing its trashing of "the raw vulgarity of the swimming-pool rich." Crowther betrayed, though, what to us seemed his advanced age (he was sixty-two) by comparing the film admiringly to the farces of Preston Sturges. True, Sturges' comedies of social absurdity made for an apt comparison to Mike Nichols' work on *The Graduate*, but such Sturges masterpieces as *The Lady Eve* (1941) and *The Palm Beach Story* (1942) had been released long before most Baby Boomers were born. At *Saturday Review*, Hollis Alpert was so enthusiastic that six months after his rave of December 23, 1967, he followed up with a lengthy analysis laying out *The Graduate*'s enduring appeal to young audiences. In the *New Republic*, Stanley Kauffmann rejoiced that "for once, a happy ending makes *us* feel happy." (He did not anticipate that Charles Webb would later take him to task for this assessment.)

Such critics as Alpert and Kauffmann surely enticed some

viewers to see the film. And nay-sayers like Simon and Kael doubtless convinced others to stay away. But, as Kael had discovered, *The Graduate* was essentially critic-proof. From the very first, audiences flocked to theaters where it was screening. And they contributed to lively debates in many a letters to the editor section. For every letter-writer who called the film boorish or blasphemous, there was another who strongly supported it. Take, for instance, Miriam Weiss from Stony Brook University, class of '69, who told readers of the *New York Times* that she considered Benjamin Braddock "a spiritual brother." Said she, "He was confused about his future and about his place in the world, as I am. He was chasing an ideal in spite of all the obstacles that society put in his path in the attempt to co-opt or eliminate him." This young collegian, like many viewers to whom I've spoken over the years, insisted that *The Graduate* "affected me more deeply than any other movie I've ever seen."

As the fame of *The Graduate* grew, public figures started weighing in. David Brinkley had gained renown as coanchor of the nation's top-rated nightly news broadcast, the *Huntley-Brinkley Report* (1956–1970), and his personal popularity rivaled that of the esteemed Walter Cronkite. The acerbic Brinkley, a regular contributor to the *Ladies' Home Journal*, wrote an April 1968 column titled "What's Wrong with *The Graduate*." Because his college-age son and his pals considered *The Graduate* "absolutely the best movie they ever saw," Brinkley checked it out for himself. He found it not only "pretty bad" as an entertainment but also predictable and banal in its antiadult sentiments. Brinkley's column reassured the magazine's middle-aged, middle-brow female subscribers (in other

words, the mothers of young people like me) that *The Graduate* had nothing profound to say about the relationship between the generations. Wrote Brinkley, "All that is new about the Generation Gap is the phrase itself. And in spite of the enthusiasm for it among the young, it seems to me *The Graduate* only makes a few exaggerated points about familiar facts of life and then slides off into the kind of frantic nonsense Mack Sennett would have made if he had had the money."

A contrasting view was presented by Senator Jacob Javits, a liberal Republican from New York who served in the US Senate for a quarter of a century. Javits, not normally considered a movie critic, penned a piece for *Variety* warmly praising the film for depicting without condescension the decade's youthful Americans and their angst. Acknowledging the very real tension between those in my age group and our parents, he advocated that the problems of the Baby Boom generation be treated by political figures with the same honesty, compassion, and respect that the makers of *The Graduate* had shown. (Javits' admiration for the film seems genuine, but I can't resist pointing out that he himself enjoyed a friendly relationship with Joseph E. Levine, having delivered an after-dinner speech at Levine's sixtieth birthday bash for three hundred guests at New York's Waldorf-Astoria in September 1965.)

It was by no means rare in the late 1960s for social commentators to worry about the state of American youth. Author William Goldman's remark resonated with many: "Something terrible and strange is going on today between the young and the old." It sometimes seemed in the popular press that everyone under

twenty-five was either agitating for social overthrow or turning on, tuning in, and dropping out. Joan Didion, who had wandered in bewilderment among the flower children of San Francisco's Haight-Ashbury, wrote in her famous 1967 essay "Slouching Towards Bethlehem" that the older generation was perhaps to blame for the mental disarray of their offspring: "At some point between 1945 and 1967 we had somehow neglected to tell these children the rules of the game we happened to be playing. Maybe we had stopped believing in the rules ourselves, maybe we were having a failure of nerve about the game." Didion's comment supports Benjamin Braddock's plaintive howl that the rules of the adult world don't make sense. So, from Didion's perspective, Ben-the-Graduate and society's young dropouts were contending with the same grim dilemma: that their elders had led them astray. Though it was hardly Mike Nichols' intention to send such a message, it was one that many moviegoers were ready to receive.

By 1970, Philip E. Slater, chairman of the sociology department at Brandeis University, was publishing a best seller in which he argued for the need to completely retool American society. Slater's *The Pursuit of Loneliness: American Culture at the Breaking Point* uses *The Graduate* as a major proof-text for the social dilemmas of the late sixties, pointing out that many middle-aged reviewers wholly failed to grasp the magic spell the film cast over youthful audiences. To Slater, *The Graduate* "is a ritual of purification and cleansing, a celebration of the *capacity* of feeling to triumph over pattern." He insisted that the "bad behavior" of Ben in disrupting Elaine's wedding paralleled the "bad behavior" of radical protesters who offended older generations with sit-ins

and demonstrations. Slater viewed Ben's actions along religious lines. By wielding the cross as a weapon, Ben "transforms it from a symbol of church convention and ritual to one of revolutionary Christianity, in which love takes precedence over ceremony." At the same time, according to Slater, Ben uses his cross to perform the time-honored act of staving off vampires, these being the American parents who suck out their children's essence for their own vicarious satisfaction.

Vampires indeed! The sheer wackiness of this latter notion seems less surprising if you realize that Slater had participated in clinical experiments with LSD from 1952 to 1954. There's also the fact that Brandeis University in this era was a hotbed of professorial types who loudly deplored America's consumer society. When Slater died in 2013, his obituary in the *New York Times* chronicled a highly eccentric life. In 1971, hard upon the success of *The Pursuit of Loneliness*, he resigned his academic position at Brandeis, resolving to lead a simpler existence. He tried acting, wrote novels, and founded a personal growth center, while also continuing to publish sociological treatises. By the time of his death in Santa Cruz, California, at age eighty-six, he had winnowed all of his possessions down to the contents of two boxes. In terms of his embrace of austerity, the resemblance to author Charles Webb is striking.

Slater's viewing of *The Graduate* as a radical expression of the need for social upheaval apparently matched the feelings of the scores of students who—protesting their administration's support for weapons research and a racially insensitive gymnasium on the site of a Harlem park—occupied five buildings at Columbia

University over an eight-day period in April 1968. The bulk of the Columbia rebels knew *The Graduate*, with some legendarily having snuck through their own barricades to watch it in Manhattan theaters. Most of them cheered the film's youthful heroes, whom they viewed as fellow activists in the making. Later in 1968, Mike Nichols had occasion to chat with a participant in the Columbia takeover. "In a way," explained the student to Nichols, Ben and Elaine's escape from the church "was what the strike was all about. Those kids had the nerve, they felt a necessity, to break the rules." But Mark Rudd, a mainstay of the Columbia revolt who went on to become a major figure in the ultraleftist Weather Underground, hardly identified with the film's protagonist. Deeply committed to opposing injustice and the Vietnam War, Rudd recognized no personal bond with an aimless young man who lacked any sense of social responsibility. Said Rudd to me in 2007, comparing Benjamin Braddock to himself and his fellow sixties radicals, "Here's an alienated kid who graduated and didn't know what he was doing. Well, *we* weren't alienated anymore. We were beyond alienation."

Mark Rudd's comment shows that in the national conversation sparked by *The Graduate* there were many possible perspectives, even among the young. In a review published in *Film Quarterly* in spring 1968, fledgling critics Stephen Farber and Estelle Changas condemned the film as "a youth-grooving movie for old people." Their complaint was that "Nichols doesn't risk showing young people who are doing truly daring, irreverent things, or even young people intelligent enough to seriously challenge the way old people live." Yet, to the disgust of the two authors, "young people are falling for the film along with the old people, because it satisfies their

most infantile fantasies of alienation and purity in a hostile world, their most simplistic notions of the generational gap, and their mushiest daydreams about the saving power of love."

(Forty years later, Farber himself—now an established film historian—told me that his views on *The Graduate* still stand, though today he would temper his harsh language: "In youth you have this fervor and vehemence—you want to take on people who you think are wrong. . . . Some of it was youthful impetuousness. I took extreme positions sometimes that now I would modulate." Back in the day, however, he and Changas could muster up nothing but disdain for those who did not share their outrage.)

Farber and Changas were not the only under-thirty cultural critics who distanced themselves from their generational peers on the subject of *The Graduate*. At a time when top publications were frequently turning to young voices to explain the changing world, the *New Yorker* printed a rambling twenty-six-page critique of *The Graduate* by recent Harvard grad Jacob Brackman. Brackman, who would go on to write for *Esquire* and other major periodicals, began by acknowledging some reasons for the film's popularity with the Baby Boom generation. For one thing, during the climactic wedding sequence, "kids at *The Graduate* can let go because Benjamin kicks hell out of a whole entourage of parents—and with an unassailable motive." Still, Brackman hotly rejected the film as an accurate depiction of adolescent discontent on the order of *The Catcher in the Rye*. To his way of thinking, "If we give unreserved praise to our cultural leaders for a vision of youth that ignores a generation's worth of change, we must expect them to remain as barren of relevance as our political leaders."

Stoked by the arrogance of youth (and, he admits, by a whole lot of cannabis), Brackman ended by faulting Mike Nichols and company for not laying out the real choices to be made by those on the brink of adulthood in sixties America. For him, in ignoring such sources of late-sixties tension as protests, pot, and Vietnam, Nichols "has created a world in which they play no part, a world still obsessed with that old hangup sex. . . . Nichols has made a film about growing up that is really about growing down, the lowering of consciousness; a film about dropping out that is really about working in; a film about alienated youth that refuses to acknowledge the momentous sources of alienation." Brackman argued that the film was doing American youth a disservice: "If television, magazines, or at least a serious film like *The Graduate* reflected how grievously expectations for America have shrunk, a great many more young people would begin to discover one another. . . . The true Benjamins—those who feel themselves isolated, suspended in limbo between Lyndon Johnson and Ken Kesey, between acquiescence and domestic guerrillahood—would come to understand the depths of their fellowship and strength."

Mike Nichols, who freely admitted that he'd never managed to read Brackman's piece through to the end, nonetheless had no problem with moviegoers who gave *The Graduate* their own interpretive spin. Two years after the film's release, he told interviewer Joseph Gelmis that "my opinion really doesn't have much more validity than anybody else's." To Nichols the power of movies is such that "a film can easily be more than the people who made it." In the best of cases, "I think that when artists—and by that I

mean writers and just a very few film directors—get something right, it touches on and becomes your own life."

Farber, Changas, and Brackman may not have been blown away by *The Graduate*. But thousands of young people like me were willing to swear that Nichols, along with his cast and his crew, had gotten something very right, that the film had in some mysterious, intimate manner become a part of ourselves. Like the critics, we might recognize lapses in credibility and basic logic, such as the fact that the story's Golden Boy graduate—winner of collegiate prizes both academic and athletic—comes off as an intellectual nebbish, as well as a semiklutz unlikely to have starred on any sports team. Still, we fans were prepared to overlook such failings, because we recognized in *The Graduate* the essence of what was going on in our own lives. Miraculously it became *our* film, as much as it was the film of Mike Nichols, or Larry Turman, or Dustin Hoffman. But we young moviegoers who regarded *The Graduate* as *our* story did not all interpret the film along the same lines. True to film editor Sam O'Steen's credo that "you see what you want to see," youthful fans like me took from *The Graduate* those elements that spoke to our personal experience of growing up in the late sixties. In that sense, the film functions as a cinematic Rorschach test.

David Ansen, who would later become a movie critic for *Newsweek*, was one of the viewers who found in *The Graduate* a revelation about the meaning of his own young adulthood. Forty years later, he wrote about the experience, noting that "when I first saw *The Graduate* it seemed to uncannily mirror my own life. Like

Dustin Hoffman's Benjamin, I had just graduated from a college in the East, returned home for a summer in Los Angeles (where I did my share of alienated pool-floating), and when I saw the movie I was, like Benjamin, in Berkeley. It was as if I were seeing my own life on screen for the first time: but of course everybody felt that way." According to Ansen, the secret of the film's appeal is that Benjamin—"who expresses no political opinions, never mentions any of the issues of the day, indeed barely speaks for the first (and best) half of the movie—was a blank slate upon which an entire generation was free to project its self-image." Ansen's insight helps explain the passion with which we young people took *The Graduate* to our hearts.

The voices of some of those young fans still echo through the years.

15

Fan Voices

"Like Benjamin, we weren't all sure what we wanted,
but we knew what we *didn't* want: 'plastics.'"
—David Ansen (2007), *Newsweek*

A t prestigious Stanford University, it's still an an-
nual tradition to screen *The Graduate* at year's end,
strictly for graduating seniors. Even today, most at-
tendees admit that, like Benjamin, they're a little worried about
their future. Journalist Marcus Mabry, a gay African American
born in 1967, has loved the film since he encountered it on the
Stanford campus: "I identified with Dustin Hoffman. Not over
the seduction, obviously, but over the plastics. The question of
what am I going to do with my life. What to do next, where to go."

One Stanford student body president from the sixties, David
Harris, would become famous as the leader of the national draft
resistance movement. Facing arrest for draft evasion, he strongly

connected with hard-edged 1967 films like *Bonnie and Clyde* and *Cool Hand Luke*. As he put it to me, "At the time, I was staring down the barrel of potentially five years in prison. So it's not hard for me to identify with the outlaws." Still, while on the brink of major life changes, Harris could also see himself in Benjamin Braddock's shoes. He recognized that he too was teetering on "that cusp where you're leaving parental authority and trying to step into the world on your own terms."

Jack Ong knew all about leaving parental authority. Ong was the seventh child born to a Chinese immigrant couple who ran a small store in Mesa, Arizona. Old enough, in the aftermath of World War II, to feel the sting of anti-Asian bias, young Jack found escape at the movies. He knew from early childhood that he and his youngest sister had been conceived to look after their old-world mother in her declining years. When the moment arrived, he did not shirk his obligation, though it weighed him down just when most in his age group were discovering adolescent freedom.

Then along came *The Graduate*, which Ong saw at least five times. He was especially enthralled by the film's ending, in which Ben—with the lovely Elaine at his side—runs away from society's constraints. By suggesting to him that he too could be a rebel, *The Graduate* helped change his approach to life. As he divulged to me, he quickly went from being "a really good boy living up to my prophecy" to someone quite different, a young man who felt compelled to go home and announce to his aging mother that she couldn't live with him any longer. (Fortunately his sister was there to take on the commitment. Meanwhile he himself, following this

spur-of-the-moment act of defiance, gradually became consumed with guilt. The result was years of addiction, a suicide attempt, and final redemption by way of a reborn religious faith.)

Ong's response may have been extreme, but he was not unique in finding in *The Graduate* a lesson about the possibility of breaking adult rules. Young viewers, some of them still in the throes of puberty, strongly identified with Ben's indecisiveness and sense of confusion. Those entering college readily adopted as a hero the son who refused to satisfy his parents' middle-class expectations. A Pennsylvania-bred fan, Dennis Palumbo, recalled for me that "I was on my way to college to be an engineer. I was the first of nine grandchildren, and I was gonna be doctor, lawyer, engineer, or—as a fallback position—priest. Those were my four choices. And I'll never forget the image of that party, where people kept going up to [Benjamin] and saying, 'Well, I'm just telling you the future, kid—plastics!' And he goes into the water in that scuba suit. And that's how I felt. I felt like I was drowning, because I didn't want to be an engineer." Palumbo eventually found the courage to become a screenwriter, and then a psychotherapist.

By contrast, Gerry Nelson was a New Yorker of immigrant stock, someone who was born near the end of the Great Depression and finished his schooling at a time when learning a trade was top priority. That's why he gravitated toward engineering, because it seemed "the best trade consistent with my abilities to earn a living for myself." Nelson explained to me that "the thing that was so appealing . . . about *The Graduate* was here was someone who was more or less giving himself the liberty to say 'I don't know *what* I want to do.'" In other words, Nelson loved the sense that

Benjamin Braddock felt free to experiment, even if that meant doing nothing at all until the spirit moved him.

Jody David Armour is a law professor who focuses on the impact of race on legal decision-making. But he started out as an Akron, Ohio, inner-city kid with a dad in prison. When he first encountered *The Graduate* on television in the late 1970s, he was instantly drawn to its lead character's refusal to focus his energies on making money. Armour told me, "As an adult I just take it for granted that money is a good thing, and you get as much money as you can. And if you get enough of it, you can spread some of it around to those that don't have it, but there's nothing wrong with getting money." Mulling over the allure of moneymaking, he admits, "I think that's sad that I tend to have that reflex now, because I can remember a time when that very materialistic way of looking at things was looked down on by some groups of people. And you could find those groups of people in a movie house, or [watching] TV in the middle of the night, when *The Graduate* came on."

This view of *The Graduate* as a critique of crass materialism is shared by star Dustin Hoffman, who tends to place the film in a specific historical context. I met Hoffman at a film industry gathering, held at an upscale Beverly Hills Mexican eatery. He proved surprisingly approachable, despite the throngs of fans waiting their chance to schmooze with the star. When I asked him why *The Graduate* hit a nerve with young audiences, he theorized that the film's youthful characters are "the children of Depression babies." The parents in *The Graduate*, said Hoffman, hailed from the generation that came of age in the cash-strapped 1930s. They worked hard, made their way, and became affluent in the booming

postwar economy. When relating to their offspring, as represented by Benjamin Braddock, "instead of love they gave *things*." What to me makes this comment so striking is that it nicely matches Hoffman's strained relationship with his own father, a product of the Depression era. Many moviegoers—reaching adulthood in the sixties—saw *The Graduate* as capturing their personal struggles with parents who'd come a long distance, economically speaking, and now had great expectations for the kids they'd hoped to guide toward their own slice of the American Dream.

I've also spoken to those who found in *The Graduate* a reflection of the era's widening cultural divide. True, youthful critics like Jacob Brackman didn't see the film's characters as going nearly far enough in their rebellion against the established order. But many others viewed *The Graduate* as endorsing the audacity of Baby Boomers who were initiating huge social changes on the American scene. That's why some mainstream authority figures regarded this film as a personal affront. Frank McAdams, a former Marine officer who served in Vietnam, reminisced to me about a major who meddled when a screening was scheduled for the grunts under his command. Instead, without warning, there was a last-minute substitution of some Doris Day movie. McAdams disclosed his conviction that "that major had something to do with it, because he didn't like the theme of *The Graduate*, the way that the older generation was portrayed. One of the reviews, I think it was in *Stars and Stripes*, said it was a definite counterculture film. So the major simply took it off the list, and our troops never saw the movie."

Hilton Obenzinger, once a shaggy-haired sixties activist at Columbia University, sent me a lively account of how a viewing

of this film led directly to a confrontation with the forces of law and order. It's a small story that throws light on the tension (and the ever-present possibility of violence) between generations at a watershed moment in American life:

> I was with several friends from Columbia during winter break in the Miami area, enjoying the warm weather and the prospect of a boat ride down the Keys. We went to see *The Graduate,* and when we left the movie house we were so giddy and exuberant that we all ran down the street, imitating a key moment in the film. Suddenly a cop car showed up and squealed to a stop beside us, the officer ordered us to halt (I don't think he had a revolver drawn, but we felt like he did), and then he threatened to arrest us. But when he discovered that we were only running down the street for fun and not crime, he sputtered: "What if there was a robbery just down the street? You could have been shot." We just stood dumbfounded. Then he waved us off and said something I've never forgotten: "Aw, take off—why don't you just go to the school yard and eat mushrooms!" How bizarre, we thought afterward, laughing every time we remembered the whole incident, especially his farewell. Mushrooms? If he had offered us some mushrooms we would certainly have taken him up on the offer!

Obenzinger's tale is a reminder of the appeal of *The Graduate* to high-spirited young rebels who delighted in thumbing their noses at the status quo.

The Graduate was denounced from many pulpits. More than one priest warned his flock that the film was anti-Catholic. Among some of the younger Roman Catholic clergy, though, there was a surprisingly different response, generated in part by the Church's recent clampdown on liberalizing trends. The midsixties was a time when many youthful Catholic educators returned to college, courtesy of government funding for teacher training. On campuses like Notre Dame, they heard from radical theologians, joined antiwar protests, and discovered avant-garde films. This heady era quickly ended in July 1968 when Pope Paul VI published his encyclical *Humanae Vitae*, which contained (among other things) a ringing affirmation of the Church's long-held ban on artificial birth control. Many of the younger clerics, who'd hoped for something far more progressive, were dismayed. Brother Gerard Molyneaux of the De La Salle Brothers was then teaching in a parochial high school. By the end of 1968, one-third of the brothers on the faculty had left their order.

The school to which Molyneaux had been sent was in leafy Mt. Lebanon, Pennsylvania. The neighborhood, as he described it to me, was "upper-middle-class, all-white, very wealthy, excellent schools." He told me that when *The Graduate* arrived, "I remember seeing it five times within a span of two weeks—I was that excited by it." The excitement was contagious. Molyneaux especially identified with Ben in the climactic church scene, swinging a large cross like a sword. It was a Friday night screening at a suburban theater, "and that audience was going crazy. I've never heard shouting and yelling and laughing and screaming like that since. . . . There was certainly an attack on religion, and, boy, it really hit the audience perfectly."

It hit Molyneaux hard too, particularly the fact that Benjamin Braddock "looks like St. Peter, the way that his jacket is draped across the front of him, when he's swinging that cross. He looks like a saint." The image of Ben, inside an antiseptic-looking church, facing down the forces of societal repression, spoke strongly to Molyneaux's hope for a more liberated and emotionally resonant theology.

MY FRIEND AND former colleague Mark Evan Schwartz is a native North Carolinian who would eventually become a professor of film studies. Schwartz tells me he's viewed *The Graduate* in three distinct periods of his life. In high school when the film first came out, he found it hilarious, and incredibly sexy. As a graduate student, he learned to appreciate Mike Nichols' brilliant cinematic choices. A few years back, when he and his wife sat down to see it yet again, both gravitated toward the sadness of Anne Bancroft's character and watched with tears in their eyes.

For a number of Baby Boomers, the film's sexiness was its great attraction. Adult sexuality as contained in Charles Webb's novel became far more titillating when presented in visual form on a movie screen. The film version of *The Graduate* served as wish fulfillment for many young men who dreamed of a red-hot older woman willing and able to school them in the pleasures of the flesh. Actor Jon Provost was well beyond his *Lassie* days when he saw *The Graduate*, and he let me know he found its appeal immediately obvious: "Wow! Tell me what seventeen-year-old kid didn't have that fantasy!" But right from the beginning, some viewers recognized the extent to which the film is also Mrs. Robinson's

story. Todd Leopold, a writer/producer for CNN Digital, has long wondered whether, as a creature of her own era, Mrs. Robinson could ever truly find freedom. He wrote to me, "If she'd come around ten years later, she'd be Jill Clayburgh in *An Unmarried Woman*; twenty-five, she could be either Thelma or Louise."

Young women of the sixties brought a female perspective to their viewing of *The Graduate*. Many had no trouble identifying with the male hero in his rejection of his parents' world. But the film touched their lives in other ways as well. Career coach Donie Nelson, newly divorced circa 1967, used *The Graduate* as a litmus test for her dates, judging from their reactions whether they were capable of taking risks. Writer Erica Manfred loved the movie upon its first release, but has since become bothered by its sexual politics—by the fact that the leading man is treated as heroic even though he has slept with his girlfriend's mother—and describes the overall impact as "terribly misogynistic." She notes that *The Graduate* arrived "on the cusp of feminism," and adds her conviction that "a few years later it wouldn't have been made. But it was about rebelling against the conformity of suburbia, and I sure identified with that: the hippie sensibility."

Some of the film's female fans, responding to the birth of the women's movement, focused from the start on Mrs. Robinson. In 1967 Ruth Rosen was a graduate student in history at UC Berkeley, Elaine Robinson's alma mater. As a member of Berkeley's first consciousness-raising group, Rosen met three young women who were already wives and mothers. She vividly described for me what she learned from their experience: "They felt trapped. . . . Not to mention that my mother talked about being trapped her whole

life. So this was not a new theme in my life, and it also frightened the hell out of me." Upon seeing *The Graduate*, she identified not with Ben but with his seducer, whom she viewed as a desperate housewife coerced by society into an unhappy marriage, reluctant childbearing, and furtive affairs. Accepting Mrs. Robinson's pathetic lot as a worst-case scenario, Rosen firmly resolved that her own life choices would be different. Though she has never lacked for romantic partners or family relationships, she has always been careful to preserve her own autonomy. Rosen ultimately took as her professional field of study the evolution of social gender roles. That's how she came to publish, in the year 2000, *The World Split Open: How the Modern Women's Movement Changed America*.

If *The Graduate* can be said to have taken the pulse of a generation, this was especially true when it came to responses to the film's final moments. Literary scholar Leo Braudy, born in 1941, spoke to me of a "downer" ending, in which our hero has "made the romantic gesture and he doesn't know what to do next." Braudy was not alone in seeing trouble ahead for the newly minted young couple at the back of the bus. Others too, products of sixties cynicism, suspected that Ben and Elaine were not bound for a life of happily-ever-after.

A strain of sixties optimism, though, encouraged many young people to see only rosy possibilities for those brave enough to buck the system. Katharine Haake, a college professor who grew up in a small California town, remembered to me that "we all thought it was great. I was fifteen. So what else was I going to think?" Draft resistance leader David Harris had no illusion that the road would

be smooth for Ben and his beloved, but he found it reassuring that they could escape as a couple. In his mind, the pair had the great advantage of being young, in love, and buoyed by the sense that they were ready for anything. Harris himself, soon to marry singer/activist Joan Baez, told me he knew just how they felt: "I was young, and in love, and thinking I was ready for anything too."

Given how many early moviegoers had big smiles on their faces when the lights came up, producer Lawrence Turman seems justified in assuming that most viewers would take the film's ending as a victory. As Dick Orton, a cinephile from Michigan, explained it to me, "The movie ends when you get the girl." But Orton's upbeat assessment of Ben's future hints at the ambiguity woven into *The Graduate*: "He's got a college education, he's a smart guy, he got the Halpingham award. And a beautiful woman at his side—he'll do okay. I'm sure he went into plastics."

16

Hollywood Hullabaloo

"We feel the story through Benjamin—his feelings are the ones we are also feeling. That's the first thing this movie taught me, how to tell a story through a character's point of view."
—Ron Howard (2000), *New York Times*

April 10, 1968: The California sun was still shining brightly as men and women in evening dress paraded up the red carpet in front of the Santa Monica Civic Auditorium. Onlookers spotted Dustin Hoffman, incongruously dressed in white tie and tails, escorting the pretty daughter of antiwar presidential candidate Eugene McCarthy. The occasion was the fortieth annual Academy Awards ceremony, celebrating the best films of the year 1967.

When viewers like me tuned in to ABC's first-ever color broadcast of the Oscar festivities, we witnessed a ritual that in many respects had not changed in decades. Hollywood's most beautiful people showed off their designer duds. Musical production

numbers dragged on too long. Winners were tearful, and losers tried hard to look nonchalant. Perennial emcee Bob Hope ogled pretty women and griped about once again going home empty-handed: "Welcome to the Academy Awards, or, as it's known in my house, Passover."

Still, it was hardly show business as usual. The ceremony had originally been scheduled for April 8. But at 6:01 p.m. on April 4, 1968, civil rights leader Martin Luther King Jr. was fatally shot on a motel balcony in Memphis. With Dr. King's funeral slated for April 9, five of the Oscar show's major participants—Rod Steiger, Sidney Poitier, Louis Armstrong, Diahann Carroll, and Sammy Davis Jr.—announced they would boycott if the Academy Awards went on as planned. In response, board members scrambled to delay the Oscar festivities until the public grief surrounding Dr. King's death had subsided. So what audiences saw on April 10 was a curious amalgam of solemnity and fluff. Academy President Gregory Peck kicked off the evening by paying tribute to Dr. King's memory. I remember cringing when he was followed by Hope, who wisecracked that the postponement had been hard on the nominees: "How would you like to spend two days in a crouch?"

What made the 1968 Oscar ceremony so exciting for me and for other youthful cineastes was that it honored a landmark year for American film. It was in 1967 that Hollywood movies finally acknowledged the dramatic changes occurring within the American social landscape. This was a time when white flight was becoming a major issue in American cities and a year when six summer days of racially charged violence in Newark, New Jersey, left over

two dozen people dead. Now some filmmakers were exploring with great moral seriousness the plight of the African American. And the other big issues of the late sixties—the Vietnam War, the sexual revolution, the rise of a youth culture distrustful of the established order—were suddenly being refracted in the year's most talked-about films.

Of the five nominees for the Best Picture of 1967, two starred Sidney Poitier, who had recently been named America's number one box-office draw. In *Guess Who's Coming to Dinner*, Poitier played a well-bred young woman's unexpected fiancé, perfect in every way except for the color of his skin. *In the Heat of the Night* presented him as a tough, smart big-city detective who earns the respect of Rod Steiger's bigoted Southern police chief. Both films allowed an African American to be seen in heroic terms, using Poitier iconically to shatter age-old stereotypes. The critics' darling in 1967 (and a film hugely admired by young campus activists) was *Bonnie and Clyde*, which adapted techniques of the French New Wave to an American setting and broke new ground in its handling of screen violence. Though telling a story of rural outlaws during the Great Depression, *Bonnie and Clyde* had distinct ramifications for its own equally bloody era: Director Arthur Penn told me that he shot the film with the carnage of Vietnam very much on his mind. An odd anomaly among the Best Picture candidates was *Doctor Dolittle*, an old-fashioned family musical starring Rex Harrison as the whimsical veterinarian who can talk to animals. This lavish, lumbering flop gained its place on the nominee list mostly through the machinations of Twentieth Century-Fox, which—as revealed in John Gregory Dunne's juicy tell-all, *The*

Studio—had poured into its production the then-princely sum of $15 million. (Today this would be more like $106 million.) After wining and dining Academy voters, the studio ended up with nine nominations for its white elephant.

By far the most popular of the year's nominated films among ticket-buyers was *The Graduate*. But that hardly meant it was due to be blessed with Oscar love. *The Graduate* was a small comedy vying against ambitious dramas. And it had the additional disadvantage of its outsider status: Voters back then were accustomed to supporting en masse the output of the major studios with which they were affiliated. When nominations were announced, the public learned that *The Graduate* had earned a total of seven, two fewer than *Doctor Dolittle*, while *Bonnie and Clyde* and *Guess Who's Coming to Dinner* jointly led the pack with ten. Impressively, *The Graduate*'s nods came in so-called prestige categories: Best Picture, Best Director, Best Actor, Best Actress, Best Supporting Actress, Best Screenplay Based on Material from Another Medium, Best Cinematography. Joseph E. Levine, never one to let a golden opportunity go to waste, got busy on a new ad campaign.

Sitting in a prime seat on Oscar night, waiting to find out if he'd be called to the stage as the producer of the year's best feature film, Larry Turman was nervous. Did King's assassination cast a pall over the ceremony for him? My question gave him pause. Then: "Well, I'd like to sound really classy, elegant, and sensitive and say 'Absolutely!'" Turman prefers to consider himself "involved, committed, caring," when it comes to righting the wrongs of American society. But on an evening when Hollywood celebrated Hollywood, it was *The Graduate* that occupied his mind.

At first there was not much for him to cheer about. A nervous-looking Dustin Hoffman and Katharine Ross (in a modest white gown and long gloves) were introduced by Bob Hope as "kids" who might not be experienced enough to read cue cards. They presented the cinematography Oscar to Burnett Guffey for his vivid work on *Bonnie and Clyde*. An exuberant Estelle Parsons collected the Best Supporting Actress Oscar for playing Blanche Barrow in the same film, which was beginning to look like the one to beat. But Dustin Hoffman's former roommate (and, briefly, cast mate) Gene Hackman, nominated as Best Supporting Actor for his *Bonnie and Clyde* role, was bested by George Kennedy, who played a sympathetic convict in *Cool Hand Luke*. In the adapted screenplay category, the possibility of a wrestling match between Calder Willingham and Buck Henry over authorship of *The Graduate* was forestalled when the Oscar went instead to Stirling Silliphant for *In the Heat of the Night*.

In the top acting categories, *The Graduate* continued to be shut out. Dustin Hoffman and *Bonnie and Clyde*'s Warren Beatty, both in the vanguard of what was coming to be dubbed the New Hollywood, were upstaged by veteran actor Rod Steiger for his memorable performance as *In the Heat of the Night*'s good ol' boy sheriff Gillespie. In an era when winners largely refrained from injecting politics into their speeches, only Steiger, accepting his Best Actor Oscar, called attention to the larger issues at hand by proclaiming that "I'd like to thank Mr. Sidney Poitier for the pleasure of his friendship, which gave me the knowledge and understanding of prejudice in order to enhance my performance. Thank you, and we *shall* overcome."

The Best Actress winner was a surprise. The smart money was on Anne Bancroft, or on Faye Dunaway for *Bonnie and Clyde*, but the name in the envelope was that of Katharine Hepburn, for playing a supportive wife and mother dealing with social change in *Guess Who's Coming to Dinner*. It was hardly the most demanding role of Hepburn's stellar career, and I had a hunch the award was a sentimental nod to Hepburn's long personal and professional relationship with Spencer Tracy. Tracy had died a mere three weeks after he finished portraying Hepburn's spouse in this film, one whose gentle approach to the nation's black-and-white divide was timely, though many found it somewhat unconvincing.

With the evening trending toward an embrace of films that dealt with racial issues, it was not a total shock when the Best Picture Oscar went to *In the Heat of the Night*, a well-crafted but stylistically conventional thriller. Like many young people watching on TV, I was dismayed that my favorites had gone down to defeat. But insiders like Larry Turman and Arthur Penn personally told me that *The Graduate* and *Bonnie and Clyde*—two bold artistic works championed by hip audiences—had surely canceled each other out. At least *The Graduate* did not go home empty-handed. Although Best Picture and Best Director honors traditionally are won by the same film, it was Mike Nichols (not Norman Jewison of *In the Heat of the Night*) who was singled out for his directorial achievement. Nichols had gained Hollywood's respect as well as an Oscar nomination for his very first film, *Who's Afraid of Virginia Woolf?* Now *The Graduate* had elevated him into the Hollywood pantheon. He made a short, gracious speech: "Until this moment, my greatest pleasure in *The Graduate* was making it. Because it's

a picture made by a group, and we cared for each other and we cared for what we were doing. So this award quite literally belongs to them at least as much as it does to me."

Years later, Nichols admitted to film historian Mark Harris that winning the golden statuette in fact gave him little pleasure. "Back then," he explained, "I was a) very spoiled, b) very neurotic, and c) I had a very impaired sense of reality. To me, the Academy Award meant that you ended up at the Beverly Hills Hotel at midnight feeling empty. I don't know where I was, but that night, I just wasn't there." It's a telling remark, one that underscores Nichols' own unlikely resemblance to Benjamin Braddock. Buck Henry once noted that his friend Nichols, who had started out with so little to call his own, deeply wanted and needed adulation. Still, when invited to celebrate the fruits of his labors, Nichols— like Benjamin—sometimes responded by cutting himself off from those who came to pay him tribute.

NICHOLS MAY HAVE felt empty after his Oscar win, but he had the satisfaction of knowing that his film had helped transform Hollywood. It contributed to the downfall of the antiquated studio system by showing that major commercial success was possible without reliance on the Hollywood studios' vast web of resources. By conveying a frank sexuality and revealing that beds could be used for something other than sleeping, it hastened the demise of prim romantic comedies in the Doris Day mold. At the same time, it conditioned American audiences to change their notions of what was acceptable for on-screen viewing. Almost overnight, *The Graduate*'s subliminal flashes of a woman's bare breasts would come to seem tame indeed.

Along with *Bonnie and Clyde* (and, two years later, *Easy Rider*), *The Graduate* also helped convince studio bosses that young adults comprised an audience that should be served. By the early seventies, studios were busily greenlighting projects specifically tailored to my generation of youthful moviegoers. This meant films about war, as seen through the eyes of reluctant draftees, like the doctor-soldiers in Robert Altman's 1970 Korean War satire, *M*A*S*H*, who choose juvenile hijinks as a form of protest against the powers that be. It also meant films that highlighted the tension between generations. One such was Bob Rafelson's *Five Easy Pieces* (1970), in which a brash young Jack Nicholson tries fiercely to separate himself from the standards set by his upper-crust family. Then there was 1973's *American Graffiti*: USC film school graduate George Lucas enlisted a smart young cast to spark audience nostalgia for what it felt like to come of age in 1962. *American Graffiti*'s reliance on a musical score entirely composed of rock 'n' roll oldies hearkened back to the use of familiar Paul Simon tunes to set the mood in *The Graduate*. And Lucas was one of many up-and-coming movie folk—the majority of them film school alumni—who shared Mike Nichols' appreciation for European New Wave stylistics, and were looking for ways to deviate from classic Hollywood cinematic practices. (For Lucas this meant encouraging improv and shooting in sequence, in what he called a documentary style.) But beyond all this, *American Graffiti* was marked by its affection for youthful shenanigans, and by keen awareness of the painful process of growing up.

Some of the new decade's movies for young audiences tried hard to be timely. *Getting Straight* (1970), set on a large university campus, melds Vietnam nightmares with a brutal clash between

student activists and riot police. At its center is an idealistic yet cynical graduate student (Elliott Gould) who must decide where he stands. A bedroom glimpse of Gould through the shapely legs of fellow student Candice Bergen clearly evokes *The Graduate*. This image was prominently featured in some advertising posters and on the cover of the soundtrack album, but the film performed modestly, and today it's remembered mostly as a period piece.

Meanwhile, *The Graduate*'s famous romantic entanglements were mirrored in a 1972 dark comedy, *The Heartbreak Kid*, which took Elaine Robinson's aborted nuptials one step further. Though traditional romantic comedies often close with an exuberant wedding celebration, this film opens with one. But then we watch Charles Grodin, as a youngish New York sporting-goods salesman, dump his annoying bride of three days during their Miami Beach honeymoon, in order to pursue a gorgeous blonde Minnesota coed played by Cybill Shepherd. Before the final fade-out, there's a second wedding, but no promise of happily-ever-after. This project, obviously meant to shock and amuse, involved several of Mike Nichols' close associates. It was the second film directed by his longtime comedic partner, Elaine May, and was written for the screen by his Broadway crony, Neil Simon, adapting a Bruce Jay Friedman short story. *The Heartbreak Kid* was popular enough to be remade (with major plot changes) by the Farrelly brothers in 2007; in its own day it was enjoyed by audiences and praised by critics like Vincent Canby of the *New York Times*, who called it "a first-class American comedy, as startling in its way as was *The Graduate*."

The Heartbreak Kid is certainly funny, but it has never inspired

the same long-term devotion as *The Graduate*. Yes, it continues the now-familiar trope of young people flouting adult expectations, but to me it lacks specific appeal for postadolescents looking to rebel against their parents' world. Ben and Elaine may have won the affection of youthful viewers, but the self-centered twosome who come together at the end of *The Heartbreak Kid* are as thoroughly repellent to viewers like me as is the jilted bride. This is, for better or for worse, a movie that doesn't like any of its characters terribly well. It strikes me as remarkable that the film's star, Charles Grodin, was very much in the running to play Benjamin Braddock. *The Heartbreak Kid* boosted Grodin's long and distinguished acting career, but in it he lacks the sweetness that makes Dustin Hoffman's Ben (whatever his misbehavior) so easy to embrace.

Ben might have been—at least in Mike Nichols' mind—Jewish inside, but externally both the Braddock and the Robinson families are representatives of American WASP culture. That's another way in which *The Heartbreak Kid* is a film with a difference: It consciously sets up a Jewish marriage that is overthrown by the blonde allure of a shiksa. In its day, this rendered it just as controversial within the mainstream Jewish community as Philip Roth's outrageous 1969 novel, *Portnoy's Complaint* (which itself would be filmed in 1972). Without question, *The Heartbreak Kid* proved offensive to many American Jews.

But although such projects, with their sardonic glimpses of bourgeois Jewish American culture, made some moviegoers queasy, the new era was a boon to actors from Jewish backgrounds. Suddenly they no longer had to fret about not resembling the WASP

ideal, nor did they need to hide (as such stars as John Garfield and Kirk Douglas had done) behind anglicized names. The casting of Dustin Hoffman as *The Graduate*'s romantic leading man was a shock to Hollywood, which had spent decades trying to sidestep the Judaic roots of its founders. But in the wake of *The Graduate*, young Jewish males were suddenly everywhere, and often they were playing characters with backgrounds similar to their own. This was the era that launched Richard Benjamin (*Goodbye, Columbus*, 1969), and Richard Dreyfuss (*The Goodbye Girl*, 1977), along with Grodin. It was all part of what film critic J. Hoberman, paying tribute to Elliott Gould in the *Village Voice*, wittily called the Jew Wave. Nor were actors with Jewish parentage the only ones who benefitted from the loosening of Hollywood's standards of masculine good looks. Such obviously ethnic performers as Al Pacino and Robert De Niro could thank Dustin Hoffman for helping to break the ice.

I should add—as film historian Neal Gabler does in *Barbra Streisand: Redefining Beauty, Femininity, and Power*—that in the late sixties Streisand boldly made her ethnicity a part of her public appeal. In the wake of her success, many young girls thought twice about requesting a nose job as a Sweet Sixteen gift. But I would argue that Streisand started no trend toward the acceptance of other leading ladies who defied the WASP standard of female attractiveness. In fact, most of the Jewish actors Hoberman mentions in his "Jew Wave" article were paired on-screen with the likes of Marsha Mason, Candice Bergen, and (in the case of Dustin Hoffman) such luscious blondes as Mia Farrow, Faye Dunaway, Susan George, and Meryl Streep. Nice Jewish girls, in other words,

continued to be (as *The Heartbreak Kid* had shown) Hollywood rejects.

When it came to men, though, at least one famous Hollywood hunk was alarmed at the apparent shift in public taste. Neile McQueen Toffel has revealed that *The Graduate* brought out all her husband's insecurities. Said Steve McQueen after seeing Dustin Hoffman's performance, "God, baby, I can't believe this guy's going to be a movie star, can you? I mean, he is one ugly cat. Good actor, yeah, but he sure is homely." McQueen brooded a great deal about the possibility that he and such classically handsome talents as Paul Newman might be shoved aside by the newcomer. Toffel writes in her memoir that "Steve would stare at his image in the mirror and say to me, 'Look at that, baby, take a look at that face and that body and tell me the truth. Who would you pick, him or me?' We would both laugh, although I knew he was serious."

STEVE McQUEEN MAY have been remarkably unsettled by the unconventional looks of Dustin Hoffman, but many a would-be actor saw Hoffman as an inspiration. Ed Begley Jr. is just one Baby Boomer who chose acting as a profession after watching *The Graduate*. A generation later, when high-school student Jason Schwartzman was cast in the leading role of Wes Anderson's *Rushmore*, his mother, Talia Shire, rented for him three films she felt would capture the spirit of his misfit character. These included *The Graduate*, as well as the 1971 oddball classic *Harold and Maude* and 1975's Al Pacino heist drama, *Dog Day Afternoon*.

Yet it was young directors who most passionately embraced *The Graduate* as a lesson in filmmaking. When Ron Howard first

saw *The Graduate*, he was not yet fourteen years old and was still playing Opie on *The Andy Griffith Show*. Though an actor since age five, he had long been fascinated by what went on behind the camera. So his father's invitation to come see *The Graduate* in first-run was life-changing. Howard told the *New York Times* in 2000 how much he had been affected by Mike Nichols' razzle-dazzle stylistics: "This is the movie that made me realize what it meant to direct a movie, what was really involved." After that first viewing, "I just kept revisiting it. At first, not analyzing, just enjoying it. But then, as I saw it more and more often, analyzing it." In 1972, while shooting *American Graffiti* in Northern California, he and cast mate Charlie Martin Smith—another aspiring director—spent hours discussing *The Graduate*, then watched it a few more times at a local drive-in. (Back then, of course, home video did not exist, so a film basically had to be seen in theaters, or not at all. One corollary was that a really popular movie could stick around in local cinemas for years on end. Famously, a French antiwar film called *King of Hearts* played in an art house near Harvard University for half a decade.) By Ron Howard's own admission, *The Graduate* helped shape him into the Oscar-winning director he is today. All in all, says the USC dropout, "this is the movie that I went to school on."

As film studies programs grew in popularity at colleges across the nation, many students began toting around Louis Giannetti's *Understanding Movies* (first published in 1972), which made frequent references to *The Graduate*'s aesthetic choices. More than twenty-five years later, Richard T. Jameson wrote in the scholarly *Film Comment* that "no other film in going-on-seven decades

had so decisively made so many people notice the kinds of selection and design that can go into making the movie experience." Among today's most admired filmmakers, those who've mentioned the impact of *The Graduate* on their own work include Steven Soderbergh, David O. Russell, Todd Haynes, and the Coen brothers. Steven Spielberg has called *The Graduate* "a visual watershed," praising in particular its inventive use of long lenses (as in the scene wherein Elaine discovers the affair between Ben and her mother) as an effective way to illuminate character.

The influence of *The Graduate* even crossed the Pacific Ocean. Growing up in Taiwan, Ang Lee felt obliged to follow in the footsteps of his father, an academic steeped in the Chinese classics. That's why at first Lee steered clear of filmmaking as a career choice. Yet when he saw *The Graduate*, he became convinced there was nothing frivolous about making movies. This new conviction led him to New York University's Tisch School of the Arts, and ultimately to Best Director Oscars for both *Brokeback Mountain* and *Life of Pi*.

THROUGH THE YEARS, many Hollywood films have reminded viewers of the tone and subject matter of *The Graduate*. In 1999 it was the Oscar-winning *American Beauty*, with Kevin Spacey starring in a dark dissection of American suburbia. Spacey's Lester Burnham, a forty-two-year-old ad executive, might well have been Benjamin Braddock facing a midlife crisis. Though Lester has a pretty wife, an appealing teenage daughter, and a lovely home, he's far from happy about what adulthood has brought him. His fundamental disillusionment seems to stem largely from the collapse

of his marriage to Carolyn (played by Annette Bening). Old photos prove that these two once had spunk and audacity, and that they were happy together. Now Lester is desperately trying to regain a youthful sense of wonder, with tragic results.

American Beauty can fairly be called the flip side of *The Graduate*. Its central characters are far older and sadder than Benjamin and Elaine. Their world contains new problems—like drugs and homophobia—that *The Graduate* doesn't tackle. And the film's ending is less an exuberant escape from the status quo than it is a poignant leave-taking. But this film stylistically resembles Mike Nichols' intricate work on *The Graduate*, using camera angles and set design creatively to underscore the way Lester and his contemporaries are held captive by their surroundings. First-time film director Sam Mendes, like Nichols before him, came from the stage. Like Nichols in *The Graduate*, he infused *American Beauty* with a novice's excitement about the motion picture medium. In fact, Mike Nichols himself had been offered the chance to direct Alan Ball's powerful script. Nichols chose to turn down the project because of other commitments, but was soon an outspoken admirer of what Mendes had wrought.

Some viewers have also spotted similarities to *The Graduate* in youth-centered movies like *Rushmore* (1998) and *Garden State* (2004), in both of which a sensitive young man chafes at conforming to the rules of adult society. For female viewers there was Howard Zieff's popular 1980 comedy, *Private Benjamin*, presenting a young woman (Goldie Hawn) on the brink of a dream marriage who realizes in the nick of time that her fiancé is not good husband material. In her couture wedding gown, in front of

a chapel full of guests, she punches him in the jaw and walks out on the ceremony, tossing her veil to the breeze. Social historian Susan Faludi, noting the similarity to *The Graduate*, points out that "in the feminist version of this escape-from-the-altar scenario, it was no longer necessary for a man to be on hand as the agent of liberation." So in Faludi's terms it's as though Elaine Robinson no longer requires a Ben to free her from the shackles of an unwanted marriage and an oppressive family life. In a post-sixties version of *The Graduate*, she can take care of the matter herself.

An award-winning indie film from 2009 shows how a younger generation has adopted *The Graduate* as its own. *(500) Days of Summer* is an appealingly quirky romantic tale set among young hipsters who live and work in downtown Los Angeles. The protagonist, played by Joseph Gordon-Levitt, is a designer of sappy greeting cards who once studied to be an architect. Here's how he's introduced by the off-screen narrator: "This is a story of boy meets girl. The boy, Tom Hansen of Margate, New Jersey, grew up believing that he'd never truly be happy until the day he met The One. This belief stemmed from early exposure to sad British pop music and a total misreading of the movie *The Graduate*." Unfortunately for Tom, his beautiful coworker, Summer Finn (Zooey Deschanel), doesn't share his faith in the primacy of happily-ever-after love. Tom and Summer's relationship will ebb and flow, but late in the film there's a pivotal moment in which they venture out to see *The Graduate* at a local revival house. The surprise is that Ben and Elaine's escape from the church at the film's ending reduces Summer to tears. She won't tell Tom what's wrong, won't take his hand, won't allow him to buy her dinner. Her

unexpectedly heartfelt reaction to *The Graduate* is our first clue that she's not the adorable cynic he's always assumed her to be. And it's also the moment of Tom's first realization that she's slipping out of his grasp.

How exactly has Tom misread *The Graduate*? Throughout the film he has clung to the view that love is destiny, that the two of them are meant for each other, to have and to hold, forevermore. But this is not exactly a mature perspective on life with the capricious Summer. Like Ben and Elaine, Tom and Summer are at their most endearing when their behavior as a couple is fundamentally childlike. There's that delicious moment, for instance, when they pretend that an Ikea furniture store is their private home, mysteriously invaded by a large family of Chinese shoppers. At the fade-out of *The Graduate*, Ben and Elaine may or may not be recognizing the daunting need to grow up. Summer appears, at the close of *(500) Days of Summer*, to have arrived at something of the same place, leaving Tom and his adolescent fantasies far behind. But all is not lost. He remains a romantic, though a bruised one, and we're rooting for him as he boyishly embarks on new possibilities. Adulthood can wait. He's Benjamin Braddock on the trail of another dream girl.

BENJAMIN BRADDOCK WON our hearts by fleeing the traps posed by his parents and their generation. It can be argued that this century's most uproarious screen comedies owe something to Ben's refusal to join the adult world on its own terms. *The Hangover*, from 2009, is one example: It's the kind of boys-will-be-boys buddy flick in which seemingly grown-up males light out for Las Vegas

in order to kick over the traces of their humdrum adult existence. These particular boy-men, though, don't seem capable of the kind of growth shown by Ben in *The Graduate*.

When Mike Nichols was still alive, he and today's iconic writer-director-producer Judd Apatow sincerely admired each other's comedic work. The unrepentant slackers of such Apatow hits as 2007's *Knocked Up*—grooving endlessly on weed, smutty sex talk, and a blithe disregard for mature behavior—might make us think back to the postgraduation Ben, who saw nothing wrong with devoting his days to beer, sex, television, and a swimming-pool raft. Still, Ben is capable of shaking off idleness and spring-ing into action once he finds meaning in his life by way of love. Something of the same dynamic animates Seth Rogen's slacker character in *Knocked Up*, although (at least at first) he's moved less by love than by a sense of responsibility to his unborn child. The box-office success of this film, in which two accidental parents-to-be bond over their obligation to their unexpected bundle of joy, proves that audiences can still respond to an outrageous premise in which likable characters defy the familiar rules of social behavior to forge their own path.

But not every film inspired by Benjamin Braddock is suc-cessfully outrageous. In 2005, almost forty years after *The Graduate's* release, Hollywood made a sly attempt to update the film's cast of characters. *Rumor Has It*, directed by the usually bankable Rob Reiner, was presented not as a literal sequel to *The Graduate* but rather as a glimpse at the later lives of two Pasadenans who were supposedly the inspirations for Charles Webb's Benjamin and Mrs. Robinson. In the world of this follow-up, a Benjamin-type

who has surprisingly evolved into a tech mogul (Kevin Costner) rocks a household ruled by a still-powerful matriarch (Shirley MacLaine), and somehow ends up in bed with MacLaine's young granddaughter (Jennifer Aniston). What's supposed to fuel the laughs is the fact that Costner has now slept with three generations of women from the same family; there's also the kinky possibility that Aniston's character is in fact his own daughter. But when the film was released, hilarity did not ensue—and *Rumor Has It*, though widely promoted, mercifully disappeared.

As an attempt at capitalizing on *The Graduate*, *Rumor Has It* was clearly a miscalculation. Partly the problem stemmed from filmmakers' assumption that Benjamin's famous interplay with Mrs. Robinson would be funny in any context. But *The Graduate* remains lodged in so many brains at least partly because it captured the concerns of a specific (and a highly eventful) era. To remove the story from its time and place is to rob it of much of the emotional resonance that it has accrued over the years. Nonetheless, producers keep trying to find ways to recapture the magic.

In 1980, readers of Hank Grant's column in the *Hollywood Reporter* learned of a plan to turn *The Graduate* into a Broadway musical, with Shirley Jones stepping into Mrs. Robinson's sheer black stockings. Nothing came of this, but a theatrical adaptation of *The Graduate* made its London debut in 2000. The nonmusical play, by Terry Johnson, combined the main thrust of Charles Webb's novel with some borrowings from the movie ("Plastics"). It then added eccentric new material, like the Braddock family's joint visit to a psychiatrist and a final scene in which Ben, after that fateful bus ride, tries to cheer up Elaine in their drab motel

room by gifting her with a box of her favorite breakfast cereal. (Once Elaine learns about Ben's past sexual history, mother and daughter acknowledge the change in their relationship by getting drunk together in what strikes me as a highly perverse bonding ritual.) The stage production—which boasted some Simon and Garfunkel tunes but nothing resembling Mike Nichols' directorial flourishes—was a moderate hit, first in the West End and then on Broadway. It surely owed its short-lived popularity to the audience's fond recollections of the 1967 film, as well as the fact that zaftig Kathleen Turner, playing Mrs. Robinson, briefly bared all. On this topic, Mike Nichols waspishly quipped to Richard Corliss of *Time*, "I didn't see the stage production, but it interested me that people would throng to see a 50-year-old naked woman, when most of them had a perfectly good one at home."

This ill-advised stage venture served to highlight how very successful, aesthetically as well as commercially, the film adaptation of Webb's *The Graduate* had been. For those involved with the making of the movie, *The Graduate* paid dividends that had nothing to do with plastics. Many of them graduated (with honors) to even bigger ventures. One, though, decidedly did not.

17

Speaking of Sequels

"All this drama in my life, all this financial crisis—it's really playing a role. The penniless author has always been the stereotype that works for me. . . . When in doubt, be down and out."
—**Charles Webb (2008),** *Los Angeles Times*

Dustin Hoffman had his own idea for a sequel. In 1992, to commemorate the twenty-fifth anniversary of *The Graduate*, he sat down for a videotaped conversation with entertainment journalist Craig Modderno. Hoffman explained to Modderno that he envisioned himself playing a middle-aged Benjamin Braddock, one whose marriage to Elaine had long grown stale. The crux of the story would be Ben's secret affair with his young son's girlfriend. He divulged he had broached this concept to Mike Nichols, who immediately grasped its implication: that Benjamin had turned into Mrs. Robinson. Nichols suggested that perhaps in this scenario Ben would be making his living as a director of TV commercials, a "plastic" profession if there ever

was one. Nothing came of Hoffman's brainstorm, though it's remarkable how closely his story outline resembles the plot of 1999's Oscar-winning *American Beauty*, in which a fortysomething ad exec reverts to adolescent sexual longings as a way out of his safe suburban existence.

When a much-younger Hoffman finished shooting *The Graduate*, however, his chief goal was to distance himself as far as possible from the role of Benjamin Braddock. He was embarrassed by all the attention that the film had brought him, and felt he didn't deserve the acclaim. As a perfectionist, he anticipated being found out as a failure or a fraud. At the same time, he resented the popular notion that Mike Nichols had simply stumbled across a real-life Benjamin and put him on screen for all to see. He was frustrated that many fans—especially young women—misperceived him as "an innocent who walked around with 'The Sound of Silence' always playing in the background wherever I went."

On April 25, 1968, an interview with Hoffman was published in the *Columbia Daily Spectator*, the student-run newspaper at New York's Columbia University. Given that the piece appeared while angry protesters were occupying campus buildings, it's perhaps no surprise that Hoffman found his own way to sound like a rebel. He told racy stories about his sexual initiation as a teenager and about his adventures on the set of *The Graduate*, where Anne Bancroft's stark-naked body double definitely held his interest. But he claimed to have little concern for the movie's reception. When asked about a harsh review in *Time*, he responded coolly, "I couldn't care less about *Time* magazine, I couldn't care less about the *New York Times*. I must say, I don't even care about

The Graduate that much. I just did the job and the hell with it."
Though an ambitious young actor who had just been launched on
a major career, Hoffman was trying hard to separate himself from
the hidebound Hollywood Establishment.

Mike Nichols thought he understood what Hoffman was
going through. Nichols speculated in 1968 to a writer from a Brit-
ish film journal that the newly minted movie actor had been up-
ended by his overnight celebrity: "I would see him on television in
various immensely vulgar TV shows being interviewed and having
Israeli starlets flirting with him and having moronic interviewers
asking unanswerable questions and he seemed exactly like the boy
in the picture. There was no way to answer anything that was said
to him; there was no way for him to behave." In Nichols' terms,
the success of *The Graduate* had turned Hoffman into Benjamin
Braddock, just home from college and facing the adulation of his
parents' friends, whether he liked it or not.

As a performer Dustin Hoffman was determined to showcase
his range. That's why, even while insisting that his true place was
on the New York stage, he actively campaigned for the role of
the down-and-out Ratso Rizzo in John Schlesinger's upcoming
dramatic film, *Midnight Cowboy*. To prove he could separate him-
self from Benjamin Braddock's buttoned-down image, he stopped
shaving and dressed like a street bum to meet Schlesinger in a
Times Square automat at 1 a.m. Playing Ratso won him respect as
well as a second Oscar nomination, but Mike Nichols was shocked
that he'd settled for what was in some respects a supporting role.
Hoffman remembers Nichols griping, "I made you a star, and
you're going to throw it all away? You're a leading man and now

you're going to play this? *The Graduate* was so clean, and this is so dirty."

Hoffman has always regarded Mike Nichols with admiration, and Nichols spoke graciously about Hoffman's talents as well. But their relationship was clearly complicated. Film editor Sam O'Steen insisted in his *Cut to the Chase* that Hoffman badly wanted to play the slippery Milo in Nichols' first post-*Graduate* film, a 1970 adaptation of Joseph Heller's widely discussed World War II novel, *Catch-22*. Buck Henry was entrusted with the screenplay, O'Steen again manned the editing room, and Richard Sylbert returned to take charge of the production design. Elizabeth Wilson, Norman Fell, Charles Grodin, and even Art Garfunkel were featured in the all-star cast. But the part Hoffman coveted went to his *Midnight Cowboy* costar, Jon Voigt. Although over the years Hoffman continued to send Nichols scripts, they never again joined forces. O'Steen's surmise is that Nichols was deliberately choosing not to work with his former protégé. Larry Turman told me his own theory, based on the fact that immediately after *The Graduate* was in the can, Nichols signed on to direct Anne Bancroft in a prestige production of Lillian Hellman's *The Little Foxes*, produced on Broadway by New York's Lincoln Center. If Turman's recollection is accurate, Hoffman was offered a role in this stellar revival, but turned it down. Turman explains that Nichols, despite a tough exterior, could sometimes be intensely vulnerable. So the turndown by Hoffman "might have engendered Mike's frustration, anger, hostility, who knows what."

But Dustin Hoffman—though denied the chance to be part of another Mike Nichols film ensemble—hasn't suffered from a

lack of good opportunities. Yes, there was a time, early on, when paparazzi delighted in snapping photos of the Graduate himself waiting in unemployment lines to collect his $55 weekly stipend. Still, he has earned challenging roles in many talked-about films. *Kramer vs. Kramer* (1979) won him his first Oscar, and he added a second for *Rain Man* (1988). As he's grown older, he's become more willing to play smaller parts, like Ben Stiller's affable Jewish father in *Meet the Fockers*. He has also made his directorial bow by way of a delicate 2012 English film about aging musicians, *Quartet*. At the 2017 Cannes Film Festival, his role as a difficult dad in Noah Baumbach's *The Meyerowitz Stories* won wide acclaim.

Although from the start Hoffman has seemed to resist the trappings of stardom, those who know him tell a different story. Through the years he has craved attention while simultaneously pretending not to care. Producer Robert Evans, in his raucous memoir, *The Kid Stays in the Picture*, describes what happened when Evans and Hoffman attended the Cannes Film Festival with their then-wives in the early 1970s. On the Croisette, the two tennis buddies played the game of stopping passersby, taking bets on which hummed tune would be recognized more quickly, "Mrs. Robinson" or the theme from Evans' own big hit, *Love Story*. Evans further casts doubt on Hoffman's lofty pronouncements about his aesthetic goals, noting that "I knew all too well that when it came to making a deal, Dustin was more concerned with green than art."

Meanwhile former Hoffman colleagues have hinted that as his Hollywood clout increased so did his prickly perfectionism: He was liable to pull rank both on set and off. Sam O'Steen

recalls that Hoffman was no troublemaker early in the shoot of *The Graduate*, but that he gradually developed the bad habit of screaming at underlings, like one unfortunate assistant director whom he blamed for misplacing his script. Near the end of her life, actress Elizabeth Wilson disclosed that she and Hoffman had been chums in their Off-Broadway days, and that they remained friendly during the filming of *The Graduate*. Later, however, she declared herself heartbroken when word got back to her that he'd said, "She'll never become very famous. I don't want to move around with people who are not well-known; I don't want that stigma. I only want to be with well-known, successful people."

Taken at face value, such suggestions of arrogance on Hoffman's part hardly speak well of him. But the consensus is that over the years he's become a kinder and gentler person. And also, it seems, one who's more comfortable in his own skin. A *New York Times* interview from 2005, marking the gala being thrown in his honor by the Film Society of Lincoln Center, was titled "Dustin Hoffman Stops Trying So Hard." Now that he's one of Hollywood's elder statesmen, he focuses on his family, accepts roles for the fun of it, and has even dabbled in community involvement. (He currently chairs the artistic advisory board of the Broad Stage, an ambitious arts complex that's overseen by Santa Monica College, which was where he first discovered acting.) Hoffman may never have returned to the role of Benjamin Braddock, but there's no question that *The Graduate* has given him a summa cum laude life.

Throughout their professional careers, other major players have tried hard to outrun the shadow of *The Graduate*. Though the

beautiful Katharine Ross quickly took on other high-profile parts, notably as the earthy Etta Place in 1969's *Butch Cassidy and the Sundance Kid*, she was never able to stray far from girlfriend roles. Now that she's long been a mature woman, one who's experienced multiple marriages and the birth of a child, she's afforded few opportunities to display her talents. Doubtless Hollywood ageism is to blame, but she also seems much distracted. On March 11, 2011, Howard Breuer of *People* wrote that Ross had obtained a restraining order against her twenty-six-year-old daughter (with current husband, Sam Elliott), because Cleo Rose Elliott had repeatedly stabbed her with a pair of scissors. Ross told *People* that Cleo had "verbally and emotionally abused me even as a little girl but became increasingly violent at age 12 or 13." A month after it was issued, the restraining order was quietly dropped, and a 2013 photo spread in the *Malibu Times* shows mother and daughter posing together in an attractive display of family harmony. I'm glad that good feelings have been restored, but saddened that Ross seems to expect payment before she'll talk about her *Graduate* memories.

Anne Bancroft, of course, was the big name when *The Graduate* was first released. The theme of the 1968 Academy Awards ceremony—the one that saw *The Graduate* nominated for multiple awards—was Forty Years of Oscar. The evening's broadcast was punctuated with video clips of Oscar-winning leading ladies, each of them briefly narrating a decade in the history of the Academy of Motion Picture Arts and Sciences. Following Katharine Hepburn, Olivia de Havilland, and Grace Kelly, Bancroft appeared on-screen to update viewers on the Oscar winners of the sixties. She was posed beside a swimming pool, wearing a one-shouldered Grecian

gown and an elaborate coiffure. Holding up one of the familiar gold statuettes, she announced that "Oscar is entering middle age. He's even gained weight. Back in 1928, he weighed just under seven pounds. And today he weighs eleven." Eyeing the bare torso of the figure in her hands, she purred, "Isn't that interesting?" And then she grinned a mischievous Mrs. Robinson grin.

Bancroft clearly enjoyed being Mrs. Robinson, but she did not want the role to define her. Following *The Graduate*, she was Oscar-nominated for exploring two very different characters, an aging ballerina in *The Turning Point* (1977) and a mother superior in *Agnes of God* (1985). In other media she portrayed everyone from Mary Magdalene (in the TV miniseries *Jesus of Nazareth*) to Golda Meir (on the Broadway stage), while also directing an independent film and popping up in three of husband Mel Brooks' outrageous comedies. Still, she could not escape allusions to *The Graduate*. During a rare 2003 interview, she grumbled, "I am quite surprised that with all my work, and some of it is very, very good, that nobody talks about *The Miracle Worker*. We're talking about Mrs. Robinson. I understand the world. . . . I'm just a little dismayed that people aren't beyond it yet."

Although fans felt that Bancroft had many great roles left to play, she succumbed to uterine cancer on June 6, 2005, at the age of 73. One of those eulogizing her in the press was Dustin Hoffman, who admitted he could not think of her in the past tense. Said Hoffman, "She was one of the most alive people I ever met. Such exuberance, and she had this laugh in her that filled her from head to toe. I can see her, see her laughing right now." But Bancroft, for all her spirit, could not manage to outlive her

best-known film. Hoffman's words were part of a farewell tribute that was published in the *Los Angeles Times*. It proved typical of the many obituaries Bancroft inspired, in that it bore the headline "Versatile, but Forever 'Mrs. Robinson.'"

Buck Henry was catapulted by *The Graduate* into a major screenwriting career. He wrote features both for Mike Nichols and others, contributing to Peter Bogdanovich's screwball farce, *What's Up, Doc?* and years later adapting Joyce Maynard's satiric novel, *To Die For.* In 1978 he branched out with *Heaven Can Wait,* in which he not only played the role of a newbie guardian angel but also shared directing credit with Warren Beatty, earning an Oscar nomination in the process. He also wrote for television and was a favorite guest host on *Saturday Night Live.*

Yet *The Graduate* has always remained on his radar. True, he has turned down all serious offers to come up with a sequel, calling it "really creepy and sometimes aesthetically criminal for the popular arts to cannibalize themselves." But that hasn't stopped him from having fun with the notion of a follow-up. In 1992, when asked by Robert Altman to improvise a film pitch for an opening scene in *The Player,* Henry was seen on camera trying to entice a studio development exec played by Tim Robbins with his idea for *The Graduate, Part II*: "Ben and Elaine are married still. They live in a big old spooky house up in Northern California somewhere, and Mrs. Robinson lives with them, her aging mother, who's had a stroke. . . . Mrs. Robinson had a stroke, so she can't talk. . . . It'll be funny. Dark and weird and funny, and with a stroke."

On January 24, 2000, a squib in *Variety* announced that Buck Henry and *The Graduate's* creator, Charles Webb, were working

together on a project called *Bathing Suits*. It was described as blending comedy and satire in telling the coming-of-age story of a high school girl, a budding artist fighting off social conservatism. (Descriptions of its plot suggest a final twist faintly reminiscent of *The Graduate*'s audacious ending.) According to *Variety*, financing was already in place for *Bathing Suits*, and both a producer and a director had come aboard. In Hollywood, though, nothing is ever certain. No one involved with *Bathing Suits* now wants to comment about its status, and the fact that Henry himself has been weakened by a stroke makes his future participation highly questionable. So this attempt to reunite a pair of *The Graduate*'s major players in a story that hints at similar themes seems doomed to languish in the well of silence.

IN 2016 MIKE Nichols' remarkable run on stage, screen, and television was chronicled in two affectionate documentaries, PBS's *Mike Nichols: American Masters* and HBO's *Becoming Mike Nichols*. Nichols' 2014 death at the age of 83 had brought forth heartfelt tributes from all corners of the entertainment industry. Everyone associated with *The Graduate* agrees that it was he who made all the difference, giving their careers an essential boost by shaping a film that lives on in the public imagination. But he was clearly never much tempted to spawn a *Son of Benjamin Braddock*. Film scholar Richard T. Jameson, writing in *Film Comment* in 1999, nicely summed up the relationship of *The Graduate* to Nichols' later cinematic achievements: "Nichols would never again make such a quintessential 'young man's film,' flaunting his discovery and mastery of a new medium." Editor Sam O'Steen, who worked

with Nichols on twelve films, agreed that Nichols became less "show-offy" over time. His assessment: "I think as you do more films, you become more comfortable, and you don't feel you have to move the camera so people will notice." But I wonder if later audiences didn't miss the precocious cheekiness of Nichols' early film work. I know I did.

At any rate, it was a sign of his invaluable artistic curiosity that he never repeated himself, never clung to his past achievements. Following *The Graduate*, Nichols' films have run the gamut from joyous comic romps (*The Birdcage*, 1996) to political satire (*Primary Colors*, 1998) to highly-charged dramas (*Closer*, 2004). Both the somber *Silkwood* (1983) and the upbeat *Working Girl* (1988) garnered Nichols additional Oscar nominations. On Broadway he showed the same range, tackling everything from *Annie* to Anton Chekhov's *Uncle Vanya* (in a version he himself helped to translate from the Russian). Among his various stage honors were Tonys for directing Neil Simon's highly commercial *Plaza Suite*, Tom Stoppard's challenging *The Real Thing*, and Eric Idle's goofy Monty Python spin-off, *Spamalot*. Late in his career he turned to television, winning Emmys for directing small-screen adaptations of *Wit* (2001) and, most notably, Tony Kushner's highly complex AIDS drama, *Angels in America* (2003).

There are some (though I am not among them) who feel Nichols' most accomplished film was his darkest, 1971's *Carnal Knowledge*. This bleak look at the mating dance between the sexes won plaudits for its frankness and for the no-holds-barred performances of Jack Nicholson and Ann-Margret, among others. (Candice Bergen was also featured, and Art Garfunkel effectively

played Nicholson's girl-chasing pal.) In *Carnal Knowledge* Nichols moved far beyond *The Graduate* in terms of his skepticism regarding matrimony. On this subject, the late Arthur Penn—who had once directed Nichols and May on Broadway—had some insight. In 2008, as Penn and I sat in his art-filled Manhattan apartment just off Central Park West, we chatted about the genuine devotion between Clyde Barrow and Bonnie Parker. It was then he compared his own *Bonnie and Clyde* to Nichols' caustic view of couple-hood in *The Graduate*. Said Penn, "That's the difference between Mike and me. I've been married fifty-two years."

Nichols, as his career took off, seemed to change spouses with each passing decade, and there were other romances in between. Then in 1988 he wed TV journalist Diane Sawyer, and they remained contentedly together until his death. That may be part of the reason why, when accepting a Tony for directing Philip Seymour Hoffman in a 2012 Broadway revival of Arthur Miller's *Death of a Salesman*, Nichols announced from the stage that "you see before you a happy man." It was fitting that his lifetime of achievement, one that had aroused so much delight in others, was finally bringing satisfaction to a director who was never easily pleased.

WHEN LAWRENCE TURMAN first watched Mike Nichols' rough cut of *The Graduate,* he realized how fortunate he'd been in his choice of partners. As he writes, "I felt that Mike Nichols had delivered a tougher, stronger, edgier, and more penetrating telling of the story than I had envisioned when I optioned the book." The fact that *The Graduate* continued to rake in money made Turman,

briefly, the hottest producer in Hollywood. Two major studios offered him head-of-production jobs that would have allowed him to oversee a whole slate of projects. Enjoying his independence, he turned them down. But he did call on his new clout to get studio financing for a perverse little drama called *Pretty Poison*, and then for a major adaptation of a Broadway hit, *The Great White Hope*.

Feeling confident, Turman decided it was time to become a director. And so he turned to another short novel by Charles Webb, *The Marriage of a Young Stockbroker*. He insisted to me that he hated the fact that his material came from Webb, because "it made it appear like I was climbing on a bandwagon." Still, it's telling that he would revisit the source of his greatest career success, choosing a story whose tone and surroundings bear a distinct resemblance to *The Graduate*. For the 1971 film, Richard Benjamin was cast in the leading role. His character, Bill Alren, is at least as disaffected as *The Graduate*'s Benjamin Braddock. Trouble is—he's already married, to the beautiful but passive Lisa (Joanna Shimkus). Rebelling against dull domesticity and a mind-numbing job in a brokerage, Bill finds temporary satisfaction in voyeurism and anonymous sex. There are also various family entanglements we're apparently supposed to find funny, and Elizabeth Ashley as his wife's cold-blooded sister contributes something of a Mrs. Robinson turn.

In a climax that seems to want to ape both *The Graduate*'s impudence and its spoofing of Southern California lifestyles, all the main characters show up at a ritzy country club, where Bill enters the women's locker room and pulls Lisa into the linen closet for some hot sex. He's quit his job and obtained a Mexican quickie

divorce, so they can now love each other in perfect unmarried freedom. (The screenplay, by Lorenzo Semple Jr., describes at this juncture "the loudest goddam SOUND of a ZIPPER ever heard in the history of motion pictures.") The final fillip is a shot of ex-husband and ex-wife joyfully driving off together in his sports car. She's still clad only in a towel, which—as they zoom down the road—flutters gently to the ground. This ending, with its coy suggestion of nudity, illustrates what has passed in Hollywood for boldness.

In person, Larry Turman has little good to say about his first directorial project. Calling himself "a cockeyed optimist," he explains he had connected with a story in which a man "discovers his true inner self through the power of love." But he admits that *The Marriage of a Young Stockbroker* paled in comparison to *The Graduate* because "the plot to serve that story was less good, less identifiable, and much less well executed." Nor, in retrospect, was Turman pleased with his own accomplishments: "My work as a director wasn't good enough. My casting wasn't smart enough. . . . There's a reason Dustin Hoffman is a movie star and Richard Benjamin is not. Dustin is vulnerable and likable. Richard Benjamin—wonderful guy and a wonderful actor—he comes across on screen as brittle, cold, distant." In Richard Benjamin's defense, his voyeuristic role is a terribly hard one to render sympathetic, especially to the women in the audience. But Turman seems never to have taken this fundamental problem into account. All in all, he confesses, "I failed as a producer as well as a director."

In the meantime, Larry Turman became caught up with a lawsuit long remembered in legal as well as Hollywood circles. In

1968, hard upon the success of *The Graduate*, Joseph E. Levine had sold Embassy Pictures to Avco for about $40 million (more like $272 million today), thereby creating Avco Embassy. He himself stayed on for six years as the company's chief executive officer. In 1973, when it came time to license *The Graduate* for television viewing, Avco Embassy (then still under Levine's direction) packaged it with seven dismal Embassy flops for a sale to CBS-TV. This block sale, combined with some creative bookkeeping, dramatically diminished Turman's expected share of the profits from *The Graduate*'s TV revenues, and he sued in 1975 in Los Angeles District Court under the Sherman Anti-Trust Act. Because of its complexity, the matter took five years to litigate, but Turman came away with treble damages, to the tune of $999,000. And the practice of block sales to television began to disappear.

Having recuperated from the trial and from his first outing as a director, Turman went back to doing what he did best. After a string of moderate successes, he made a rewarding detour into academia, becoming the chair of the Peter Stark Producing Program in the famous USC School of Cinematic Arts. On the job since 1991, the now-elderly Turman nurtures aspiring young producers with enthusiasm and grace. In 2005 Turman published *So You Want to Be a Producer*, in which he takes pains to debunk the glamour of his profession. Late in the book he describes receiving an announcement from the Academy of Motion Picture Arts and Sciences about a special screening of a newly restored print of *The Graduate*, with Mike Nichols set to appear as an honored guest. Turman quips wryly, "No mention of me whatsoever. If you've read this far, you know I think the world of Mike, but *The*

Graduate exists as a film only because of me. So you want to be a producer?"

CHARLES WEBB, AUTHOR of the original novel, has probably gained less than anyone from *The Graduate*, though much of this is due to his emphatically whimsical approach to the adult world. When the film debuted, he was holding down a menial job stocking cosmetics in a department store. A $5,000 Christmas gift sent by Joseph E. Levine, at the urging of Mike Nichols, helped him quit so that he could devote himself to future writing projects. By the time John Riley interviewed him for *Los Angeles* magazine in 1969, just prior to his thirtieth birthday, he was living with his wife, Eve, and their two young sons in a large but almost bare South Pasadena rental home, furnished with little more than a few sticks of furniture and a giant copy machine. His second novel, *Love, Roger*—an eccentric romp that evolves into a sexual threesome— had just earned a strong review from *Time* and would briefly be optioned to Universal Pictures.

So Webb was living the dream of making money from his writing, but he was not at all sure this was what he wanted. In many ways, he was Benjamin-like in his resistance to plastics, and to other forms of conventional American capitalism. Said he at the time, "That's the trouble with money—it's a distraction. You have to do something with it." Charles and Eve's response to money, then and now, has been to give it away. The success of *The Graduate* as a film inevitably led to a paperback edition of Webb's novel, which quickly began selling in the millions. Eventually the pair donated its copyright to the Anti-Defamation League, which has

happily benefitted from the novel's earnings since 1991. In a 2002 interview, Webb explained their reasoning. (By this point, Eve had changed her name to Fred, out of sympathy for an organization dedicated to men with low self-esteem.) As Webb put it to a somewhat mystified interviewer, "Though neither Fred nor I are Jewish, we gave the rights to the ADL because we felt they had influenced us in a profound way, to understand prejudice in all of its forms and victims."

The couple's penchant for ridding themselves of money and property would be an ongoing motif. In 1970 they used proceeds from the movie sale of *The Marriage of a Young Stockbroker* to buy an eleven-room $65,000 home in Williamstown, Massachusetts, not far from Charles' alma mater. The quiet area was supposed to give Webb the solitude he needed as a writer, but after a few short weeks they donated the house to the National Audubon Society and moved to upstate New York. Then it was back to Southern California, where they set up housekeeping in a trailer park in artsy Ojai, battling local authorities for the right to home-school their children. Over the years other houses and valuables were bought and then given away. A startling 1988 piece in *People*, subtitled "Footloose, Fundless and Looking for Help," described the duo as living out of a Volkswagen van along with their mutt, whom they had inventively dubbed Mrs. Robinson. They had briefly been sheltered by a woman in Bethel, Connecticut, but the arrangement fell apart when she disapproved (understandably, I think) of their fondness for nudism. By this point Fred was be-latedly growing worried about their financial straits: "I guess we thought that because we were so generous, the world would come

to our aid if we needed it. I guess we were naïve." As Webb bluntly put it, "Fred is totally disoriented and I am falling apart." "Falling apart" has turned out to be a good description of Webb's life from this point onward.

The odyssey continued. They spent three years at a Motel 6 in the easygoing beachfront community of Carpinteria, California, then decided to move to England, when they felt they could live as they chose without the "failure" label being applied. Again their financial situation was precarious, but their impulsive gifts to others continued. Having sold the film rights to his 2001 novel *New Cardiff* for $120,000 (it became a little-seen Colin Firth movie called *Hope Springs*), Webb donated the equivalent of $20,000 to a local artist, who then briefly attracted attention in 2003 by mailing himself to Britain's Tate museum in a packing crate. Performance art is something with which the Webbs clearly identify. Fred has been the centerpiece of her own offbeat creative events, featuring the artist in the buff. And both applauded the contribution of their younger son, David, to the local fine arts scene: He publicly cooked and ate a copy of *The Graduate*, garnished with cranberry sauce.

Given his lifelong resistance to materialism, how did Webb feel about *The Graduate* as a box-office bonanza? And what did he think of Mike Nichols' stylistic approach to his work? For years, Webb claimed he had never bothered to see the film version. But as always, his statements are a wee bit suspect. A few months after its release, on May 4, 1968, he sent a long diatribe to critic Stanley Kauffmann of the *New Republic*, quibbling with what Kauffmann had called the film's "moral stance." In Webb's stated view, the

Benjamin of his novel was "a highly moral person" who "does not disrespect the institution of marriage." Webb passionately argued that "in the book the strength of the climax is that his moral attitude makes it necessary for him to reach the girl before she becomes the wife of somebody else, which he does. In the film version, it makes no difference whether he gets there in time or not. As such, there is little difference between his relationship to Mrs. Robinson and his relationship to Elaine, both of them being essentially immoral." This mind-boggling letter was published in the May 1968 issue of the *New Republic*, along with Kauffmann's reply. Quipping that "my first reaction to this letter was that it was written by Elaine May," Kauffmann expressed total bafflement that "the author of this novel, even though possibly upset at being brushed off in all the furor about the film, can equate morality with marriage-licenses so absolutely." (He finished up his riposte with a question: "No, really, is it Elaine May?") Circa 2008, in an e-mail exchange with Mark Harris, Webb himself backed away from the position he'd expressed so strongly to Kauffmann, admitting that "I cringe at the quote. . . . Was I really that priggish? Yes, I suppose I was."

By the time he corresponded with Harris, Webb had undergone several apparent shifts in his attitude toward marriage as a moral force. Eve had in 1975 shed her last name in order to symbolically liberate herself from being "owned by my father and then Charles." Then in 1981, the Webbs divorced. They variously explained this as a show of solidarity with gays who could not legally wed or as a protest against the inequality of women in marriage. In any case, they never lived apart. They remarried in

1998 so as to smooth their immigration to England and have remained inseparable, despite Fred's severe 2001 mental breakdown that at one point had them getting their mail at a Salvation Army shelter.

Though Webb had cheerfully cast off the rights to his most celebrated novel, he now speaks appreciatively of the film version. The stage adaptation of *The Graduate* in 2000 once again put his name before the public, as did a brand-new edition of the novel from Washington Square Press. In 2007 he was able to capitalize on the fame of the original by unveiling (initially in England) a sequel titled *Home School*. Though the promise of a follow-up to *The Graduate* created a stir on both sides of the Atlantic, the novel was mostly a misfire, with its curious emphasis on the legalities of homeschooling one's children. It seems Mrs. Robinson (here reduced to a sexy caricature) is called upon by Ben, with Elaine's reluctant cooperation, to seduce the principal of Warren G. Harding High School on behalf of her grandkids' educational choices. She then hangs around to look for fresh meat in the homeschooling community.

Explaining the focus of his new work, Webb insisted that *The Graduate* too had actually been all about Ben's disenchantment with modern education systems, so that the sequel was merely following this important thread to its logical conclusion. The novel does contain some outrageous set pieces involving a freewheeling hippie couple (a horny handyman-type and a wife still breastfeeding her nine-year-old), but it hardly works as a follow-up to the famous saga of Benjamin Braddock. I'm guessing that Webb, himself largely resistant to responsible maturity, was wrestling in

his new novel with the concept of Benjamin as a grown-up. But the rather dour, drab peacemaker we see in *Home School* is not the Ben with whom my peers and I had fallen in love. And the untangling of Ben's multigenerational domestic affairs after that bus ride—a natural subject for a sequel—is skipped over in *Home School* with frustrating haste.

Larry Turman, learning from me about Webb's sequel almost ten years after its publication, was nonplussed that he had not been informed sooner. When *Home School* was described to him, he reacted with cynicism: "He was probably trying to resurrect his fame and finances." Charles Webb, in Turman's mind, is "a very strange guy. Sad, actually, when you think about it." To Turman it's no surprise that Webb would keep working, over the years, to trade on characters and situations that are so well-loved. After all, "Everyone has an ego. He probably liked being Charles Webb, when he was Charles Webb."

Mike Nichols too remained philosophical about Charles Webb's odd relationship to the whirlwind that was *The Graduate*. In 2008 Nichols said of Benjamin Braddock's story, "It really belongs to nobody now. . . . It certainly doesn't belong to Charles Webb. I don't think it served to unbalance him, but it served to age and confound him. It was whipped away from him." Nichols, for his part, felt no need for guilt about the filmmakers' possible role in Webb's odd disintegration. As he explained, "We didn't do it. We just made the movie! But then again, I think everybody feels it was whipped away from them."

THE EXPERIENCE OF making *The Graduate* transformed, in one way or another, all those involved. They too, after the furor subsided, were faced with the need to move on. But if each cast and crew member was in some respects Benjamin Braddock, it makes a twisted sort of sense that at least one of the Benjamins would fall victim to the challenges posed by his own outsized success.

18

Pop! Goes the Culture

"I sometimes wonder if any of us really understands another person's movie." —**Lawrence Turman (2005),** *So You Want to Be a Producer*

I n 2008, a novelist named John Manderino published *Crying at Movies*. In this comic memoir Manderino uses moviegoing vignettes to chronicle the key turning points of his own young manhood. *The Graduate*, of course, makes an appearance. It seems that when Manderino was a lowly college sophomore, a senior asked him out because she adored *The Graduate* and thought he resembled Dustin Hoffman. Manderino was not flattered. In his mind, "Benjamin was short and looked like a rodent." Still, he was attracted to the young woman, and so he managed to convince her that he was indeed sweet, sensitive, and depressed, just like Ben. In the next chapter we find them in bed together. Who knows how many other young men have scored because of this film?

The Graduate was apparently a boon to every height-challenged young guy cursed with a big nose. But in other ways too it managed to lodge itself deep in the American psyche. This was recognized by the Library of Congress, which in 1996 selected it—on the strength of its aesthetic and cultural significance—for inclusion on the National Film Registry. Two years later, 1,500 experts voting in an American Film Institute poll chose *The Graduate* from among four thousand nominees as number 7 on its list of the top 100 American movies. In a second AFI poll held in 2007, the ranking of *The Graduate* fell, but only to number 17. Other AFI polls from this era gave high marks to *The Graduate* as both a comedy and a love story, while the song "Mrs. Robinson" was recognized as one of the all-time great movie themes. Then in 2014 the *Hollywood Reporter* began conducting its own survey of movieland insiders. Among what it called "Hollywood's 100 Favorite Films," *The Graduate* came in at number 28. On the magazine's 2016 poll of "Hollywood's 100 Favorite Movie Quotes," the number 29 spot was occupied by the deathless "Mrs. Robinson, you're trying to seduce me. Aren't you?" (Speaking of which, the lady's slightly later response—"Would you *like* me to seduce you?"—is prominently featured in "Too Funky," a George Michael music video from 1992.)

But it wasn't simply a matter of placement on polls. The film quickly became part of the cultural shorthand. For one thing, the name "Mrs. Robinson" began to resonate, even leading to jokes when Mary Robinson was elected president of Ireland in 1990. Older women attracted to younger men were known to quip, "I wouldn't mind being his Mrs. Robinson," and in some circles the moniker even evolved into a transitive verb, as in "She's trying to

Mrs. Robinson him." Admittedly, no one has uncovered a missing link between the lady's feline wardrobe and the word "cougar." And yet the recent popularity of this slang term for an attractive middle-aged woman primed for sexual adventure seems to have a Mrs. Robinson tinge.

Nor is a specific verbal reference always necessary. Even today, visual nods to *The Graduate* are everywhere. Case in point: Not long ago I walked into a new and trendy little Santa Monica coffee bar. As I waited for my latte, someone who knows me asked if I had chosen my seat deliberately. That's when I turned and spotted, directly over my shoulder, an oversized framed movie poster, the kind found in European train stations. It advertised *Il Laureato*, which is Italian for *The Graduate*. And there was the familiarly quizzical Benjamin in that hotel room, bisected by the shapely leg of Mrs. Robinson.

The association of Mrs. Robinson with a stockinged leg, coyly arched or extended, has led to countless humorous variations. Google Images reveals scores of couples striking the familiar pose, in imitation of Bancroft and Hoffman. Newspaper cartoonists, some of them connected with innocent family-oriented strips like *Zits*, have mimicked it. A *New Yorker* cartoon published on May 26, 2014, shows a sexy leg pointing downward toward a laptop keyboard, while a Benjamin figure standing beneath the leg's arch asks, "Mrs. Robinson, are you trying to get me to listen to your podcast?" Some of the poster art for a short-lived Robert De Niro comedy called *Dirty Grandpa* (2016) foregrounds an older man pulling a gartered sock up a hairy leg while in the background his grandson (played by Zac Efron) stands bemused. The caption: "This is Jason. He's a little worried about his grandpa."

Naturally *The Simpsons* got into the act too. In the second season (1990–1991) of the satiric animated series, Dustin Hoffman is a guest voice in an episode titled "Lisa's Substitute," billed under the gag pseudonym Sam Etic. (Yes, this is surely a play on the word "Semitic.") Jewish jokes abound as Hoffman voices Mr. Bergstrom, a substitute teacher who gives brainy Lisa Simpson the appreciation she sorely needs. Midway through the episode, Bart Simpson's middle-aged teacher vamps Mr. Bergstrom after school. Sitting on a classroom desk, smoking a cigarette, she lifts her leg suggestively while discussing her failed marriage. Through that leg we watch Mr. Bergstrom squirm: "Mrs. Krabappel, you're trying to seduce me." Then in 2009, as a prelude to the seventy-second annual Academy Award ceremony, emcee Billy Crystal was digitally inserted into a number of Hollywood classics, like *Spartacus*, *The Godfather*, *Rebel Without a Cause*, and *E.T.* The audience guffawed as he reproduced the sunporch scene from *The Graduate*. When Dustin Hoffman's Ben asks if he's being seduced, the camera cuts to Crystal perched on a bar stool, decked out in Mrs. Robinson's sexy finery.

Movies have long found ways to make sly reference to *The Graduate*. Albert Brooks' *Mother* (1996), in which a grown son comes home for some TLC, amends the song "Mrs. Robinson" to refer to the leading character's own screen mother, the doting but slightly dotty Mrs. Henderson, played by Debbie Reynolds. The use of the song "Mrs. Robinson" is also a running joke in two of the *American Pie* films (1999, 2001), which show the teen-aged Finch falling under the spell of his buddy Stifler's overripe mom (Jennifer Coolidge). Then there's a curious adaptation of the "Mrs. Robinson" theme (in a cover version recorded by the

Lemonheads) to underscore the FBI raid on Jordan Belfort's mansion at the climax of 2013's *The Wolf of Wall Street*. Since there's no seductive mother figure in this Martin Scorsese film, I suspect the choice of the tune here hints at the idea of merry retribution, and of the lead character (played by Leonardo DiCaprio) finally getting his just deserts.

It is not only scenes starring Mrs. Robinson that later filmmakers have chosen to reference. The opening of Quentin Tarantino's *Jackie Brown* (1997), in which Pam Grier—in profile—stoically rides a moving walkway at Los Angeles International Airport, is a knowing steal from *The Graduate*. Seventeen years later, at the start of the last season of AMC's popular *Mad Men*, ad exec Don Draper arrives in L.A. via a similar shot (though film buffs with time on their hands note that, unlike Benjamin and Jackie, Don is heading from the right side of the screen to the left as he somberly glides through LAX —and he's met at the curb by a pretty young woman who's definitely not Mrs. Robinson). In both *Jackie Brown* and *Mad Men*, the allusion to *The Graduate* would seem to suggest a profoundly isolated individual, detached from his or her surroundings, hoping for some unexpected form of salvation.

Many films and TV episodes contain shreds of *The Graduate*. Even a breezy comedy like Nancy Meyers' *The Holiday* (2006), in which Jack Black plays a video store clerk introducing Kate Winslet to his favorite film music, makes room for a brief Dustin Hoffman cameo. As Black and Winslet banter amid aisles of DVDS, *The Graduate*'s star shakes his head at Black's impromptu rendition of "Where have you gone, Joe DiMaggio?" (Under his breath, Hoffman is heard muttering, "I can't go anywhere.") Especially ripe for

spoofing is the escape-from-the-altar sequence at the end of *The Graduate*. It was this plot twist to which conservative political candidate Pat Buchanan referred in March 1996 while vying for the Republican presidential nomination. In public remarks creatively linking himself to Hoffman's Benjamin Braddock, Buchanan cast the GOP as the girl he could save from an uninspired marriage to presumptive nominee Senator Robert Dole.

Political allusions to *The Graduate* continue. As part of the *New Yorker*'s "Aftermath: Sixteen Writers on Trump's America," published two weeks after the election of Donald J. Trump, comedian Larry Wilmore kicked off an essay called "The Birther of a Nation" with a reference to the film's opening line: "We are about to begin our descent into Los Angeles." Wilmore compared this to the image of the real-estate mogul gliding down Trump Tower's golden escalator to announce his candidacy for the highest office in the land. In Wilmore's words, "He was ready to begin his descent to the Presidency."

As for television writers, they love to show Ben-clones busting up weddings by hammering on glass while hollering the names of their beloveds. That's what Grampa Simpson does in the 1994 *Simpsons* episode titled "Lady Bouvier's Lover," in which he interrupts Jacqueline Bouvier's wedding to Montgomery Burns and totters off with the bride. (We fade out on the elderly couple ensconced in the backseat of the Seniorville Trolley, while on the soundtrack two young voices croon, "Hello, Grampa, my old friend.") In a slightly more serious vein, Adrian Monk taps and hollers on two separate nuptial occasions, first to reunite a long-separated couple and then to stop the bride from marrying a

murderer. This amusing 2007 episode of *Monk*, titled "Mr. Monk and the Wrong Man," ends with yet a third wedding disruption, leading to the much-put-upon bride finally running into the arms of the right suitor.

The most elaborate parody of *The Graduate*'s ending appears at the climax of *Wayne's World 2* (1993). This sequel to the goofy *Wayne's World*—about the life and times of two public-access TV stars—persuaded some Gen X'ers I know to check out *The Graduate* for themselves. *Wayne's World 2* again features Mike Myers as Wayne Campbell, a good-hearted doofus. Leaping into a bright red sports car, he frantically hightails it to Santa Barbara while Simon and Garfunkel strum on the soundtrack. (When he stops at a gas station to inquire about the First Presbyterian Church on Gordon Street, none other than Charlton Heston steps in to play the attendant.) As in *The Graduate*, Wayne runs out of gas, then sprints to the modernistic glass-and-stucco structure, rapping on the plate-glass panel fronting the balcony in order to disrupt the wedding in progress. Only problem: He's at the wrong church.

The *Wayne's World 2* production team had managed to secure the same location that was featured in *The Graduate*. But modern filmmaking trickery establishes that in the world of Wayne there are in fact two identical churches, facing one another. In his haste, Wayne had first bolted into the *Second* Presbyterian Church. Oops! Sheepishly acknowledging his mistake, he dashes across the road to the *First* Presbyterian, where his adored Cassandra is marrying bad guy Christopher Walken. (The minister is none other than Buck Henry, in an unbilled cameo.) Every beat of *The Graduate*'s wedding sequence is carefully replicated,

from the guests all staring over their right shoulders at the intruder to the huge angry close-ups of the wedding party. During the ensuing brawl, Wayne—fittingly for an overaged adolescent—grabs a handy electric guitar rather than a gold cross to keep everyone at bay, and then shoves it through the door handles of the church to seal his enemies inside. Afterward he grabs the hand of the lovely bride, played by Tia Carrere, and the two of them joyously run to board a passing city bus.

Why go through the trouble of copying, beat by beat, a movie that in 1993 was a quarter of a century old? The Wayne's World movies prided themselves on being plugged in to pop culture trivia, and the young audiences they attracted got a kick out of linking up with cultural artifacts that were a hit before they (if not their mothers) were born. Philip Hogan's parents were preteens when *The Graduate* was released. They taught their son (born in 1987) to appreciate the films that marked their own coming of age. When I first connected with Hogan, he was a Georgia college student, barely twenty-one years old. Despite the passage of time since the film's debut, he had discovered his own connection with Benjamin Braddock, "especially now that I'm in college. I didn't know what I wanted to do with my life. I still don't. I'm still trying to figure all this out, it's very overwhelming, it's very confusing. And I think it's very easy to relate to him, in his position in the movie." So the anxieties faced by Benjamin Braddock live on in at least some millennial hearts and minds.

Ten years after *Wayne's World 2* introduced *The Graduate* to a new generation of movie fans, a much-truncated spoof of the same wedding sequence was put to commercial use in a TV spot,

intended exclusively for overseas audiences. The imaginative car commercial, directed by Hollywood maestro Michael Bay, features Dustin Hoffman himself, once again speeding toward that very same church. Though now a well-preserved sexagenarian, he races up the stairs, pounds the glass, and absconds with the young and beautiful bride, who flings her veil to the winds. Big difference: His luxury car is waiting at the curb to receive them. But it's not a red Alfa Romeo 1600 Spider Duetto (a model that sold fabulously well in the wake of the film's success, and inspired the launching of a sub-model dubbed "The Graduate"). Instead, Hoffman's ride has here been transformed into a brand-new silver Audi sedan. Once they're under way, he chuckles to the young lovely in the passenger seat, "You're just like your mother." That's when the bride turns to him with a radiant smile and whispers, "Thanks, Dad." The final beauty shot is of the Audi vrooming down the highway.

So DESPITE THE film's apparent disdain for materialism, *The Graduate* has entered the world of commerce in ways large and small. Not long ago, I spent the night at the Durant Hotel, a Berkeley, California, landmark (built in 1928) that has enjoyed a recent makeover. Its décor now oh-so-shrewdly capitalizes on visitors' mental associations with the University of California campus in the picturesque sixties. To celebrate the role played by Berkeley in *The Graduate*, the hotel has decorated every guest room with a large film poster introducing Benjamin, who's "a little worried about his future." It's enough to give many hotel guests a trip back in time. (In 2017, the Durant joined a boutique international hotel chain and is now officially known as Graduate Berkeley. The film posters remain in place.)

Of course, the great symbol of crass American commercialism in *The Graduate* can be summarized in just one word: plastics. References to *The Graduate* still abound in popular-press articles on everything plastic, from credit cards to cosmetic surgery. The film's original fans were only too quick to seize on plastics as indicative of the phoniness of their parents' generation. This despite the fact that—as Jeffrey L. Meikle points out in his 1995 cultural history, *American Plastic*—young people like me had grown up playing with Wham-O hula hoops, Barbie dolls, Revell model airplanes, and Lego blocks, while also eating off melamine dishes and writing with Bic pens. Although Meikle speaks of *The Graduate* as helping to give plastic products the stigma of second-rate imitation, an article in *Time* points to the opposite conclusion. Bruce Handy's *Time* essay, inevitably titled "Just One Word," reports on a 1997 national exposition of the plastics industry, held in Chicago. There Handy discovers that in the three decades since Mr. McGuire took Ben aside for some career advice, the manufacture of plastics has come to represent a $225 billion industry, one growing far faster than the nation's gross domestic product. Handy quotes John Clark of Brown Plastics Engineering Company, who exclaims that "*The Graduate* was a hell of an advertisement for the industry." In fact, more than one businessman at the expo admits to having taken away from the film the notion that the plastics industry is an exciting place to be. In the years since *The Graduate*'s release, says Handy, "plastics won."

Given that Mrs. Robinson likes to dress in the pelts of wild animals, it's possible that her sheer black stockings reflect a silkworm's finest hour. This is highly unlikely, however. Since the close of World War II, most women's stockings—however chic

and expensive—have been made of nylon, which is described as a thermoplastic. So perhaps Mrs. Robinson, with her raw anger tamped down beneath a thin membrane of civilization, is the most plastic character in *The Graduate*. In any case, she is inseparable from her style sense. *Poplorica*, a 2004 popular history of American inventions by Martin J. Smith and Patrick J. Kiger, devotes a chapter to the development of pantyhose. In passing, the authors note the allure of Mrs. Robinson seductively rolling a stocking up a shapely leg. For fans of stockings and garter belts, whatever their gender, this scene in *The Graduate* represents an iconographic moment. Anne Schlitt's "Where Have All the Stockings Gone?" blog post vividly posits that if Mrs. Robinson had been wriggling into a pair of pantyhose in that hotel room, Benjamin Braddock would probably not have bothered to stick around.

Mrs. Robinson's sense of style has earned her many admirers over the years. Her leopard jacket, in particular, has won recent plaudits from Internet fashionistas. Other women, managing to overlook the character's tragic side, seek to emulate Mrs. Robinson's brazen self-possession and her can-do attitude. A 2005 how-to book by British authors Wendy Salisbury and Maggi Russell is titled *Move Over, Mrs. Robinson*. Its subtitle: *The Vibrant Guide to Dating, Mating and Relating for Women of a Certain Age*. For a time in the early twenty-first century there was a mysterious San Francisco collective known as the Mrs. Robinson Society. I never managed to penetrate its inner circle, but it described itself on Facebook as "a movable social club and think tank for sophisticated, vibrant, fully evolved ladies of a certain ilk who enjoy openly sharing progressive ideas about art, culture, and personal

relationships." According to its now-defunct website, its goals were to "Enchant, Provoke, Discern, Venture, Respond." And it had adopted as its watchword a simple question: "What would Mrs. Robinson do?" Clearly, as feminine roles keep evolving in American society, there are women who've adopted Mrs. Robinson as a figure not of pathos but rather of empowerment.

YET THE BULK of the viewers who identify with *The Graduate* continue to see themselves in Benjamin's shoes, rather than in Mrs. Robinson's stockings. After all, young people of both genders still feel alienated from their parents' world and unsure about their future goals. *Time* magazine traded on the linkage (however complex) between Benjamin Braddock and the youth of America for its June 7, 1968, cover feature. The story itself, titled "The Cynical Idealists of '68," profiled seven seniors at major American universities in terms of the challenges they would face after graduation. But the magazine's cover, which appeared when *The Graduate* was still topping the box office, was simply captioned "The Graduate 1968." In marked contrast to the idealized sketch of the "Twenty-five and Under" who'd been *Time's* Man of the Year in 1967, *Time's* 1968 graduate was represented by the full-color photograph of an actual person, UCLA's Brian Weiss. Weiss, editor-in-chief of the campus newspaper, was shown wearing the traditional cap and gown, but also a turtleneck, a full beard, a large peace symbol dangling from a chain around his neck, and a somewhat troubled expression. His main preoccupations, according to the article inside, were domestic politics and the Vietnam War, not subjects in which Benjamin Braddock showed much interest.

Of course, Brian Weiss in 1968 had seen and enjoyed *The Graduate*. I knew Brian from our mutual involvement with the *Daily Bruin*, and we'd kept in touch over the years. When I sat down for lunch with a still-bearded Brian at a Pasadena Afghan restaurant some four decades after he'd posed for that *Time* cover, he told me, "I think there were a few iconic films at the time that virtually everyone saw." He'd enjoyed *The Graduate*, but—as a longhair and a conscientious objector—he had identified far more with 1969's *Easy Rider*, which he viewed as capturing "how society judges based on not *who* you are but *how* you are." Brian still believes that as a 1968 graduate he himself was facing down the realities of his era in a way that Benjamin Braddock did not. Nor did he look anything like the clean-cut Ben. *Time* returned to its *The Graduate* motif once more, on May 24, 1971. On a cover emblazoned with a banner that read "The Graduate, 1971," *Time* depicted a shaggy-haired young man in full graduation regalia, gassing up a modest car. Large type screamed, "Now Where Are The Jobs?" (This is a question, of course, that connects the 1971 degree-holder with today's hard-pressed millennials. Perhaps this graduate should have looked into plastics.)

Though *Time* may have delighted in the visual contrast between Brian Weiss and Benjamin Braddock, some government organizations clearly hoped to make the most of young people's self-identification with the hero of *The Graduate*. A vintage TV commercial, probably from the late sixties, is a close-to-exact replica of the film's opening party scene. As a young preppy descends a staircase, his parents' overdressed friends cluster around him, cooing about his college accomplishments and offering him advice

for the future. Law school is enthusiastically suggested ("There's money in law!"). We even spot a Mrs. Robinson type, who blows smoke in his face. Finally he's cornered by a hearty fellow who has just one word for the graduate: "Plastics." The screen freezes on the dazed-looking young man as a narrator intones, "There's time enough to start a good career. First find out something about life. If you don't, you may never learn that money isn't the only thing in it." It's a highly effective promo for the Peace Corps. (Would a two-year posting in some remote African village have helped to cure Benjamin Braddock's malaise? Or made him all the more eager to escape real-world problems?)

Similarly, the US domestic anti-poverty program, familiarly known as VISTA, called on *The Graduate* to help it recruit young volunteers. In 1968 VISTA issued a black-and-white poster featuring an image of Dustin Hoffman as Benjamin Braddock. In huge white letters, the poster asks, "WHAT'LL YOU DO AFTER YOU GRADUATE?" At the bottom, in small letters, there's the kicker: The word "VISTA" along with the reminder that, in putting your idealism to work, "You can put off plastics for a year." This poster was apparently so persuasive that it was reprinted several times over the next two decades. But the pristine copy recently offered on eBay went, after spirited bidding, for $635. If yours was the winning bid, you could charge it to your American Express card. Score another one for plastics.

IN A PLASTIC-COATED world, *The Graduate* continues to appeal to those who want their future to be . . . different. It's fair to guess that in today's crowded media environment, there will

be few films with *The Graduate*'s staying power. With so many alternative forms of entertainment now available, movies mean far less to the current crop of young adults than they did to us back in 1967, before the advent of cable TV, the Internet, video gaming, and smartphones. Still, some millennials—like Philip Hogan—admit that this particular vintage flick has captured their hearts. *The Graduate*'s persuasive power lies not in its ideology but rather in the open-ended way it encourages its fans to resist the status quo. It emboldens young people to break adult rules and choose their own adventure. For their parents—members of an older generation—it conjures up sweet memories of that long-ago decade when they too felt brave enough to seize the day.

This little movie from 1967 is still known around the globe, but it remains most meaningful to Americans, who stand the best chance of recognizing the film's upper-middle-class milieu as a familiar one. For some devotees it provides a good excuse to continue their slacker existence. After all, if grown-up lives are meaningless, why not simply stay adrift? Those more romantically inclined are encouraged by the ending of *The Graduate* to find their answer in love, whether or not this includes matrimonial vows. Some women, both young and old, discover in Mrs. Robinson's story a reminder of the dangers of male domination. And there are nihilists who take away from the film the impulse to smash to smithereens the powers that be. Those who approach the ballot box hoping to overthrow all that has gone before can be viewed as sharing Benjamin's conviction that the rules of his parents' world are not worth learning.

Of course *The Graduate* is only a movie. Many of today's

younger moviegoers have not seen it, and others shrug off its influence as something from another era. But if you get a certain gleam in your eye when the subject of *The Graduate* arises, you know the pleasure of hearkening back to a film in which the sound of silence can be overcome by an unlikely young man bellowing in the name of love. Whatever age you may be, if the vision that was planted in your brain still flickers, it's a sign you retain a shard of Benjamin Braddock's youthful capacity for hope and wonder.

Maybe plastics have not triumphed, after all.

ROLL CREDITS

Joseph E. Levine Presents
A Mike Nichols / Lawrence Turman Production

Starring
Anne Bancroft
and
Dustin Hoffman
Katharine Ross

Costarring
William Daniels
Murray Hamilton
Elizabeth Wilson

With special appearances by
(in alphabetical order)
Brian Avery
Walter Brooke
Norman Fell
Alice Ghostley
Buck Henry
Marion Lorne

Director of Photography
Robert Surtees, A.S.C.

Production Designer
Richard Sylbert

Film Editor
Sam O'Steen

Production Supervision by
George Justin

Assistant Director — Don Kranze

Sound — Jack Solomon

Assistant Film Editor — Bob Wyman

Set Decorator — George Nelson

Camera Operator — George Nogle, Albert Bettcher

Script Supervisor — Meta Rebner

Makeup — Harry Maret

Hair Dresser — Sherry Wilson

Gaffer — Earl Gilbert

Grip — Richard Borland

Assistant Production Designer — Joel Schiller

Filmed in Panavision
Color by Technicolor
Furs by Maximilian
Special Jewelry by Harry Winston

Costumes — Patricia Zipprodt

Hair Styles — Sydney Guilaroff

Songs by Paul Simon

Sung by Simon and Garfunkel
Additional Music by Dave Grusin

Casting Consultant — Lynn Stalmaster

Screenplay by
Calder Willingham and Buck Henry
based on the novel by Charles Webb

Produced by
Lawrence Turman

Directed by
Mike Nichols

THE CAST

Mrs. Robinson Anne Bancroft

Ben Braddock. Dustin Hoffman

Elaine Robinson Katharine Ross

Mr. Braddock. William Daniels

Mr. Robinson. Murray Hamilton

Mrs. Braddock Elizabeth Wilson

Room Clerk Buck Henry

Carl Smith Brian Avery

Mr. McGuire Walter Brooke

Mr. McCleery. Norman Fell

Mrs. Singleman. Alice Ghostley

Miss DeWitte. Marion Lorne

Woman on Bus Eddra Gale

FOR FURTHER READING

Allis, Tim, and William Sonzski. "Post-*Graduate* Life Proves Unkind to Author Charles Webb—Footloose, Fundless and Looking for Help." *People*, October 24, 1988, 67–68.

Brackman, Jacob. "The Graduate." *The New Yorker*, July 27, 1968, 34–65.

Brode, Douglas. *The Films of Dustin Hoffman*. Secaucus, New Jersey: Citadel Press, 1983.

Carringer, Robert L. "Designing Los Angeles: An Interview with Richard Sylbert." *Wide Angle*, vol. 20, no. 3, 1998, 97–131.

Clooney, Nick. *The Movies that Changed Us: Reflections on the Screen*. New York: Atria Books, 2002, 67–77.

Ephron, Nora. "An Interview with Mike Nichols." *Wallflower at the Orgy*. New York: The Viking Press, 1970, 146–61.

Gelmis, Joseph. *The Film Director as Superstar*. Garden City, New York: Doubleday & Company, Inc., 1970, 265–92.

Giannetti, Louis D. *Understanding Movies*. Englewood Cliffs, New Jersey: Prentice-Hall, Inc., 1972.

Gitlin, Todd. *The Sixties: Years of Hope, Days of Rage*. New York: Bantam Books, 1987.

Harris, Mark. *Pictures at a Revolution: Five Movies and the Birth of the New Hollywood*. New York: Penguin Books, 2008.

Johnson, Terry. *The Graduate*, adapted for the stage, based on the novel by Charles Webb and the screenplay by Calder Willingham and Buck Henry. London: Methuen, 2000.

Kashner, Sam. "Here's to You, Mr. Nichols: The Making of *The Graduate*." *Vanity Fair*, March 2008, 419–32.

Lahr, John. "Making it Real: How Mike Nichols Re-Created Comedy and Himself." *The New Yorker*, February 21, 2000.

Meikle, Jeffrey L. *American Plastic: A Cultural History*. New Brunswick, New Jersey: Rutgers University Press, 1995.

O'Steen, Sam, as told to Bobbie O'Steen. *Cut to the Chase: Forty-Five Years of Editing America's Favorite Movies*. Studio City, California: Michael Wiese Productions, 2001.

Schickel, Richard, and John Simon, editors. *Film 67/68: An Anthology by the National Society of Film Critics*. New York: Simon and Schuster, 1968.

Slater, Philip E. *The Pursuit of Loneliness: American Culture at the Breaking Point*. Boston: Beacon Press, 1970, 53–60.

Surtees, Bob. "Using the Camera Emotionally." *"Action!," The Magazine of the Directors Guild of America*, vol. 2, no. 5, September–October 1967, 20–23.

Sylbert, Richard, and Sylvia Townsend, with Sharmagne Leland-St. John-Sylbert. *Designing Movies: Portrait of a Hollywood Artist*. Westport, Connecticut: Praeger, 2006, 89–96.

Turman, Lawrence. *So You Want to be a Producer*. New York: Three Rivers Press, 2005.

Webb, Charles. *Home School*. New York: Thomas Dunne Books, St. Martin's Press, 2008.

Webb, Charles. *The Graduate*. New York: Washington Square Press, 2002.

Whitehead, J. W. *Appraising "The Graduate": The Mike Nichols Classic and Its Impact on Hollywood*. Jefferson, North Carolina: McFarland & Company, Inc., 2011.

NOTES

Frequently Used Abbreviations:

AI = Author Interview

DVD = fortieth anniversary special edition DVD of *The Graduate* (2007)

LAT = *Los Angeles Times*

LTA = Lawrence Turman Archives, UCLA Special Collections

NYT = *New York Times*

SYW = *So You Want to be a Producer* by Lawrence Turman (New York: Three Rivers Press, 2005)

TNY = *The New Yorker*

Part I: Making the Movie

Chapter 1: The Book

3 *"I was always the kid"* Charles Webb in John Riley, "'*The Graduate*' Faces Success at 30," *Los Angeles*, vol. 14, no. 6 (June 1969), 32.

4 *first date took place in a local graveyard* David Smith, "Who are You, Mrs. Robinson?," *The Observer* (February 6, 2005).

4 *before long Eve was pregnant* Tim Allis and William Sonzski, "Post-'Graduate' Life Proves Unkind to Author Charles Webb—Footloose, Fundless and Looking for Help," *People* (October 24, 1988).

4 *becoming a doctor like his father* Jack Fincher, "Will the Real Graduate Please Stand Up?," *Life* (November 29, 1968).

5 *"my fantasy life became super-charged"* Webb in Smith, *The Observer*.

5 *"wrote a short plot outline"* Ibid.

5 *"Anything I write is autobiographical"* Webb in Fincher, *Life*.

5 *Eve's mother, Jo Rudd* Smith, *The Observer*.

6 *prose style modeled after the work of Harold Pinter* Ambrose Clancy, "A Post-'Graduate' Life," *Los Angeles Times* (May 14, 2002).

6 *not a generational attack* "'The Graduate': Will Success Spoil Who?—Charles Webb??," *Los Angeles Herald Examiner* (February 16, 1968).

6 *it angered his father* William Georgiades, "A School of Hard Knocks for Mr. Webb," LAT (January 6, 2008).

6 *Webb would eventually turn down his inheritance* Ibid.

8 *sell their wedding gifts* Fincher, *Life*. Riley in *Los Angeles* is another source for this quixotic gesture.

8 *an experiment by New American Library* Mark Harris, *Pictures at a Revolution* (New York: Penguin Books, 2008), 27.

8 *"a fictional failure"* Orville Prescott, "Books of The Times," *New York Times* (October 30, 1963).

9 *Webb "gave me in his book"* Author interview with Lawrence Turman (September 17, 2015).

10 *"The weird dialogue and situations"* Lawrence Turman, *So You Want to be a Producer* (New York: Three Rivers Press, 2005), 193–94.

Chapter 2: The Deal

11 *"I'm a simple guy"* Joseph E. Levine in "Promoters: 'A Simple Guy,'" *Newsweek* (February 22, 1960).

12 *"I'd carry bolts of cloth"* Lawrence Turman in Sam Kashner, "Here's to You, Mr. Nichols: The Making of The Graduate," *Vanity Fair* (March 2008), 421.

14 *"I identify with that boy a lot"* Mike Nichols in Sam O'Steen, *Cut to the Chase: Forty-Five Years of Editing America's Favorite Movies* (Studio City, CA: Michael Wiese Productions, 2001), 55.

14 *reverse the order of the two names* Turman, SYW, 212.

14 *One Paramount executive* Letter in Box 22, Lawrence Turman archives, UCLA Special Collections.

15 *"He is dark-haired, moon-faced"* Paul O'Neil, "The Super Salesman: The Joe Levine Saturation Treatment," *Life* (July 22, 1962).

15 *adept amateur magician* Calvin Tomkins, "The Very Rich Hours of Joe Levine," *The New Yorker* (September 16, 1967).

15 *a reaction to his years of hunger* Sheilah Graham, "Joe Levine's Rule for Making Money," *Hollywood Citizen-News* (December 6, 1965).

15 *"He glommed onto a picture"* Philip K. Scheuer, "Meet Joe Levine, Super(sales) man!," LAT (July 27, 1959).

16 *$1 million in rented thousand-dollar bills* O'Neil, *Life*.

16 Hercules . . . *grossed $5 million* Ibid.

17 *"cutting fuck scenes"* O'Steen, *Cut to the Chase*, 78.

17 *"I nursed the picture like a baby"* Levine in O'Neil, *Life*.

18 *the chance to rub shoulders* Turman, SYW, 196.

18 *opening his New York offices* Abel Green, "Levine's Luxury Lair Underscores Upbeat," *Weekly Variety* (July 14, 1965). The replica of the Billerica Street front door is described in Tomkins, TNY.

18 *"I was rabid and intransigent"* Turman, SYW, 195–96.

19 *personally persuaded his buddy Mike Nichols* "Broadway Bank," NYT (January 10, 1965).

Chapter 3: The Script

20 *"I was trying to find a word"* Buck Henry in Jay Boyar, "When 'Plastics' Became a Bad Word," *Washington Post* (August 30, 1992).

20 *"Do film just like the book"* Lawrence Turman's brown spiral notebook, Box 23, LTA.

21 *Goldman found Webb's novel unappealing* Turman, SYW, 159.

21 *He paid New York playwright William Hanley $500* Mark Harris, *Pictures at a Revolution*, 29.

21 *"Benjamin Braddock is sort of a whiny pain in the fanny"* AI with Turman (November 19, 2007).

22 *Willingham's early draft of* Lolita Author interview with F. X. Feeney (August 27, 2015), recounting ongoing conversations with Stanley Kubrick's producer, James B. Harris.

22 *"this goddamned schizophrenic and amateurish book"* Calder Willingham, notes dated December 6, 1964, in Box 21, LTA.

23 *"vulgar and salacious"* AI with Turman (November 19, 2007).

23 *"the wicked witch should again try to enchant the hero"* Willingham, authorial notes on his 3rd draft, Box 22, LTA.

23 *agreed to delay his own project* Turman, SYW, 196–97.

24 *"SOUFFLÉ VERSUS SIRLOIN"* Willingham letter, dated April 19–22, 1965, in Box 23, LTA.

24 *"he had affection for money"* AI with Turman (November 19, 2007).

24 *Malibu beach party hosted by Jane Fonda* Harris, *Pictures at a Revolution*, 108.

25 *"the best pitch I ever heard"* Buck Henry in Sam Kashner, "Here's to You, Mr. Nichols: The Making of The Graduate," *Vanity Fair* (March 2008).

25 *"related to* The Graduate *in exactly the same way"* Ibid.

26 *"making up horrifying stage directions"* Mike Nichols in Joseph Gelmis, *The Film Director as Superstar* (Garden City, NY: Doubleday & Company, Inc., 1970), 284.

26 *how to make visible* Gelmis, 285.

27 *"less rewriting than retyping"* Richard Corliss, *Talking Pictures: Screenwriters in the American Cinema, 1927–1973* (Woodstock, NY: The Overlook Press, 1974), 362.

27 *"Henry could have tried"* Ibid., 365.

28 *"If it weren't for the dumb guys like us"* Early Henry draft of *The Graduate*, Box 22, LTA, 46.

30 *"You're too intelligent to be a virgin"* Willingham draft, in Box 21, LTA.

Chapter 4: The Cast

31 *"There is no piece of casting"* Dustin Hoffman in John Lahr, "Making it Real: How Mike Nichols Re-Created Comedy and Himself," TNY (February 21, 2000).

31 *"When you cast a movie"* AI with Turman (September 17, 2015).

31 *"will make a star of the actor who is chosen"* Box 24, LTA.

32 *three hundred amateurs* The statistic of 306 nonprofessional applicants for roles in *The Graduate* comes from Andrew Laurie, assistant to Mike Nichols, who wrote a letter settling a bet between one aspiring actor and his wife. Box 24, LTA.

32 *over three hundred amateurs personally contacted* Boxes 23 and 24, LTA.

32 *"too mature and stolid"* Box 24, LTA.

33 *"Turman, you SOB"* Mike Nichols in Sam Kashner, "Here's to You, Mr. Nichols: The Making of The Graduate," *Vanity Fair* (March 2008).

33 *"I am 38 and homely"* Box 24, LTA.

33 *Doris Day . . . turned down the part* A.E. Hotchner, *Doris Day: Her Own Story* (New York: William Morrow and Company, Inc., 1976), 199.

33 *when he sent her Charles Webb's novel* Turman, SYW, 201.

34 *Nichols has described how he met with Ava Gardner* Kashner, *Vanity Fair.*

34 *Joseph E. Levine took credit* Stuart Byron, "Rules of the Game," *Village Voice* (January 6-12, 1982).

35 *looking for a dress-up role* William Holtzman, *Seesaw: A Dual Biography of Anne Bancroft and Mel Brooks* (Garden City, New York: Doubleday & Company, Inc., 1979), 236.

35 *"a beautiful, exciting, wonderful, angry young woman"* Mike Nichols in Mark Harris, *Pictures at a Revolution* (New York: Penguin Books, 2008), 271.

35 *"news to me"* AI with Turman (September 17, 2015).

35 *Charles Grodin . . . believes he was chosen to play Benjamin* Scott Foundas, "Don't Call It a Comeback," *L.A. Weekly* (May 2, 2007).

35 *"revisionist history"* AI with Turman, November 19, 2007.

35 *"Mike loved him, a little more than I"* Ibid.

35 *"Grodin got very close"* Mike Nichols in Harris, 272.

36 *"cross between Ringo Starr and Buster Keaton"* Kashner, *Vanity Fair.*

37 *model for the role of Willie Loman* Dustin Hoffman, interview with James Lipton, Inside the Actors Studio (June 18, 2006).

37 *pitches the convenience of a Volkswagen Fastback* https://www.youtube.com /watch?v=lGdf9ea2olQ

38 *audition for . . .* The Apple Tree Michael Shurtleff, *Audition: Everything an Actor Needs to Know to Get the Part* (New York: Walker and Company, 1978), 9.

38 *upcoming debut film,* The Producers Mel Brooks, interview with Craig Modderno, *Daily Beast* (August 20, 2016). http://www.thedailybeast.com/articles

/2016/08/21/mel-brooks-looks-back-blazing-saddles-could-never-get-made-today
.html?via=desktop&source=email See also Douglas Brode, *The Films of Dustin
Hoffman* (Secaucus, New Jersey: Citadel Press, 1983), 17, for a slight variation on
the same story.

39 *"this is not the part for me"* "One on One with Dustin Hoffman" featurette, 25th
anniversary DVD edition, *The Graduate* (1992). This interview is also included in
the 40th anniversary DVD, from 2007.

40 *"Maybe he's Jewish inside"* Mike Nichols in Kashner, *Vanity Fair*.

41 *"a quintessential WASP movie"* AI with Turman (September 17, 2015).

41 *"felt like he was me"* Dustin Hoffman in Alec Baldwin podcast, "Here's the
Thing," WNYC Radio (June 9, 2015). http://www.wnyc.org/story/dustin
-hoffman-htt/

41 *"Dustin has always said"* Mike Nichols interviewed by Gavin Smith, Film Com-
ment, vol. 35, no. 3 (May/June 1999), 24.

41 *faulty whooping cough vaccine* Lahr.

42 *"immigrant's ear"* Charles McGrath, "Mike Nichols: Master of Invisibility," NYT
(April 12, 2009).

43 *"Can we do anything about his nose?"* Hoffman, Baldwin podcast.

43 *"a Jewish nightmare"* "One on One with Dustin Hoffman," DVD.

43 *"He looks about three feet tall"* Katharine Ross in David Zeitlin, "A homely non-
hero, Dustin Hoffman, gets an unlikely role in Mike Nichols' *The Graduate*,"
Life (November 24, 1967).

43 *New York subway tokens* Variations of this story appear in many places, includ-
ing Harris and also Richard Meryman, "Before They Were Kings," *Vanity Fair*
(March 2004). Hoffman mentioned the framed arrangement of subway tokens
during his June 18, 2006, appearance on Inside the Actors Studio.

44 *"sweetness and goofiness"* Turman, SYW, 199.

44 *"Mike's great gift is in casting"* Elizabeth Wilson, in Pat Grandjean, "First Q&A:
Elizabeth Wilson," *Connecticut Magazine* (April 2012).

44 *"I was a paralyzed person"* Dustin Hoffman in Lahr, TNY.

44 *"this ugly boy"* Sam O'Steen, *Cut to the Chase: Forty-Five Years of Editing America's
Favorite Movies* (Studio City, CA: Michael Wiese Productions, 2001), 56.

44 *all feared the company would go bust* Stuart Byron, "Rules of the Game," *Village
Voice* (January 6-12, 1982).

45 *"the soul was there"* Buck Henry, interview with Terry Gross, Fresh Air (February
24, 1997). http://www.npr.org/templates/story/story.php?storyId=16578078

45 *"the test he did"* Buck Henry, Pinewood Dialogue, Museum of the Moving Image
(June 22, 1996).

45 *"There* is *a genetic thing that happens"* Henry, *Fresh Air.*

45 *There's no truth to the rumor* AI with Turman (September 17, 2015).

46 *veteran comic actress Alice Ghostley* Box 25, LTA.

46 *"hired her that instant"* Turman, SYW, 201.

Chapter 5: The Shoot

47 *"This is laid back."* Richard Sylbert, in Robert L. Carringer, "Designing Los Angeles: An Interview with Richard Sylbert," *Wide Angle,* vol. 20, no. 3 (1998), 100.

48 *"I'll be glad to get rid of you two."* All quotes in this paragraph come from John Lahr, "Making it Real: How Mike Nichols Re-Created Comedy and Himself," TNY (February 21, 2000).

48 *"I had a sense of enormous relief"* Ibid.

48 *He would praise Hamilton's "incredible sadness"* Mike Nichols commentary, DVD.

49 *he had been so determined* Pinewood Dialogue with Mike Nichols, Museum of the Moving Image (March 19, 1990).

49 *"that lunatic you become"* Nichols, DVD.

49 *"a prick on the set"* Nichols in Mark Harris, *Pictures at a Revolution* (New York: Penguin Books, 2008), 102.

49 *fear of showing weakness* Lahr, TNY.

49 *"Nichols ate him alive"* Sam O'Steen, *Cut to the Chase: Forty-Five Years of Editing America's Favorite Movies* (Studio City, CA: Michael Wiese Productions, 2001), 59.

50 *"I never had the feeling"* Dustin Hoffman in Michael Williams, "Tales of Hoffman in 'The Graduate,'" LAT (December 31, 1967).

50 *"You threaten him"* All Mike Nichols quotes in this paragraph come from Betty Rollin, "Mike Nichols: Wizard of Wit," *Look* (April 2, 1968).

51 *jumping rope in the buff* This incident is mentioned in Lois Schwartzberg and Jo Schneider, "Dustin Hoffman: The Graduate," *Columbia Daily Spectator* (April 25, 1968), as well as in O'Steen, *Cut to the Chase,* and elsewhere.

51 *"Mrs. Robinson was using sex"* Anne Bancroft in David Ehrenstein, "Embracing Complexity," LAT (May 5, 2000).

51 *"the Los Angelesization of the world"* Nichols in Edward Sorel, "Movie Classics: The Graduate," *Esquire* (May 1980).

52 *"the story crystallized for [Sylbert]"* Robert L Carringer, "Hollywood's Los Angeles: Two Paradigms" in *Looking for Los Angeles: Architecture, Film, Photography, and the Urban Landscape,* ed. Charles G. Salas and Michael S. Roth (Los Angeles: Getty Research Institute, 2001), 251-52.

53 *the $5,000 helicopter stunt* Turman, SYW, 205. The $5000 price tag comes from Bob Surtees, "Using the Camera Emotionally," *"Action!" The Magazine of the Directors Guild of America*, vol. 2, no. 5 (September–October 1967).

53 *"I was almost going to send an ape"* Nichols, Pinewood Dialogue.

53 *"all her clothes are animals"* Ibid.

54 *the adults' clothing is much too young* Buck Henry script for *The Graduate*, Box 22, LTA.

55 *he went so far as to design their houses' interiors* See Richard Sylbert and Sylvia Townsend, with Sharmagne Leland-St. John-Sylbert, *Designing Movies: Portrait of a Hollywood Artist* (Westport, Connecticut: Praeger, 2006), 93. Also Harris, *Pictures at a Revolution*, 61.

55 *personal deal with Chrysler* Turman, SYW, 202.

56 *"The intended beauty of color photography"* Letter, Box 25, LTA.

57 *"the Summer of Love happened"* Katharine Ross commentary, DVD.

57 *"I never thought about the year"* AI with Turman (September 17, 2015).

57 *were accusing their parents* Carringer, *Wide Angle*. All Sylbert quotes in this paragraph are from the same interview.

58 *frivolous script* AI with Haskell Wexler (May 28, 2008).

58 *"He was brilliant"* Sylbert in Carringer, *Wide Angle*.

59 *"be prepared because"* Bob Surtees, *"Action!"*

59 *"white hot and oppressive"* Ibid.

59 *"Thank goodness, I was not just starting out"* Ibid.

60 *"a separate set was constructed"* Louis D. Giannetti, *Understanding Movies* (Englewood Cliffs, New Jersey: Prentice-Hall, Inc., 1972), 157–58.

60 *sneaking a peek at her crotch* "Dangerous Curves Ahead," *Premiere* (March 2003). An alternative theory for the origin of this shot credits the contribution of storyboard artist Harold Michelson, who worked on the film. Daniel Raim's 2015 documentary, *Harold and Lillian*, maintains that Michelson came up with this dramatic camera placement, as well as a number of the film's other memorable moments.

61 *"I see my father ducking under the rope"* Hoffman in Mary McNamara, "Introspective and at Ease," LAT (April 10, 2005).

Chapter 6: Post-Production

62 *"Cutting is almost the greatest pleasure"* Mike Nichols in Betty Rollin, "Mike Nichols: Wizard of Wit," *Look* (April 2, 1968).

62 *graduation speech was shot* AI with Lawrence Turman (September 17, 2015).

63 *"There's all this nature"* Nichols in Joseph Gelmis, *The Film Director as Superstar* (Garden City, NY: Doubleday & Company, Inc., 1970), 287.

63 *"our script is sexually provocative"* Turman, SYW, 203.

64 *mistaken his posture for a deliberate crucifixion reference* For instance, see Gelmis, 286–87.

64 *wanted to see Ben arrive too late* Turman, SYW, 198.

65 *that final bus scene* Nichols Q&A with Barry Day, "Depends on How You Look at It," *Films and Filming*, vol. 15, no. 2 (November 1968), 8.

65 *"a happy ending with a little slice of lemon"* Buck Henry, interview with Terry Gross, *Fresh Air* (February 24, 1997). http://www.npr.org/templates/story/story .php?storyId=16578078

65 *"Look, we've got traffic blocked"* Nichols in Charles McGrath, "Mike Nichols: Master of Invisibility," NYT (April 12, 2009).

66 *"It seems to be perfectly possible"* Nichols in Day, 8.

66 *"This is the ending that really was created by my unconscious"* Nichols commentary, DVD.

66 *"If you don't have this"* Steven Soderbergh, Nichols commentary track, DVD.

66 *"You shoot until something happens"* Nichols commentary, DVD.

67 *"when the scene was supposed to end"* Sam O'Steen, *Cut to the Chase: Forty-Five Years of Editing America's Favorite Movies* (Studio City, CA: Michael Wiese Productions, 2001), 62.

67 *Sam O'Steen's duties* Entire paragraph is based on O'Steen, *Cut to the Chase*. See especially pages x and 63.

68 *"In the 'revelation' scene"* AI with Philip D. Schwartz (April 20, 2016).

69 *only a single distinctive whimper* Turman, SYW, 127.

70 *"It was so clearly Dustin's voice"* Nichols, DVD.

71 *Simon and Schuster* Stuart Byron, "Rules of the Game," *Village Voice* (January 6–12, 1982).

71 *"Every kid in America"* Joseph E. Levine in Turman, SYW, 206.

72 *"satiric, sometimes almost gauche music"* Turman, SYW, 207.

Chapter 7: The Release

73 *"It had hit some wind"* Mike Nichols, DVD.

73 *called for Hoffman and Anne Bancroft to pose naked* Michael Hainey, "Marathon Man," GQ (December 2004). Kashner tells a similar story in Vanity Fair.

73 *together chose the logo* Lawrence Turman, SYW, 138.

74 *Dallas star Linda Gray* "Making Waves," *People* (November 12, 2001).

74 *Bancroft herself posed for a series of sultry glamour photos* Box 26, LTA. All of these
 shots are marked "cancelled." In 2015 Turman didn't remember why they weren't
 used, but assumed Anne Bancroft had some contractual say in the matter.

75 *"I never gave a shit about credit"* Buck Henry in Sam Kashner, "Here's to You,
 Mr. Nichols: The Making of *The Graduate*," *Vanity Fair* (March 2008).

75 *tossed out the antiquated Production Code* See Jack Valenti, *This Time, This Place:
 My Life in War, the White House, and Hollywood* (New York: Harmony Books,
 2007).

75 *"In the wink of an eye"* Turman, SYW, 180.

76 *Dustin Hoffman was such an unknown commodity* Box 26, LTA.

76 *"A Swarthy Pinocchio"* David Zeitlin, "A homely non-hero, Dustin Hoffman, gets
 an unlikely role in Mike Nichols' *The Graduate*," *Life* (November 24, 1967).

76 *such popular magazines as* McCall's, Time, *and* Playboy Douglas Brode, *The
 Films of Dustin Hoffman* (Secaucus, New Jersey: Citadel Press, 1983), 26–27.
 Brode cites several early descriptions of Hoffman. In McCall's he was described
 as having "what appears to be a hastily arranged face—a beak nose, beady eyes,
 a thick thatch of black hair—a face that is boyishly appealing, but not hand-
 some in any traditional movie star way." *Playboy* called him an "unprepossessing,
 almost runty fellow with the mournful hound-dog eyes and oversized nose." He
 was also accused by a fellow actor, Bob Lardine of the popular TV series *Route 66*,
 of "resembling both Sonny and Cher."

76 *"I felt there was a kind of disguised anti-Semitism"* Dustin Hoffman in Peter Bis-
 kind, "Midnight Revolution," *Vanity Fair* (March 2005), 316. (Hoffman's strong
 ethnic self-identification surfaces in many interviews, as, for instance, when he
 speaks to Alec Baldwin on his "Here's the Thing" podcast, WYNC Radio (June
 9, 2015). http://www.wnyc.org/story/dustin-hoffman-htt/

77 *"Revenge is always a good motive"* Hoffman in Biskind, 316.

77 *what's often called a press book* Box 26, LTA.

78 *"The movie would not have been made"* AI with Turman (September 17, 2015).

78 *his profit participation share* Turman, SYW, 210. Columnist Joyce Haber seems
 to corroborate Turman's gripe against Levine in "Place in the Sun for Mike Nich-
 ols," LAT (February 26, 1968).

79 *"You knew who your friends were"* Janis Ian, *Society's Child: My Autobiography*
 (New York: Jeremy P. Tarcher/Penguin, 2008), 47.

79 *"It's hard, in this day and age"* Ibid., 69.

79 *"It just seems to me"* Nichols Q&A with Barry Day, "Depends on How You Look
 at It," *Films and Filming*, vol. 15, no. 2 (November 1968), 5.

82 *"if you hadn't miscast the lead"* Baldwin podcast. Similar comments have fre-
 quently been reported elsewhere.

82 *he'd shown up dead drunk* Sam O'Steen, *Cut to the Chase: Forty-Five Years of Editing America's Favorite Movies* (Studio City, CA: Michael Wiese Productions, 2001), 67.

82 *"We were showing our work print"* Nichols in Nora Ephron, "An Interview with Mike Nichols," *Wallflower at The Orgy* (New York: The Viking Press, 1970), 149.

83 *Radie Harris* Kashner, *Vanity Fair*. O'Steen tells essentially the same story.

84 *New York city councilman* Lou Cannon, *Governor Reagan: His Rise to Power* (New York: Public Affairs, 2003), 206-07.

Part II: The Screening Room

Chapter 8: Benjamin Braddock Comes Down to Earth

97 *it took a number of tries* Dustin Hoffman commentary, DVD.

102 *improvise a two-family barbecue* Sam O'Steen, *Cut to the Chase: Forty-Five Years of Editing America's Favorite Movies* (Studio City, CA: Michael Wiese Productions, 2001), 58.

Chapter 9: Getting in Over His Head

109 *an entire tin of condoms* Mike Nichols commentary, DVD.

110 *a "sweater feel"* Hoffman's memory of this event is described in Douglas Brode, *The Films of Dustin Hoffman* (Secaucus, New Jersey: Citadel Press, 1983), 21. Rather different renditions of the story appear in such places as *Premiere* (March 2003). In Mark Harris, *Pictures at a Revolution*, (New York: Penguin Books, 2008), 294, it is Hoffman himself who is in blackface. The tale involving Hoffman's attempt to touch a girl's breast while putting on a jacket can be found in Craig Modderno's "One on One with Dustin Hoffman" featurette, 25th anniversary DVD edition, *The Graduate* (1992).

Chapter 10: Chillin'

117 *"an affair that's almost incestuous"* Hoffman commentary, DVD.

Chapter 11: The Beast Defanged

125 *"stolen shots"* Hoffman and Ross commentary, DVD

128 *"she's Anna Maria Italiano from the Bronx"* Hoffman commentary, DVD.

132 *rain jacket, leggings, and boots* Katharine Ross commentary, DVD

Chapter 12: Going to Scarborough Fair

137 *"she's the only character in the movie"* AI with Lawrence Turman (November 19, 2007).

140 *"We don't want careers"* Ruth Rosen, *The World Split Open: How the Modern Women's Movement Changed America* (New York: Viking, 2000), 41.

142 *tossing into a trash can* For an account by one who was there, see Robin Morgan, *Saturday's Child: A Memoir* (New York: W.W. Norton & Company, 2001), 245–46 and 259.

142 *oral contraceptive pill* *Time*'s cover story, "Freedom from Fear," appeared on April 7, 1967.

Chapter 13: Untying the Knot

153 *"their faces going dead"* All Lawrence Turman quotes in this passage are from AI with Turman (September 17, 2015).

153 *end up becoming their parents* Nichols expressed variations on this thought often, e.g., in his Q&A with Barry Day, "Depends on How You Look at It," *Films and Filming*, vol. 15, no. 2 (November 1968), 7, and also in Joseph Gelmis, *The Film Director as Superstar* (Garden City, NY: Doubleday & Company, Inc., 1970), 288.

154 *saving himself through madness* See, for instance, Frank Rich, "The Graduate: Intimations of a Revolution," *The Criterion Collection* (2016). https://www.criterion.com/current/posts/3909-the-graduate-intimations-of-a-revolution One of several other references to this Nichols idea can be found in Mark Harris, *Pictures at a Revolution* (New York: Penguin Books, 2008), 319.

Part III: After the Lights Came Up

Chapter 14: The Hoopla

165 *"No small part of the phenomenal success"* Charles Champlin, "Postgraduate 'Stockbroker,'" LAT (October 1, 1971).

165 *"It was as though they all knew"* Hollis Alpert, "'The Graduate' Makes Out," *Saturday Review* (July 6, 1968).

166 *soon reach $50 million* "'Graduate' BO Topping $50Mil," *The Hollywood Reporter* (July 31, 1968).

166 *$104,945,305* This figure comes from the Box Office Mojo website: http://www.boxofficemojo.com/search/?q=the%20graduate.

166 *"It's a shame"* Richard Schickel, "Fine Debut for a Square Anti-Hero, *Life* (January 19, 1968).

166 *Hollywood pandering to middle-brow tastes,* and following quotes John Simon, *Movies into Film: Film Criticism 1967–1970* (New York: The Dial Press , 1971), 106.

167 *"How could you convince them"* Pauline Kael, "Trash, Art, and the Movies," *For Keeps: 30 Years at the Movies* (New York: Dutton, 1994), 225. The essay first appeared in Harper's in February 1969.

167 *"curious, almost defiant strain"* Charles Champlin, "'The Graduate' to Open," LAT (December 18, 1967).

167 *"the raw vulgarity of the swimming-pool rich"* Bosley Crowther, NYT (December 22, 1967).

167 *"for once, a happy ending makes us feel happy"* Stanley Kauffmann, "Cum Laude," *The New Republic* (December 23, 1967), 22.

168 *"a spiritual brother"* and ensuing quotes Miriam Weiss, "She Identifies With 'Graduate,'" *Movie Mailbag*, NYT (June 9, 1968).

169 *"All that is new about the Generation Gap"* David Brinkley, "What's Wrong with 'The Graduate,'" *Ladies' Home Journal* (April 1968).

169 *depicting without condescension the decade's youthful Americans* Senator Jacob K. Javits, "Politics or Pix—You Gotta Make Your Audiences Believe," *Weekly Variety* (November 13, 1968). Levine's lavish "Going Like Sixty" party was covered in *Variety* for September 13, 1965. At the party, Senator Javits made the announcement that guests had contributed $19,583 to establish the Joseph E. Levine Fund for neurological research at Boston's Peter Bent Brigham Hospital.

169 *"Something terrible and strange is going on"* William Goldman, *The Season: A Candid Look at Broadway* (New York: Limelight Editions, 1984), 157. *The Season* was originally published in 1968.

170 *"At some point between 1945 and 1967"* Joan Didion, *Slouching Towards Bethlehem* (New York: Farrar, Straus and Giroux, 1968), 122–23.

170 *"a ritual of purification and cleansing"* Philip E. Slater, *The Pursuit of Loneliness: American Culture at the Breaking Point* (Boston: Beacon Press, 1970), 54.

171 *"transforms it from a symbol of church convention"* Ibid., 59.

171 *clinical experiments with LSD* Paul Vitello, "Philip E. Slater, Social Critic who Renounced Academia, Dies at 86," NYT (June 29, 2013).

172 *"was what the strike was all about"* Reported by Hollis Alpert, *Saturday Review* (July 6, 1968).

172 *"Here's an alienated kid"* AI with Mark Rudd (December 30, 2007).

172 *" a youth-grooving movie for old people"* Stephen Farber and Estelle Changas, film review of *The Graduate*, *Film Quarterly* (spring 1968), 40. Additional quotes from this review on p. 41.

173 *"In youth you have this fervor"* AI with Stephen Farber (February 8, 2008).

173 *"kids at* The Graduate *can let go"* Jacob Brackman, "The Graduate," TNY (July 27, 1968), 40.

173 *"If we give unreserved praise to our cultural leaders"* Ibid., 66. All additional Brackman quotes are from the same source.

174 *a whole lot of cannabis* AI with Brackman (August 5, 2016).

174 *he'd never managed to read Brackman's piece* Nora Ephron, "An Interview with Mike Nichols," *Wallflower at The Orgy* (New York: The Viking Press, 1970), 154.

174 *"my opinion really doesn't have much more validity"* Mike Nichols in Joseph Gelmis, *The Film Director as Superstar* (Garden City, NY: Doubleday & Company, Inc., 1970), 287.

174 *"a film can easily be more than the people who made it."* Ibid.

174 *"I think that when artists"* Ibid., 290.

175 *"you see what you want to see"* Sam O'Steen, *Cut to the Chase: Forty-Five Years of Editing America's Favorite Movies* (Studio City, CA: Michael Wiese Productions, 2001), 62.

175 *"when I first saw* The Graduate*"* David Ansen, "7,714 Movies and Counting," *Newsweek* (October 20, 2007).

Chapter 15: Fan Voices

177 *"Like Benjamin, we weren't all sure what we wanted"* David Ansen, "7,714 Movies and Counting," *Newsweek* (October 20, 2007).

177 *"I identified with Dustin Hoffman"* AI with Marcus Mabry (April 14, 2008).

178 *"I was staring down the barrel"* AI with David Harris (February 5, 2008).

178 *"that cusp where you're leaving"* Ibid.

178 *"a really good boy"* AI with Jack Ong (January 31, 2008).

179 *"I was on my way to college"* AI with Dennis Palumbo (October 20, 2010)

179 *"the thing that was so appealing"* AI with Gerry Nelson (January 12, 2008).

180 *"As an adult I just take it for granted"* AI with Jody David Armour (February 21, 2008).

181 *"instead of love they gave* things*"* AI with Dustin Hoffman (January 30, 2008).

181 *"that major had something to do with it"* AI with Frank McAdams (December 19, 2007).

182 *"I was with several friends from Columbia"* Hilton Obenzinger e-mail (December 31, 2007).

183 *"upper-middle-class, all-white, very wealthy"* All Molyneaux quotes are from AI with Brother Gerard Molyneaux, F.S.C. (January 25, 2008).

184 *a native North Carolinian who would eventually become a professor* AI with Mark Evan Schwartz (March 15, 2006).

184 *"Tell me what seventeen-year-old kid"* AI with Jon Provost (February 28, 2008).

185 *"If she'd come around ten years later"* E-mail from Todd Leopold (May 22, 2006).

185 *a litmus test for her dates* AI with Donie Nelson (October 1, 2009).

185 *"terribly misogynistic"* E-mail from Erica Manfred (October 24, 2007). All additional Manfred quotes are from the same source.

185 *"They felt trapped"* AI with Ruth Rosen (March 10, 2008).

186 *"made the romantic gesture"* AI with Leo Braudy (July 16, 2008).

186 *"we all thought it was great"* AI with Katharine Haake (February 21, 2008).

187 *"I was young, and in love"* AI with David Harris (February 5, 2008).

187 *"The movie ends when you get the girl"* AI with Dick Orton (January 5, 2008).

Chapter 16: Hollywood Hullabaloo

188 *"We feel the story through Benjamin"* Ron Howard in Rick Lyman, "Here's to You, Mrs. Robinson," NYT (November 3, 2000).

189 *"as it's known in my house, Passover"* All quotes from the Oscar ceremony of April 10, 1968, come from the viewing of an official Academy of Motion Picture Arts and Sciences video, screened at the Academy's Pickford Center for Motion Picture Study on June 9, 2008, through the courtesy of the Academy Film Archive.

190 *the carnage of Vietnam* AI with Arthur Penn (April 14, 2008).

190 *the machinations of Twentieth Century Fox* John Gregory Dunne, *The Studio* (New York: Vintage Books, 1998), 247–48. *The Studio*, which covers Dunne's year in residence on the Fox lot, paints a vivid picture of the making and promotion of *Doctor Dolittle*. Dunne's book was originally published in 1969.

191 *"I'd like to sound really classy"* AI with Lawrence Turman (November 19, 2007).

193 *insiders like Larry Turman and Arthur Penn* Turman, SYW, 215. AI with Arthur Penn (April 14, 2008).

194 *"I was a) very spoiled, b) very neurotic"* Mike Nichols in Mark Harris, *Pictures at a Revolution* (New York: Penguin Books, 2008), 412.

194 *deeply wanted and needed adulation* Buck Henry in John Lahr, "Making it Real: How Mike Nichols Re-Created Comedy and Himself," TNY (February 21, 2000).

195 *ways to deviate from classic Hollywood cinematic practices* As a veteran TV and movie actor, Ron Howard was surprised to find that Lucas would largely make *American Graffiti* in sequence. Lucas also expected the cast to surprise him by contributing ad-libs as he shot take after take in what he called "documentary

style." See Beverly Gray, *Ron Howard: From Mayberry to the Moon . . . and Beyond* (Nashville: Rutledge Hill Press, 2003), 46–47.

196 *"a first-class American comedy"* Vincent Canby, review of *The Heartbreak Kid,* NYT (December 18, 1972).

198 *the Jew Wave* J. Hoberman, "The Goulden Age," *Village Voice* (April 17, 2007).

198 *Streisand boldly made her ethnicity a part of her public appeal* See Neal Gabler's *Barbra Streisand: Redefining Beauty, Femininity, and Power* (New Haven: Yale University Press, 2016).

199 *"I can't believe this guy's going to be a movie star"* Neile McQueen Toffel, *My Husband, My Friend* (Bloomington, Indiana: AuthorHouse, 2006), 172-73. This memoir was originally published in 1986.

199 *Ed Begley Jr. is just one Baby Boomer* Bob Thomas, "'The Graduate' Still Looking Good at 38," Associated Press (May 8, 2005).

199 *Jason Schwartzman was cast in the leading role* Jay Coyle, "A Decade Past 'Rushmore,' Schwartzman Hits Stride," Associated Press (September 17, 2009).

200 *"this is the movie that I went to school on"* Ron Howard in Lyman, NYT.

200 *"no other film in going-on-seven decades"* Richard T. Jameson, "Mike Nichols," *Film Comment,* vol. 35, no. 3 (May/June 1999), 10.

201 *"a visual watershed"* Steven Spielberg in John Lahr, "Making it Real: How Mike Nichols Re-Created Comedy and Himself," TNY (February 21, 2000).

201 *Ang Lee felt obliged* Naomi Pfefferman, "Ang Lee's Catskill Culture Clash," *The Jewish Journal* (August 11, 2009).

202 *Mike Nichols himself had been offered the chance to direct* "Elaine May in conversation with Mike Nichols," *Film Comment* (July/August 2006).

203 *"in the feminist version of this escape-from-the-altar scenario"* Susan Faludi, *Backlash: The Undeclared War Against American Women* (New York: Crown Publishers, Inc., 1991), 124.

205 *Judd Apatow sincerely admired* See Judd Apatow, *Sick in the Head: Conversations about Life and Comedy* (New York: Random House, 2015), 362–71. This is a transcription of a 2012 public conversation between the two men, held at New York's Museum of Modern Art.

206 *a Broadway musical, with Shirley Jones* Hank Grant, "Rambling Reporter," *The Hollywood Reporter* (June 16, 1980).

207 *"a 50-year-old naked woman"* Mike Nichols in Richard Corliss, "Whatever Happened to Movie Sex?," *Time* (November 24, 2004).

Chapter 17: Speaking of Sequels

208 *"All this drama in my life"* Charles Webb in William Georgiades, "A School of Hard Knocks for Mr. Webb," LAT (January 6, 2008).

208 *Dustin Hoffman had his own idea for a sequel* "One on One with Dustin Hoffman," DVD.

209 *"an innocent who walked around with 'The Sound of Silence' "* Hoffman in Douglas Brode, *The Films of Dustin Hoffman* (Secaucus, New Jersey: Citadel Press, 1983), 9.

209 *"I couldn't care less about* Time *magazine"* Hoffman in Lois Schwartzberg and Jo Schneider, "Dustin Hoffman: *The Graduate,*" *Columbia Daily Spectator* (April 25, 1968).

210 *"I would see him on television"* Mike Nichols Q&A with Barry Day, "Depends on How You Look at It," *Films and Filming,* vol. 15, no. 2 (November 1968), 5.

210 *dressed like a street bum* Alec Baldwin podcast, "Here's the Thing," WNYC Radio (June 9, 2015). http://www.wnyc.org/story/dustin-hoffman-htt/

210 *"I made you a star"* Nichols' comment recollected by Hoffman in Peter Biskind, "Midnight Revolution," *Vanity Fair* (March 2005).

211 *Nichols was deliberately choosing not to work with his former protégé* Sam O'Steen, *Cut to the Chase: Forty-Five Years of Editing America's Favorite Movies* (Studio City, CA: Michael Wiese Productions, 2001), 86.

211 *the turndown by Hoffman "might have engendered Mike's frustration"* AI with Lawrence Turman ((September 17, 2015).

212 *the two tennis buddies played the game of stopping passersby* Robert Evans, *The Kid Stays in the Picture* (New York: Harper Collins, 2013), 259.

212 *"more concerned with green than art"* Ibid., 321

213 *the bad habit of screaming* O'Steen, 59.

213 *Elizabeth Wilson disclosed* Pat Grandjean, "First Q & A with Elizabeth Wilson," *Connecticut Magazine* (April 2012).

213 *"Dustin Hoffman Stops Trying So Hard"* This is the title of an article by Manola Dargis in NYT (April 17, 2005).

214 *Cleo Rose Elliott* Howard Breuer, *People* (March 11, 2011). *The Malibu Times* photo spread appeared on November 9, 2013. http://www.gettyimages.com/detail /news-photo/actress-and-her-daughter-katharine-ross-cleo-elliot-are-news -photo/464214209. Most sources indicate that Katharine Ross has been married five times, but a *Los Angeles Times* correction to its obituary of cinematographer Conrad Hall maintains that Hall and Ross never officially wed, despite six years of togetherness.

215 *"Oscar is entering middle age"* These quotes from the Oscar ceremony of April 10, 1968, come from the viewing of an official Academy of Motion Picture Arts and Sciences video, screened at the Academy's Pickford Center for Motion Picture Study on June 9, 2008, through the courtesy of the Academy Film Archive.

215 *"I am quite surprised"* Bancroft quoted by Dino Hazell in "Anne Bancroft, Mrs. Robinson in 'The Graduate,' Dies of Cancer," Associated Press (June 7, 2005). The obituary notes that she'd made this remark in 2003.

215 *"She was one of the most alive people I ever met"* Dustin Hoffman in Myrna Oliver, "Versatile, but Forever 'Mrs. Robinson,'" LAT (June 8, 2005).

216 *"really creepy and sometimes aesthetically criminal"* Buck Henry in Peter N. Chumo II, "An Affair to Remember: Buck Henry on Writing *The Graduate*," *Creative Screenwriting*, (November/December 2005), 72.

216 *a squib in* Variety *announced* Cynthia Loggia, "'*Graduate*' Scribes Work Together After Decades," *Variety* (January 24, 2000).

217 *"Nichols would never again make"* Richard T. Jameson, "Mike Nichols," *Film Comment*, vol. 35, no. 3 (May/June 1999), 10.

218 *less "show-offy" and following quote* O'Steen, 182.

219 *"I've been married fifty-two years"* AI with Arthur Penn (April 14, 2008).

219 *"you see before you a happy man"* Mike Nichols in Bruce Weber, "Mike Nichols, Celebrated Director, Dies at 83," NYT (November 20, 2014).

219 *"Mike Nichols had delivered a tougher, stronger, edgier"* Lawrence Turman, SYW, 129.

220 *Two major studios offered him head-of-production jobs* Ibid., 7–8.

220 *"it made it appear like I was climbing on a bandwagon"* AI with Turman (September 17, 2015).

221 *"the loudest goddam SOUND"* Lorenzo Semple Jr., unpublished screenplay for *The Marriage of a Young Stockbroker* (dated June 30, 1970), collection of the Margaret Herrick Library of the Academy of Motion Picture Arts and Sciences.

221 *"a cockeyed optimist"* All quotes in this paragraph are from AI with Turman (September 17, 2015).

222 *he sued in 1975* Turman, SYW, 216-17. Also Aljean Harmetz, "Producer of Graduate Wins Ruling on Sales," NYT (April 19, 1980).

222 *"No mention of me whatsoever"* Turman, SYW, 218.

223 *a menial job stocking cosmetics* "'The Graduate': Will Success Spoil Who?—Charles Webb??," *Los Angeles Herald Examiner* (February 16, 1968).

223 *almost bare South Pasadena rental home* John Riley, "'The Graduate' Faces Success at 30," *Los Angeles*, vol. 14, no. 6 (June 1969).

223 *Love, Roger* "Graduate School" (book review), *Time* (May 9, 1969). Also Maggie Savoy, "Chuck Webb: Writer First, Last, Always," LAT (June 1, 1969), regarding Universal Studios' involvement.

223 *"That's the trouble with money"* Charles Webb in *Savoy*, Ibid.

224 *"Though neither Fred nor I are Jewish"* Webb in Ambrose Clancy, "A Post-'Graduate' *Life*," LAT (May 14, 2002).

224 *an eleven-room $65,000 home in Williamstown, Massachusetts* Dan Wakefield, "The Graduation of 'The Graduate,'" New York (October 25, 1976).

224 *they donated the house to the National Audubon Society* LAT (July 27, 1970).

224 *"I guess we thought that because we were so generous"* Fred in Tim Allis and William Sonzski, "Post-Graduate Life Proves Unkind to Author Charles Webb—Footloose, Fundless and Looking for Help," *People* (October 24, 1988).

225 *"Fred is totally disoriented"* Charles Webb, Ibid.

225 *then decided to move to England* Wade Lambert, "Author of 'The Graduate' (Finally) Publishes Again," *Wall Street Journal* (May 8, 2001).

225 *$20,000 to a local artist* William Georgiades, "A School of Hard Knocks for Mr. Webb," LAT (January 6, 2008). Also *Thoughtcat* web interview (July 21, 2006), which provides a fascinating glimpse of Webb's mental state. http://thoughtcat .blogspot.com/2006/07/thoughtcat-exclusive-interview-with.html

225 *featuring the artist in the buff* Mary Vespa, "Couples: Like His Character 'The Graduate,' Charles Webb Finds a Woman to Nonconform With," *People* (February 28, 1977).

225 *publicly cooked and ate a copy of* The Graduate David Smith, "Who are you, Mrs. Robinson?," *The Observer* (February 6, 2005).

225 *never bothered to see the film version* See, for instance, Wakefield, New York (October 25, 1976).

226 *"a highly moral person"* and following Webb quotes in "Correspondence," *The New Republic* (May 1968).

226 *"my first reaction to this letter"* and following Kauffmann quote in Ibid.

226 *"I cringe at the quote"* Webb in Mark Harris, *Pictures at a Revolution* (New York: Penguin Books, 2008), 397.

226 *"owned by my father and then Charles"* Vespa, *People*.

226 *They variously explained this* Compare Clancy, LAT (May 14, 2002) and Allis et al., *People* (October 24, 1988).

227 *Salvation Army shelter* Georgiades, LAT (January 6, 2008).

227 *he now speaks appreciatively* Ibid.

227 *Ben's disenchantment with modern educational systems* "'Graduate' Author to Write Sequel," CNN.com (May 31, 2006).

228 *"He was probably trying to resurrect"* AI with Lawrence Turman (September 17, 2015).

228 *"Everyone has an ego "* Ibid.

228 *"It really belongs to nobody now"* All Nichols quotes in this paragraph from Sam Kashner, "Here's to You, Mr. Nichols: The Making of The Graduate," *Vanity Fair* (March 2008).

Chapter 18: Pop! Goes the Culture

230 *"I sometimes wonder if any of us really understands another person's movie"* Lawrence Turman, SYW, 208.

230 *"Benjamin was short and looked like a rodent"* John Manderino, *Crying At Movies: A Memoir* (Chicago: Academy Chicago Publishers, 2008), 62.

231 *"I wouldn't mind being his Mrs. Robinson"* See Michael Sragow, "'The Graduate' has Aged Well," *The Baltimore Sun* (January 11, 2002).

232 *Dirty Grandpa* http://www.imdb.com/media/rm407298560/tt1860213?ref_=ttmi_mi_all_art_15

233 *"Lisa's Substitute"* The Simpsons, season 2, April 25, 1991.

233 *reproduced from the sunporch scene* https://www.youtube.com/watch?v=npXV-UesBUU

233 *Albert Brooks' Mother* https://www.youtube.com/watch?v=RcqR5cnQyUo

233 *two of the* American Pie *films* https://www.youtube.com/watch?v=__qWxUVD2qQ

234 *a curious adaptation of* https://www.youtube.com/watch?v=Hh3bSzDQ1Po

234 Jackie Brown *and* Mad Men http://www.slate.com/blogs/browbeat/2014/04/13/mad_men_season_7_premiere_was_that_an_homage_to_the_graduate_and_jackie.html

234 *The Holiday* https://www.youtube.com/watch?v=ZSHuVnL-ghw

235 *political candidate Pat Buchanan* "Morning Report," LAT (March 15, 1996).

235 *comedian Larry Wilmore* Larry Wilmore, "The Birther of a Nation," "Aftermath: Sixteen Writers on Trump's America," *TNY* (November 21, 2016).

235 *"Lady Bouvier's Lover"* The Simpsons, season 5, May 12, 1994. https://www.youtube.com/watch?v=GyCjURaxEsg

236 *"Mr. Monk and the Wrong Man"* http://watchseries.cr/series/monk/season/6/episode/8

236 Wayne's World 2 https://www.youtube.com/watch?v=FZbW3GgZvfo

237 *"especially now that I'm in college"* AI with Philip Hogan (April 4, 2008).

238 *imaginative car commercial* https://www.youtube.com/watch?v=of10i06UDTE

238 *red Alfa Romeo 1600 Spider Duetto* "The Graduate's Car Grows Up," *The Hollywood Reporter* (March 20, 2015).

239 *popular-press articles on everything plastic* See for instance an October 2004 *GQ* article on cosmetic surgery to help men avoid the ageing process. It's called "Getting into Plastics."

239 *young people like me had grown up playing with* Jeffrey L. Meikle, *American Plastic: A Cultural History* (New Brunswick, NJ: Rutgers University Press, 1995), 2.

239 *"The Graduate was a hell of an advertisement for the industry"* Bruce Handy, "Just One Word," *Time* (July 14, 1997).

239 *"plastics won"* Ibid.

240 *the development of pantyhose* Martin J. Smith and Patrick J. Kiger, *Poplorica: A Popular History of the Fads, Mavericks, Inventions, and Lore that Shaped Modern America* (New York: Harper Resource, 2004), 115–16.

240 *"Where Have All the Stockings Gone?"* Anne Schlitt blog post, no longer available online, singing the praises of stockings, as opposed to pantyhose.

240 *Her leopard jacket* Avery Matera, "The 10 Classic Winter Coats that Basically Defined the Movies They Were In," Glamour.com (October 19, 2015). http://www.glamour.com/story/classic-winter-coats-2015?mbid=synd_moz_entermovies

240 Move over, Mrs. Robinson http://www.amazon.com/Move-Over-Mrs-Robinson-Relating/dp/1402203268/ref=sr_1_1?s=books&ie=UTF8&qid=1460844640&sr=1-1&keywords=move+over%2C+mrs.+robinson

241 *"The Graduate 1968"* Cover, *Time* (June 7, 1968).

242 *"I think there were a few iconic films"* AI with Brian Weiss (January 7, 2008).

242 *"Now Where Are The Jobs?"* Cover, *Time* (May 24, 1971).

243 *promo for the Peace Corps* https://youtu.be/RfEOzylnQmU

243 *VISTA issued a black-and-white poster* http://www.ebay.com/itm/THE-GRADUATE-1968-rare-1ST-Dustin-Hoffman-plastics-VISTA-poster-Film artgallery-/161900358627?hash=item25b2036be3:g:-4MAAOSwys5WWS-D

ACKNOWLEDGMENTS

Every book has its own backstory. This one rose like a phoenix from the ashes of a previous project, reminding me that opportunity sometimes comes when it is least expected. Which is, of course, a lesson that I share with Benjamin Braddock.

When turning the story of *The Graduate* from a private obsession into a finished book, I knew from the start that I couldn't go it alone. My thank-yous must begin with producer Lawrence Turman, chairman of the Peter Stark Producing Program of the USC School of Cinematic Arts. Despite his busy schedule, Larry made time for two in-depth interviews on the subject of *The Graduate*, fielding my many questions with candor and wit. And his production files on *The Graduate*, housed in UCLA Library's Special Collections, have proved to be a treasure trove.

In addition to UCLA Special Collections, I haunted a number of libraries and archives. These included the UCLA Film and Television Archive (Mark Quigley), USC Cinema-Television Library (Ned Comstock), the Paley Center for Media (Martin Gostanian), Beverly Hills Public Library, Boston Public Library, and my home away from home, Santa Monica Public Library. The Margaret Herrick Library of the Academy of Motion Picture Arts and Sciences is—as all film researchers know—a sanctuary in every respect. May Haduong, public access manager at the Academy Film

Archive, graciously enabled me to view the full video recording of the fortieth annual Academy Awards ceremony. My deepest thanks to all.

Among moviegoers (most but not all of them Baby Boomers) who share my passion for *The Graduate*, I must tip an imaginary hat to those quoted in this book. They include Jody David Armour, Leo Braudy, Katharine Haake, David Harris, Philip Hogan, Todd Leopold, Marcus Mabry, Erica Manfred, Frank McAdams, Brother Gerard Molyneaux, F.S.C., Donie Nelson, Gerry Nelson, Hilton Obenzinger, Jack Ong, Dick Orton, Dennis Palumbo, Jon Provost, Ruth Rosen, Mark Rudd, Mark Evan Schwartz, and Brian Weiss. Hollywood insiders Dustin Hoffman, Arthur Penn, and Haskell Wexler contributed their valuable perspectives, while Jacob Brackman and Stephen Farber aired their contrarian views.

I am fortunate to know a number of writers and filmmakers who've helped in large ways and small. Hollywood journalists F. X. Feeney and Craig Modderno generously shared insights about the making of *The Graduate*. Karen Stetler of the Criterion Collection answered my questions about the film's most recent video release. Martin J. Smith helped me track down Anne Schlitt's little paean to Mrs. Robinson's nylon stockings. Billy Mernit made time to discuss wedding movies; Kathy Seal filled me in on the 1968 student uprising at Columbia University; Hillel Schwartz explained the political climate at Brandeis University circa 1970; and Phil Schwartz walked me through the intricacies of cinematographic focus-pulling. James Curtis gave me the benefit of his own research in matters pertaining to storyboarding and visual style. In

addition, Jim Parish offered guidance, and the indispensable Susan Henry was always available when I needed her, both to read and to listen.

I am indebted to two writers' organizations whose members have cheered me on (and sometimes cheered me up). It's impossible to list everyone, but among my fellow members at the American Society of Journalists and Authors I'd like to single out Damon Brown, Randy Dotinga, Marina Krakovsky, Nancy Kriplen, Marlene McCampbell, Sherry Beck Paprocki, John Riley, Salley Shannon, and especially the dynamic duo of Minda Zetlin and Bill Pfleging, whose late-night discussion of the impact of *The Graduate* on their lives taught me a lot. Among the members of the Biographers International Organization, I'm particularly grateful to Dona Munker and Beth Phillips, both of whom cared deeply about my forward progress. And it was at a BIO conference that I connected with Patrick Kabat, who shared with me his expertise in media law.

Of course this book would have remained only a glint in my eye if it were not for my exemplary agent, Stuart Bernstein. Thank you, Stuart, for believing in me, even when I wasn't always sure I believed in myself.

I have been fortunate indeed to land at a publishing house that seems to truly care about its authors. All hail to the folks at Algonquin who've worked hard to ensure that this book is (as Benjamin would put it) *completely* baked. I'll begin by thanking Amy Gash, the most effervescent of editors, for her enthusiasm and sense of literary style. And here's to *you*: Elisabeth Scharlatt, Brunson Hoole, Michael McKenzie, Jacquelynn Burke, Lauren

Moseley, Randall Lotowycz, and Anne Winslow, as well as your colleagues whose names I'm just now learning. Special appreciation to Laura Hanifin, photo researcher extraordinaire, who knows full well that a picture is worth at least two thousand words. And a big high five to Bruce Tracy, senior editor at Workman Publishing, whose keen eye and knowledge of American pop culture have contributed so much to my text. Errors, of course, are mine alone.

Finally, thanks and warm hugs to Hilary Bienstock Grayver, Eugene Grayver, and Jeffrey Bienstock, all loyal members of my support team. And my profound gratitude to Bernie Bienstock, my personal tech advisor for over four decades. Though I knew from the start that I wanted my future to be . . . *different*, I could never have guessed at the role technology would play in my writing career. Thankfully, Bernie understands what to me remains mysterious, and is always primed to step in when I'm stymied. He can also generally be persuaded to drop everything and go see a movie.

BEVERLY GRAY
Santa Monica, California

INDEX

Italicized page numbers indicate photo captions.